LENS, LIGHT

A N D

LANDSCAPE

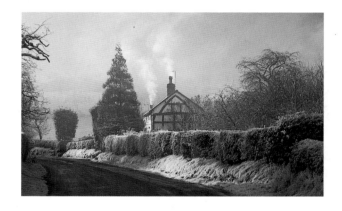

Cottage, Alderley Edge, Cheshire

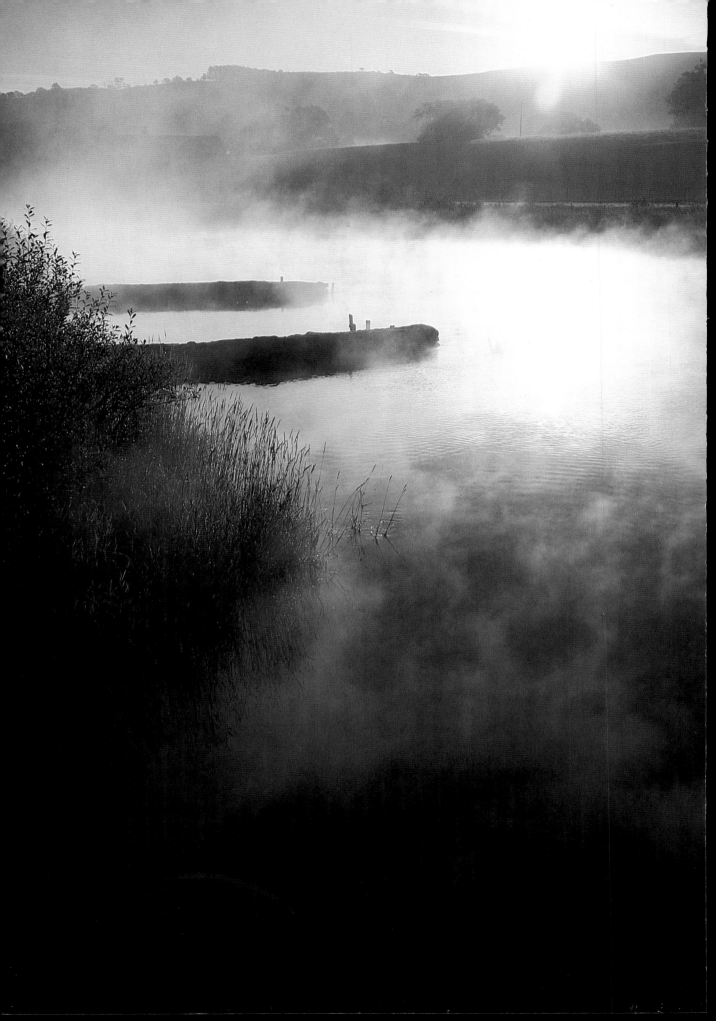

LENS, LIGHT
AND
LANDSCAPE

BRIAN BOWER

David & Charles

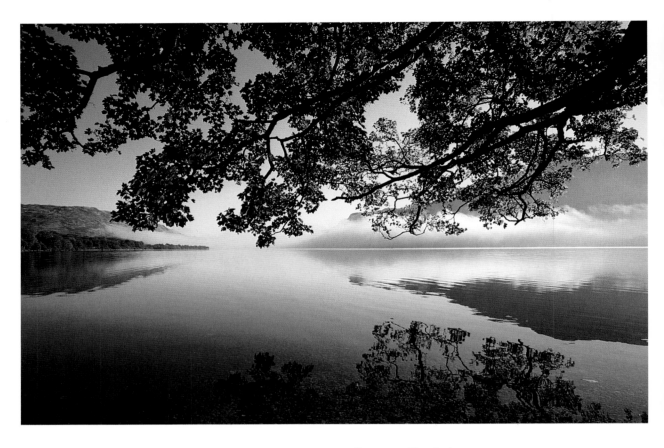

(Previous page)
Autumn morning, Pooley Bridge, Cumbria

Leica M6, 35mm Summicron, 1/60sec f5.6, Kodachrome 25 Professional.

Ullswater, Cumbria

Leica M4, 21mm Super Angulon, 1/60sec f5.6, Kodachrome 25.

A DAVID & CHARLES BOOK
Copyright © Brian Bower 1993
First published 1993

ISBN 0 7153 0121 7

Typeset by ICON, Exeter
and printed in Singapore by C S Graphics
for David & Charles
Brunel House Newton Abbot Devon

CONTENTS

1

THE PHOTOGRAPHER AND THE LANDSCAPE

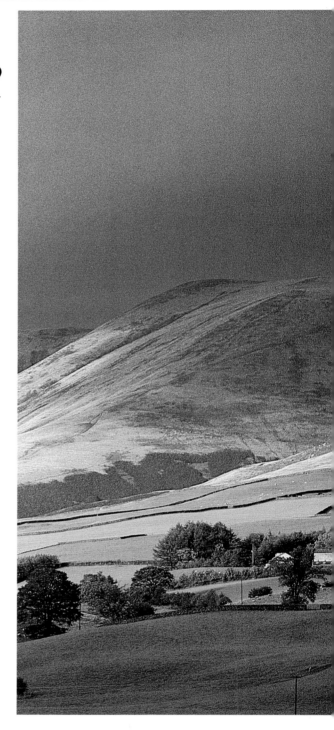

Even from the earliest times, when pictures were hacked on the rock walls of cave dwellings, the human race has had an urge to record the surrounding world, the people, the animals but most particularly the places. Subsequently, throughout all the important periods and movements of art, the landscape has been and continues to be an enduring theme for many great painters.

Modern technology in the shape of camera and lens has only been with us for one hundred and fifty years, but it has revolutionised our ability to picture the things that interest us. No longer are the skill and patience of a trained artist, acquired over an extended period, needed to produce a satisfying representation. Fox Talbot's 'pencil of nature' in 1839 showed how this could be achieved in minutes, albeit at that time requiring the skills of a chemist as well as a camera operator.

Further developments have now brought the technology to the point where it is possible to produce images of superb quality with little or no knowledge of photographic technique. The means to record our environment therefore are simple, but good landscape images are created with the mind and the eye, not by a technological box of tricks. Conveying real feeling for the subject, and capturing the many subtleties of light and weather that make for outstanding scenic images, is one of the most difficult challenges in photography.

For this reason the first part of this book has concentrated on examples of the great variety of landscape-related images. The second part discusses in depth the essential techniques of any creator of scenic images, whether painter or photographer. These are perspective, viewpoint, composition and lighting. Then in the third part equipment and materials are reviewed in considerably more detail. In this way I hope that I have emphasised that it is the impressions and the creation of ideas and images that are most important whilst the knowledge of techniques and equipment is there as a means to this end, not as an end in itself.

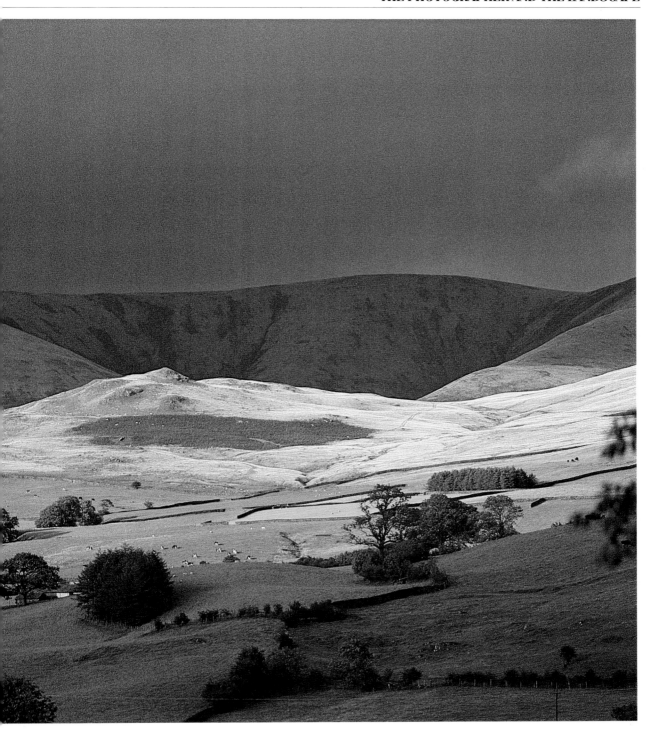

Westmorland Fells, Cumbria

A straightforward pastoral scene made worthwhile by the light. The sky was dark and foreboding but every so often there were odd patches of sunlight sweeping across the fells. I found a good viewpoint and waited for the sun to illuminate the right area of the scene.

Leica M6, 135mm Tele Elmar, ¹/₅₀₀sec f5.6, Kodachrome 200 Professional.

DEFINING LANDSCAPE

Some years ago the Ilford Company advertised 'Ilford film for Faces and Places', immediately identifying with the two most popular subjects for camera users. The family photographer perhaps concentrates slightly more on 'faces' whilst those with a keener interest in

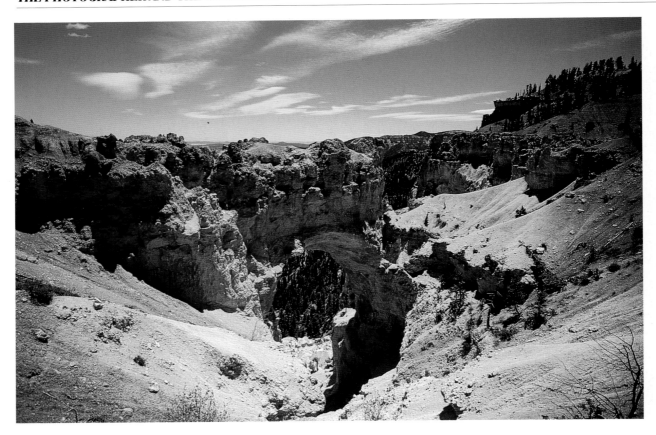

Natural Arch, Bryce Canyon, Utah

The sort of landscape that everybody who travels wishes to record as attractively as possible. I had to accept the time of day and lighting as they were, so it was a question of making the most of the opportunity presented by choice of viewpoint and lens selection.

Leica SLR, 35mm Summicron, ¹/₁₂₅sec f5.6, Kodachrome 25 Professional.

the medium will be more likely to direct their efforts to 'places'. It is in fact quite remarkable that in surveys conducted by photographic magazines, by camera makers and by photographic material manufacturers 'landscape' consistently comes at the head of the list of subject interests.

In this sense 'landscape' is used in its broadest meaning, not just that of the pastoral view of trees and hills, lakes and mountains. It embraces any photography that is 'place' rather than 'people' or 'flora and fauna' oriented. It naturally includes seascapes and skyscapes, but it also comprises photographs of urban areas, villages, great cities, industrial views, harbours, bridges and other artifacts that are a normal part of the general scene. People, flora and fauna, ships, trains may well appear in these landscapes; in fact in some cases it is inevitable. They will not, however, be the most important element and will be there to help the sense of place not be the main subject matter.

The dividing line may be something of a grey area, particularly with nature photography. Is an animal or person in a photograph putting a 'place' in context or is the place putting the animal or person in their environment? When does an architectural record become an urban landscape? These questions are really for the photographer to decide, and the composition and lighting of the photograph will no doubt influence

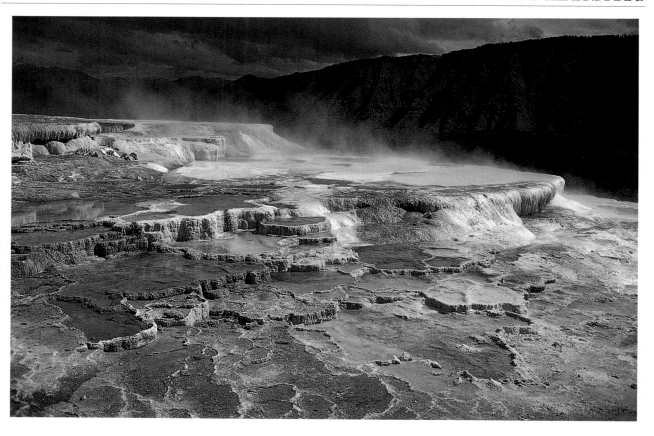

a viewer one way or the other. But does a strict dividing line matter anyway? I am sometimes amazed at the narrow opinions that some photographers have on what constitutes a landscape: 'This is not appropriate', 'That is not allowed', 'This breaks all the rules of composition' etc. You only have to look at the work of many great painters to see how difficult it is to categorise and set any sort of rules. The great landscape painter Constable almost always included some human activity in his works. Turner and Monet both produced scenes that included what was then the latest technological advance – the railway train! There are many similar examples from great landscape painters and photographers.

A broad view of the meaning of 'landscape' is the context within which this book has been written, so that many of the techniques discussed and comments on the equipment described or illustrated will have an application to other aspects of photography as well as specifically to landscapes.

THE PHOTOGRAPHER'S PURPOSE

A landscape photograph may be no more than a simple record of a place that has been visited. To the person

Mammoth Hot Springs, Yellowstone National Park, Wyoming

As well as being of interest both as a travel record and to a geologist or geographer, this view has gained a pictorial appeal from the lighting. I waited for the fitful May sunshine to catch the travertine terraces in the foreground and these were nicely set off by the dark sky.

Leica R5 SLR, 35mm Summicron, 1/125sec f5.6, Kodachrome 25 Professional.

(Overleaf)
Dawn, Ullswater, Cumbria

Here the actual location is of little importance, since the objective was to catch the mood and quiet mystery of an October dawn. Considerable effort and planning went into getting to this location at the right time and with the right conditions, but even so there is always an element of luck involved when everything goes right!

Leica M4, 35mm Summicron, 1/60sec f5.6, Kodachrome 25.

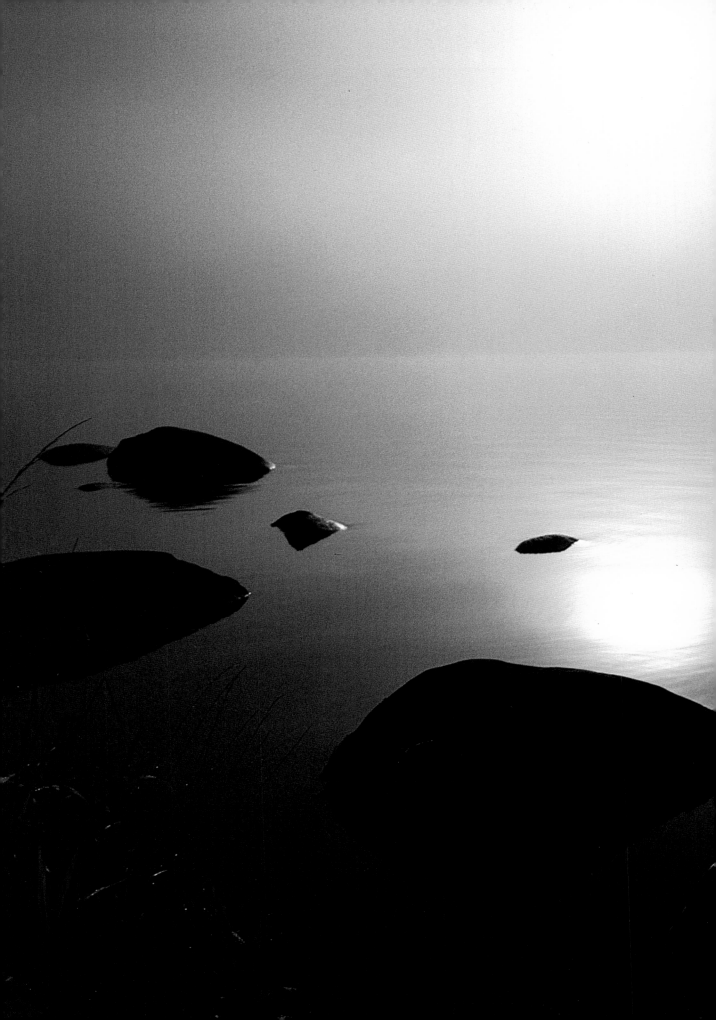

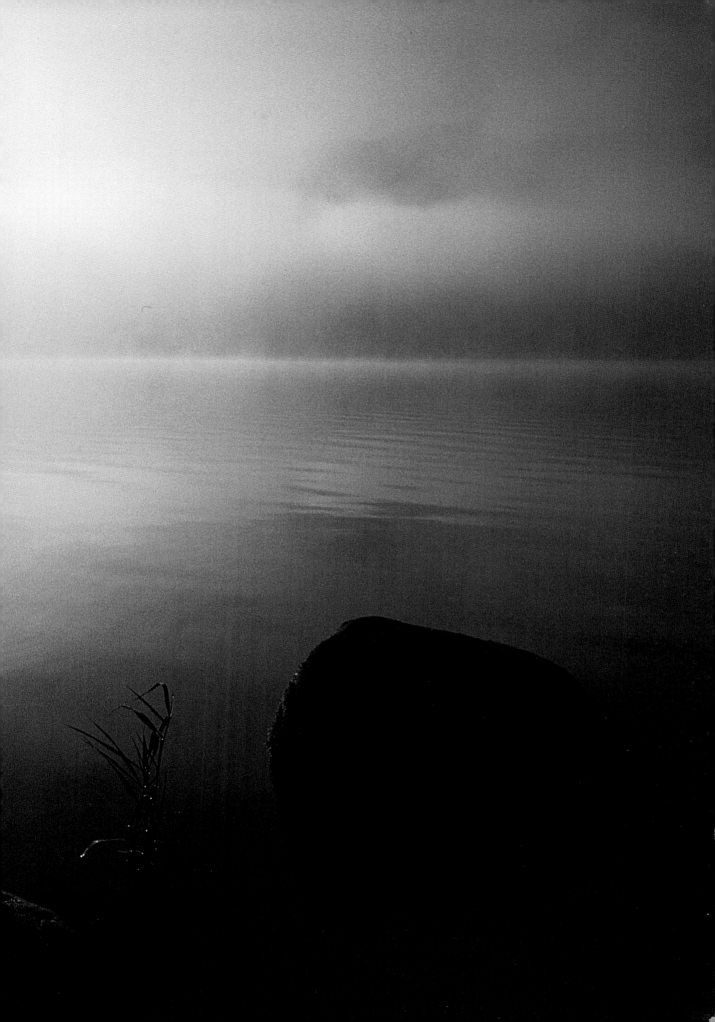

who has taken it, it will serve as that record and as a reminder of associated activities and incidents – a memory jerker. The photographer may have neither the equipment, the skill, the time nor even the inclination to want anything better. In practice, with a reasonable modern compact camera with autofocus and perhaps a zoom lens, the photographer will almost certainly produce results of a quality which will be extremely satisfying from a personal point of view – in spite of accepting the light and location just as it comes and making little or no effort to make a satisfactory composition.

Rather more serious photographers will want something better. They may not be looking to produce a masterpiece. They may not have the opportunity to return when the light will be better or to explore many different viewpoints, but they will want to do the best they can with perhaps limited time and whatever equipment they have at their disposal. Their interest may primarily be something other than the pictorial – geology or architecture for example – with the photography being used as effectively as possible to support this other interest. Even the most dedicated and professional photographers may be pressured by deadlines and/or the need to move on when touring, and in all these circumstances a good background of experience in technique as well as lighting and composition will allow the very best to be made even of situations that are less than ideal.

Truly dedicated scenic photographers have a clear idea of their objectives and will persevere until they achieve them. They may be working commercially and want the best possible photographs of a location for advertising purposes, for magazine articles or for book illustrations. This kind of landscape photography may have to be very specific indeed. As an example, a travel brochure will want to include pictures that make a place look as attractive as possible – sunny, blue skies and uncrowded. If it is a fly-drive brochure, a car may need to be included somewhere. On the other hand a landscape being used as a foil to an advertising shot is quite likely to need to have real mood. The professional will work and plan as hard as possible within the constraints of time and cost to get the best possible viewpoint and the best possible lighting to fulfil the specific requirement. In a similar category are the photographers, professional or amateur, who have an artistic desire to capture the spirit, mood and atmosphere of a location that is an inspiration visually or spiritually. They may have a location in mind and it may be months or years before everything is 'just right' or they may experience one of those occasions when,

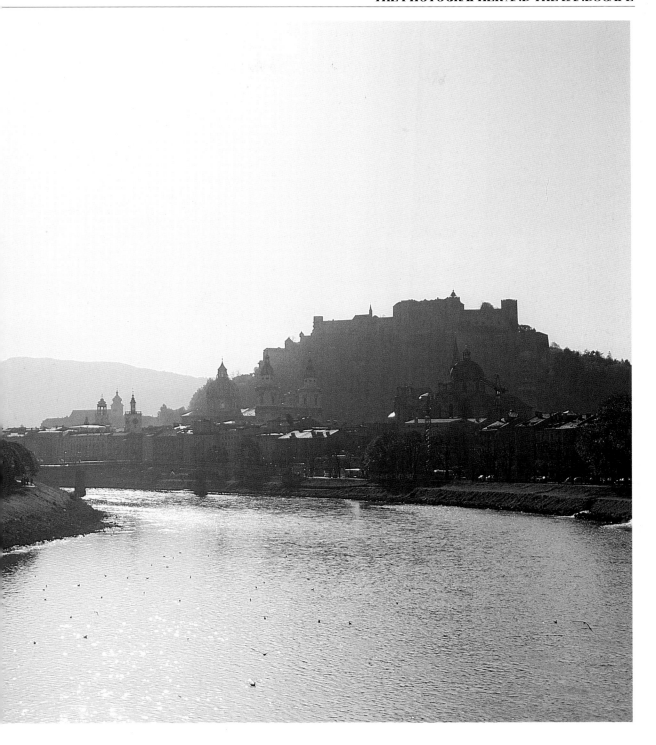

Salzburg, Austria

Leica M4, 50mm Summicron, $^1/_{250}$sec f4, Kodachrome 25.

Scenic photography is just as much about the way man has transformed the landscape as the pastoral. Great cities with their urban and industrial views are just as much worth taking trouble with as lakes and mountains. This view of Salzburg was the result of an early morning foray whilst the light was still warm and interesting. Shooting against the light added sparkle to the water and emphasised the strong shapes of the buildings and the castle on the hill.

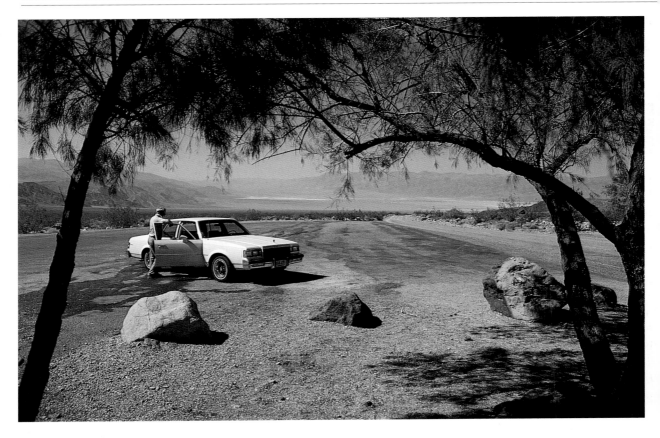

Death Valley, California

I was on an assignment for British Airways, shooting material for USA holiday brochures. This was one taken for possible use to promote fly-drive holidays. It shows the scene quite pictorially and introduces the car and person without them overpowering the view.

Leica R4 SLR, 28mm Elmarit, ¹/₁₂₅sec f8, Kodachrome 25.

by sheer chance, inspiration, light and location combine to present them with an opportunity that has to be seized immediately. Great patience together with an ability to react and work very quickly indeed when the opportunity presents itself are the mark of the serious landscape photographer.

Landscape also is the medium often used for self-expression by artist photographers or 'fine art' or 'independent' photographers as they may be called. In their case the landscape is merely a vehicle through which the photographer communicates ideas or feelings. Such a photographer is less concerned with the literal depiction of the scene before the camera than its use to convey an abstract idea or as a metaphor. Examples are seen in John Blakemore's 'Wind' series, where he successfully expresses this invisible element with some very beautiful landscape photographs, or Paul Hill's images of the English Peak District which explore the subtle marks which human beings have imposed on the fields and hills. In these cases the concept or the idea comes first and the particular landscape is used as one element to communicate that idea.

All these applications of landscape photography are equally valid. The important thing is that the photographer endeavours to achieve whatever objective has been set.

2

THE NATURAL SCENE

LAKES AND MOUNTAINS

Lakes and mountains have always been favourite landscape subjects. The desire to capture an image of a beautiful lake or an awesome mountain range has been a continuing inspiration for photographers from the earliest days of the medium.

These scenes are universal, and every continent has its famous mountains and well-known lakes, from the Rockies of North America to the Alps in Europe and from the Himalayas of Asia to the Andes of South America. Fortunately the largest or the biggest or the best known are not necessarily the most photogenic. There are many many smaller, perhaps less spectacular but infinitely more attractive areas that can, and have, produced some of the finest landscape photography.

SMALL CAN BE BEAUTIFUL

One of the most beautiful areas in Britain is the Lake District. None of the eleven lakes is particularly big – Windermere, the largest, is only 11 miles (18km) long – and the mountains are not especially high although they do include England's highest peak, Scafell, at 3,260ft (970m). Nevertheless, within an area approximately forty miles by twenty miles (sixty-five by thirty-two kilometres) is some of the most magnificent scenery. The area is small enough for the scale to be comprehensible, yet large enough to allow many remoter locations where you can escape the crowds even on the busiest summer weekend. It is a place to enjoy calm and recharge batteries, and many poets, painters and photographers have found inspiration here. It is certainly high on my list of favourite places.

Good landscape photography is all about having a feeling for a place. Ullswater in the north-eastern corner of the Lake District and Wastwater on its western edge are the lakes that pull me back time and again. On a very few occasions I feel that, over and beyond a straight view, my photographs have caught their mood and atmosphere. Their relative infrequency serves to emphasise that no matter how well you know a place, how often you visit it or how well prepared you are, the best landscape pictures depend on an element of luck – a sometimes chance element of weather, light and viewpoint that fleetingly combine. It is on occasions like these that your photographic technique has to be so well practised that it is intuitive and you can concentrate totally on making the most of an opportunity. Although the weather is always fickle, the best time to visit is late winter (February/March) and autumn (October/November). The area is certainly very pretty in summer; however, not only are the roads inevitably more crowded making access even to remoter areas less easy but the mood and mystery are less likely to be enhanced by interesting weather.

PLANNING

Naturally the world's more spectacular areas have a special appeal to anyone who loves landscape. Although a relatively short visit is unlikely to provide an opportunity to capture the combination of subject, light and weather that can make an image that is special, the challenge is irresistible.

Careful advance planning to include interesting locations at the right time of year as well as a serious effort to be in the right place at the right time of day and with the right equipment will always maximise opportunities. You may not get the ultimate mountain photographs, but by thinking ahead you are more likely to be rewarded with some worthwhile pictures. As an example, the most spectacular and photographically rewarding route into Yosemite National Park, California is from the east over the Tioga Pass. Spring (late May and early June) is a great time for Yosemite, with fresh flora and fauna and the various falls at their best with the spring melt. Tioga, however, rises to almost 10,000ft and is blocked by snow, usually until the end of May. Some of the roads in Yosemite Valley that lead to such awe-inspiring views as those from Glacier Point are also blocked. 'The window of opportunity' to cross Tioga and still capture spring therefore is not great. This shows how trips into mountain areas especially require photographers to do their homework if they wish to make the most of them. Good maps and authoritative guidebooks are an investment as is taking the time to talk to those who have been there before. I always find it helpful to study various tour operators' brochures. The better and more specialised ones are well illustrated and include valuable information on temperatures, rainfall and hours of sunshine.

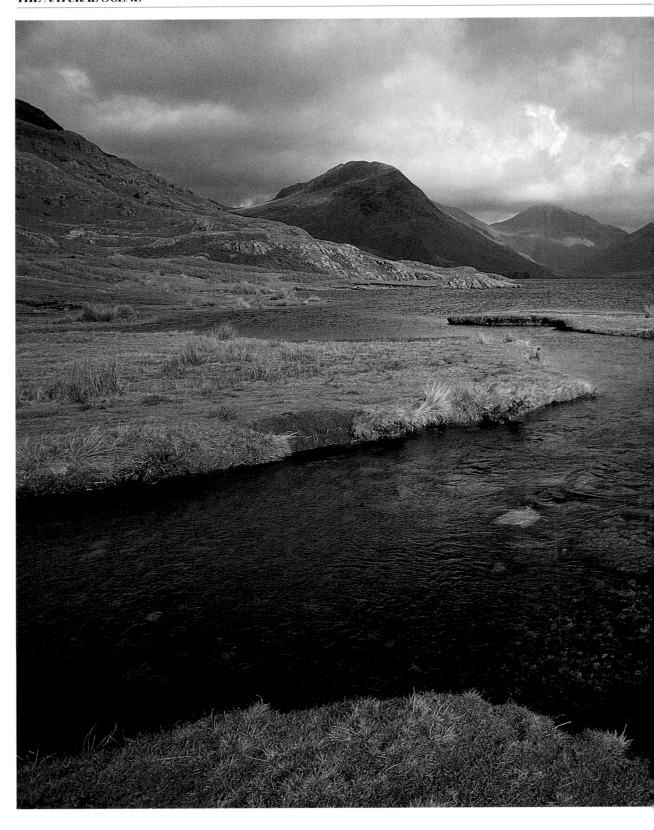

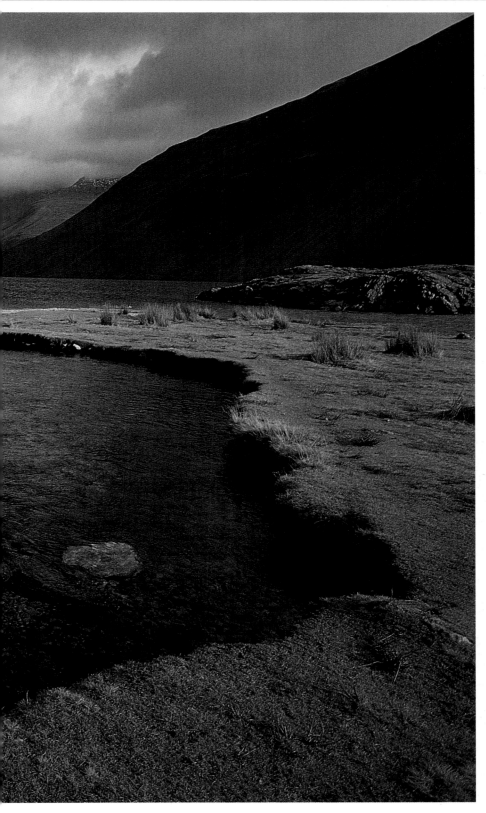

Wastwater, Cumbria

Located on the western fringe of the Lake District, Wastwater is less accessible and therefore less crowded than popular areas like Windermere. Lakeland colours are at their best in late October and early November. On this November day a strong wind was blowing and there was lots of cloud. The patches of sunlight lasted only a few seconds at a time and I had to work very quickly between long waits! An ultra-wide-angle lens allowed me to include a bold foreground whilst including the head of the lake and to still keep everything sharp.

Leica M6, 21mm Elmarit, ⅟₆₀sec f8, Kodachrome 25 Professional.

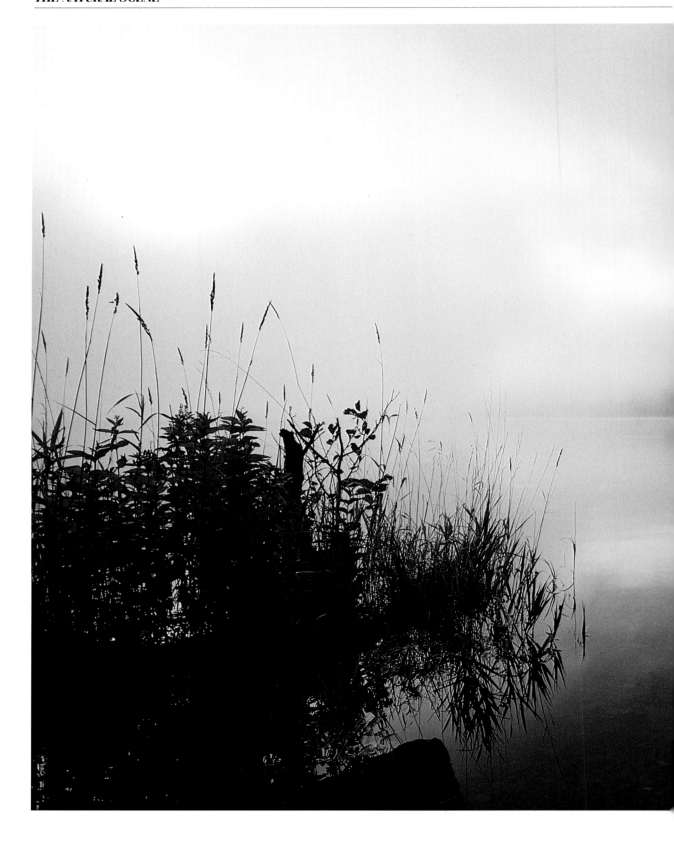

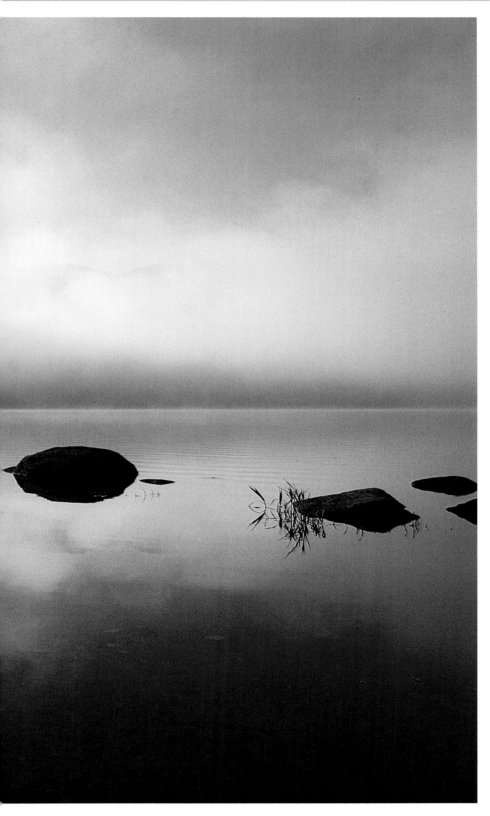

View towards Howtown, Cumbria

Another early morning shot on Ullswater. Again the pictorial element is uppermost, with the mist just clearing from the peaks across the lake emphasised by the strong silhouettes of the reeds and rocks in the foreground.

Leica M4, 35mm Summicron, 1/60sec f8, Kodachrome 25 Professional.

EQUIPMENT

Undoubtedly the best pictures in the mountains are taken from the higher levels and often the very best opportunities belong to serious hikers, backpackers and climbers. Such people, especially the latter, will need to travel light, but they will require robust, reliable camera equipment. A good-quality 35mm SLR or rangefinder camera is the answer, with the accent on the reliability rather than sophisticated automatic features. A good-quality wide-angle (28/35mm) and a medium telephoto (85/105mm) lens will suffice for practically all requirements, or a zoom in the 28–80mm or 35–105mm range.

Fortunately for the less energetic or capable amongst us, ski lifts, cable cars and in some cases a convenient road will enable easier access to the higher viewpoints in popular areas. The winter demands of ski enthusiasts have provided transportation that is a boon at all times of the year to photographers laden with gadget bags. This is true of many parts of the Alps where, in addition, good well-signposted footpaths can often be found.

TAKE CARE

Whenever you are in the mountains, always be aware that the weather can change very dramatically and very suddenly. This can be good for photography, but it can also be very dangerous. Experienced climbers and backpackers will be well aware of this and will be equipped with the right footwear, clothes, maps, compass, food and drink. If you are planning anything other than a relatively short stroll along well-frequented paths, do follow their example, pay heed to the weather forecasts and always let somebody know what your planned route is. Lakes in mountain areas can be equally dangerous with sudden storms and squalls so that similar precautions should apply if you are out in a boat.

In winter these precautions are even more important. This is certainly a time for wonderful pictures, as many of the superb images of Yosemite by Ansel Adams show, but lakes and mountains are doubly dangerous. Not only is the weather worse and the cold debilitating if you do have an accident, there are also fewer people around to give help. Do not travel alone, make sure you are equipped with the right clothing and let somebody know where you are going and when you expect to return. Remember too that many modern cameras are totally battery dependent. Batteries do not like cold and rapidly lose power as temperatures drop. Take a spare set and keep them and your camera tucked away somewhere warm.

Grant Lake, Sierra Nevada, California

This little lake lies at an altitude of over 7,000ft. The picture was taken in late May and the beautiful clear air and water from the fresh melted snow is typical. A medium wide-angle lens enabled adequate depth of field to be maintained.

Leica RE SLR, 35mm Summicron, $1/125$sec f8, Kodachrome 25 Professional.

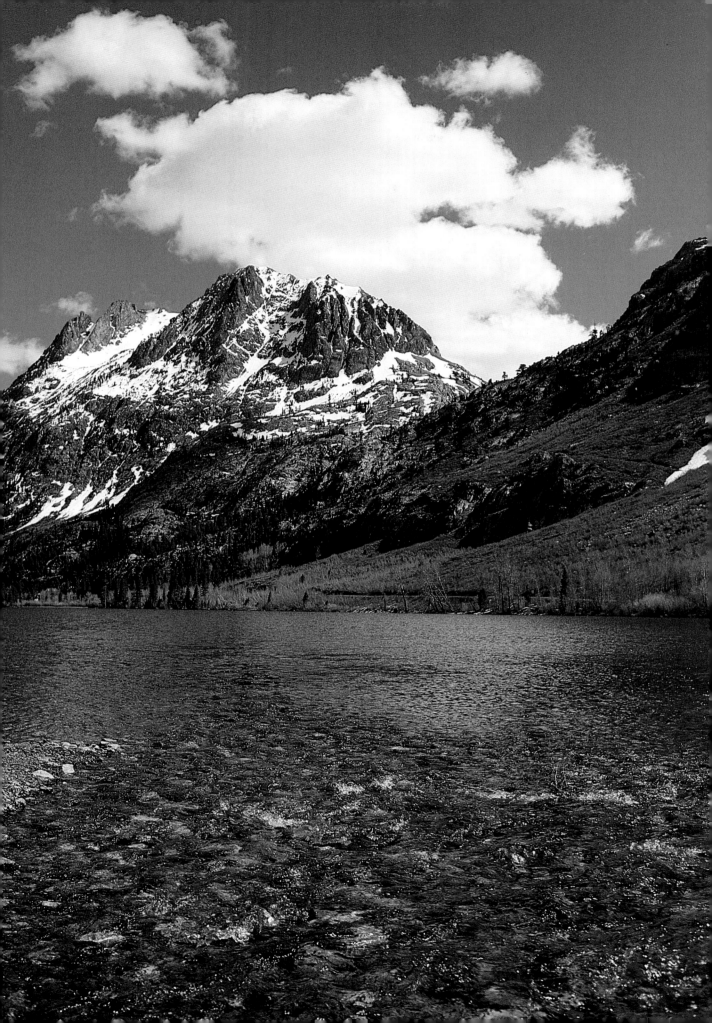

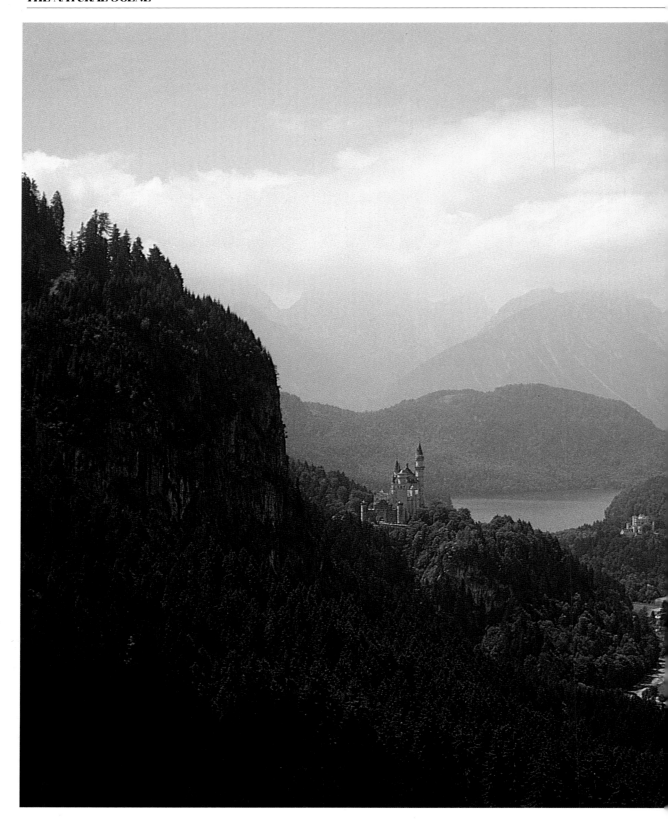

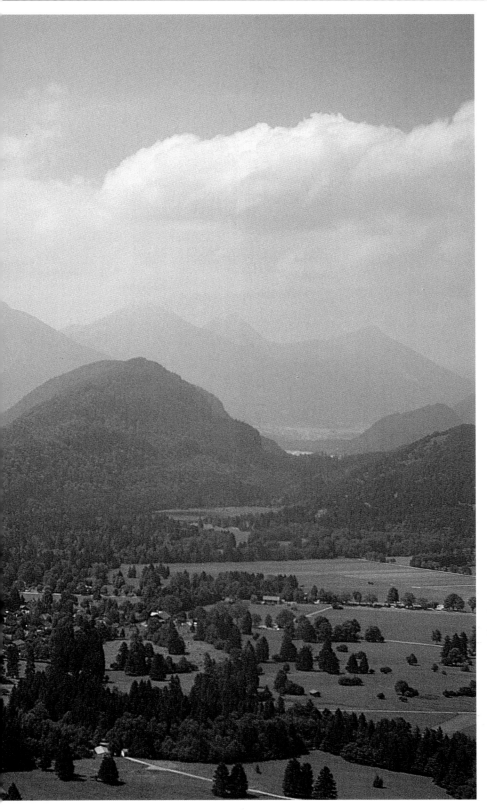

Bavarian Alps, Füssen, Germany

Many mountain areas have been developed for skiing, with cable cars and ski lifts providing easy access to higher levels. This view was actually taken from the cable car. In the distance you can pick out the castles of Neuschwanstein and Hohenschwangau.

Leica M4, 35mm Summicron, 1/250sec f4, Kodachrome 25 Professional.

(Overleaf)
The Alps near Mont Blanc

I was flying to Milan and the aircraft had started its descent, so that we were not too high above the peaks peeping through valleys full of cloud. If you are too high the size and shape of objects on the ground are minimised. Pictures from aircraft are best taken with a standard or wide-angle lens – the double perspex windows cause distortion with longer focal lengths.

Leica M4, 50mm Summicron, 1/250sec f8, Kodachrome 25.

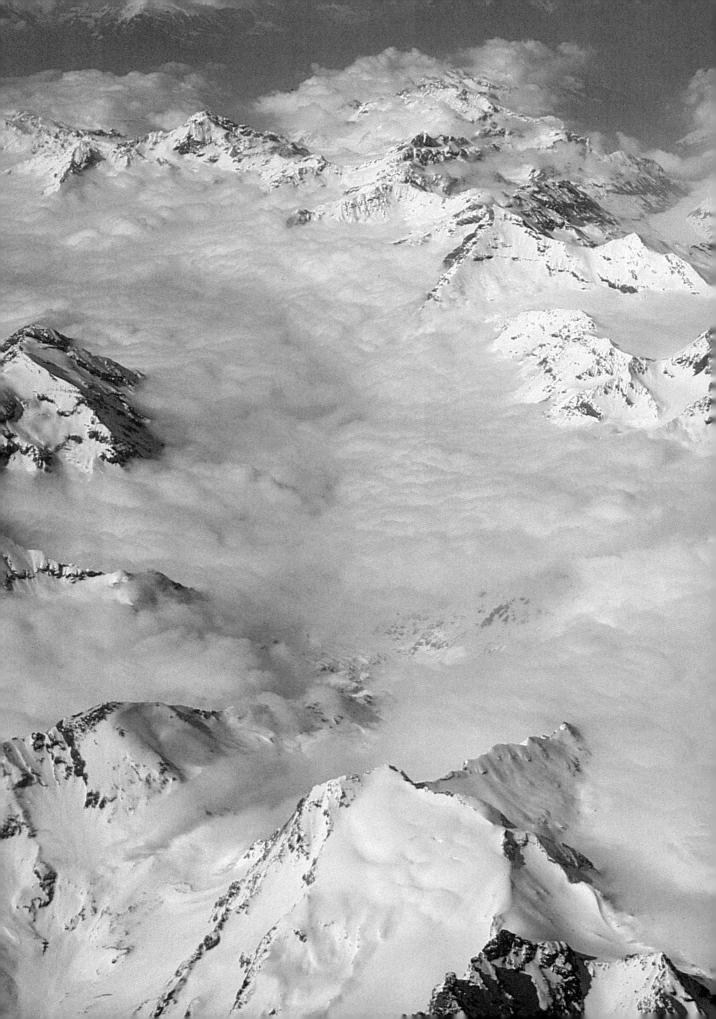

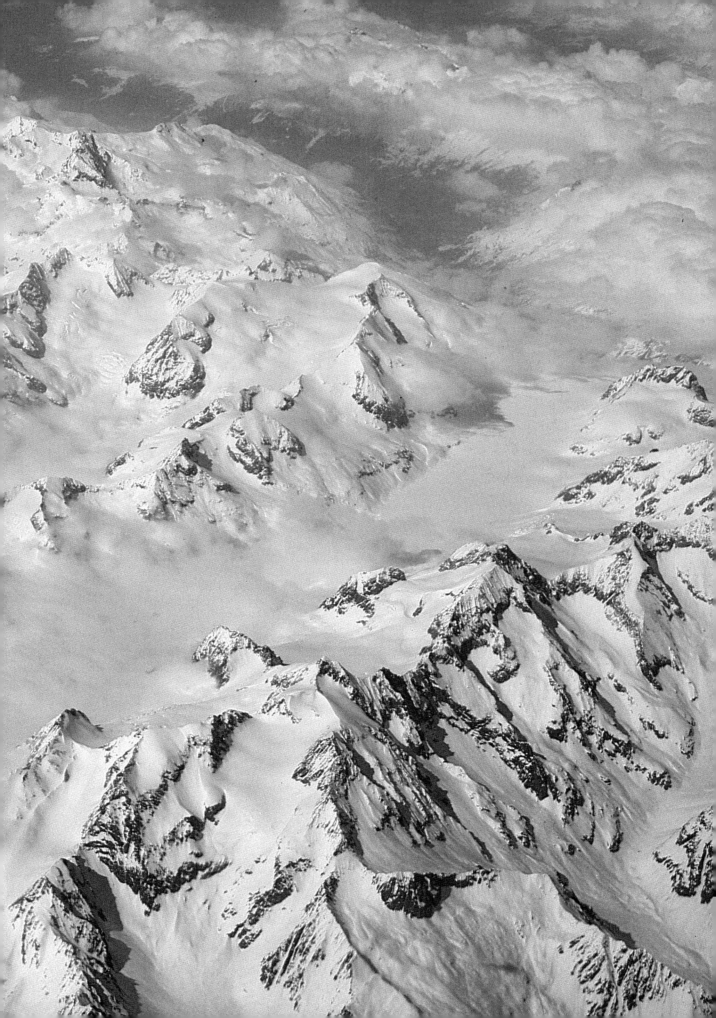

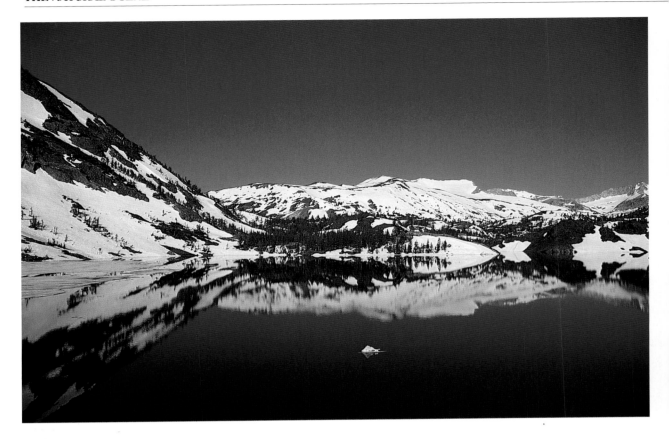

Ellery Lake, Tioga Pass, California

The lake is close to the highest point of Tioga and at over 9,000ft is sometimes frozen over until June. There was still some ice around when this was taken, whilst the mountains still full of snow made attractive reflections in the quiet water.

Leica R4 SLR, 28mm Elmarit, ¹/₁₂₅sec ƒ5.6, Kodachrome 25.

DESERTS AND CANYONS

My first visit to the American South West was in 1981. The previous year I had completed an assignment on the East Coast for a British Airways affiliate involved with long-haul tours. This had been mutually satisfying and I was keen to persuade them to let me do similar work in the Far East – specifically Hong Kong and Thailand. My contact was not at all encouraging. He already had plenty of good pictures as well as a photographer assigned to gather the more up-to-date shots that he required. He was, however, short of good material from Arizona – was I interested in going there for a couple of weeks, perhaps spending two or three days in San Francisco en route? I thought hard about this, for all of a five-hundredth of a second, before saying yes and starting to plan the trip!

A FAVOURITE AREA

That trip was one of the most exciting and enjoyable I have ever made and after England the American South West is probably my favourite of all the areas of the world that I have visited. The landscapes are spectacular, the weather is superb and the people are

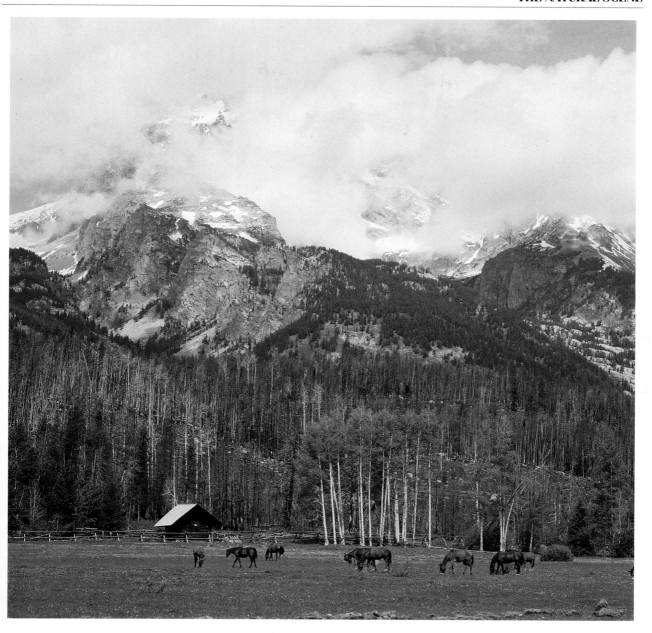

The Tetons, Wyoming

An early spring view of this attractive range of mountains near Jackson, Wyoming. The colour in the foreground provides useful contrast to the blueness of the snow-clad mountains. Clouds form and re-form and hang around the peaks. a frequent occurrence in mountain areas.

Hasselblad, 80mm Planar, ¹/₅₀₀sec f5.6, Ektachrome 100.

(Overleaf)
View from Olmstead Point, Yosemite, California

The clear low light of late afternoon picks out Half Dome in the distance and brings out the shapes and textures of the rocks in the foreground. A relatively wide-angle lens was needed to encompass the whole scene.

Leica R4 SLR, 28mm Elmarit, ¹/₁₂₅sec f5.6, Kodachrome 25.

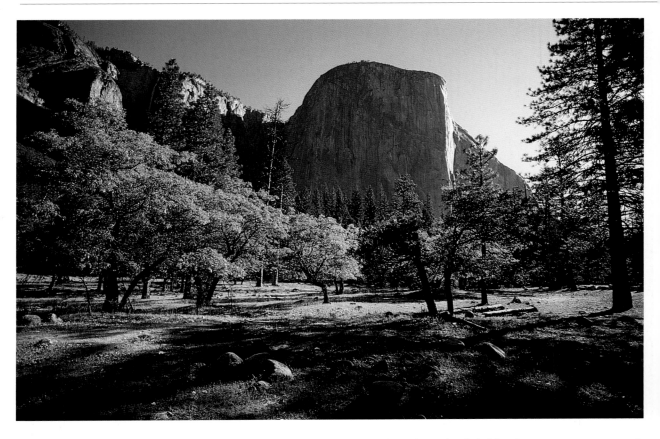

El Capitan, Yosemite, California

The view from the meadows photographed and made famous by Ansel Adams with his black and white studies. In order to get nice light with some atmosphere, and also to avoid the crowds, I was up very early. I used an ultra-wide-angle lens and included quite a bit of foreground in an effort to achieve something a little different.

Leica RE SLR, 21mm Super Angulon, ¹⁄₆₀sec f8, Kodachrome 25 Professional.

great. I have been back half a dozen times since, each time exploring new areas with my camera as well as revisiting old favourites, and there is still so much that I want to see, especially at different times of the year and in different lighting conditions, that I hope to be back plenty more times yet.

The particular area that is so rich in these deserts and canyons runs from Death Valley, California in the north-west corner across the southern tip of Nevada via Las Vegas into south Utah and then south through most of Arizona from Grand Canyon and Monument Valley in the north to Tucson and the Sonora Desert in the south. This whole area was once below sea level, but millions of years ago immense forces pushed up the many layers of sedimentary rock to a high tilted plain that has subsequently been eroded by wind, frost, rain and rivers to form the magnificent canyons at the higher levels and scorched deserts in the lower lying areas.

DESERTS

Of the desert areas, Death Valley of course has all the conventional characteristics – hot, dry and parched – as well as the famous dunes. Capturing the feel of such a place is not easy and the technique I used was to concentrate on details such as cracked ground, setting this in the overall environment by using a wide-angle

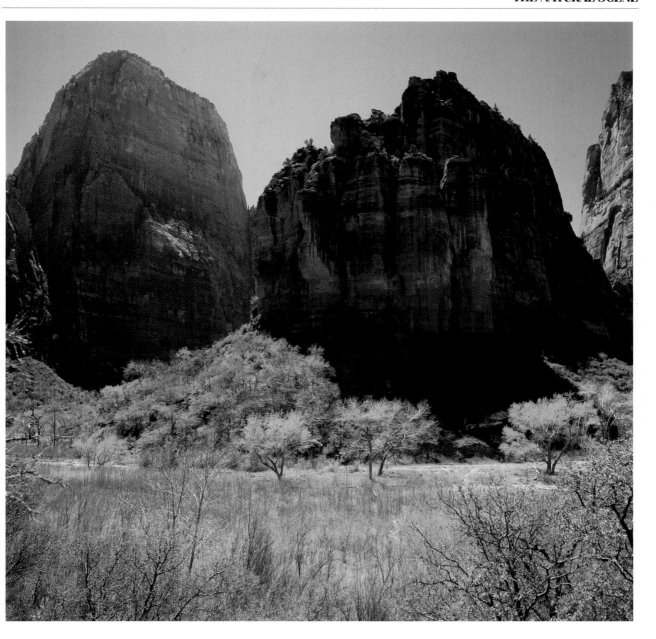

Zion National Park, Utah

*Angels Landing and the Great White Throne make a splendid
backdrop to the backlit aspens and other trees. The light was tricky so
in order to keep some detail in the shadow areas I bracketed my
exposures.*

Hasselblad, 50mm Distagon, $1/250$sec f8, Ektachrome 100.

lens. I was fortunate on one occasion, early in the year, to spot a single cactus flowering brightly and was able to use this as a contrasting foreground motif to the baked landscape behind.

Perhaps more photogenic are the desert areas of southern Arizona, where, by visiting in early spring, you may catch many of the smaller cacti in flower as well as the great saguaro that are so much a part of the scene here. The wide-angle approach described above and the long telephoto shot graphically compressing the ranks of saguaro against the mountainside are equally attractive and worth experimenting with.

CANYONS

The Grand Canyon, gouged out over millions of years by the mighty Colorado river, is the biggest and best known. Before my first visit I had read and heard so much about it that I fully expected to find that it was over-hyped and over-commercialised. I could not have been more wrong. Nothing written or said can exaggerate the impact of this immense example of nature's work the first time that you see it. Such commercial activity as there is, is well controlled and well hidden, and is remarkably unobtrusive even in the relatively tiny area where it has been permitted. No landscape photographer should miss Grand Canyon. Aim to spend at the very least a couple of days there so that you have time to absorb and appreciate the area and do make the effort to rise early for the sunrise. Generally, early morning for the first two or three hours after the sun comes up gives the best pictures, but the interplay of light and colour in the rocks changes constantly through the day. On one occasion I met a photographer who had set up his camera on a tripod and was taking the same picture every quarter of an hour from just before sunrise to after sunset in order to record these fascinating changes. The South Rim is accessible all the year round and with a little bit of luck there are excellent pictures to be made in winter. The North Rim is only open from mid-May to October because it is on average one thousand feet higher – 8,000ft compared with 7,000ft (2,100m) at the South Rim – and has an average 120in of snow each year. On balance I think that the photographic opportunities are better from the South Rim.

Do make sure that you have plenty of film. Try different lenses and viewpoints to try and capture the scale of the place and the atmosphere at different times of day. Staying for more than a single day will give you more time, an opportunity to think about your pictures and go back to get the ones you know you have missed!

Sonora Desert, Arizona

The great saguaro cactus is the Arizona state symbol and also indicative of the southern desert areas. Like many of the cacti it flowers in May, which is generally a good time to visit Arizona and capture the highly varied landscapes. An ultra-wide-angle lens was used to dramatise the size of the cactus and show its desert environment.

Leica M4, 21mm Super Angulon, $^1/_{125}$sec f8, Kodachrome 25.

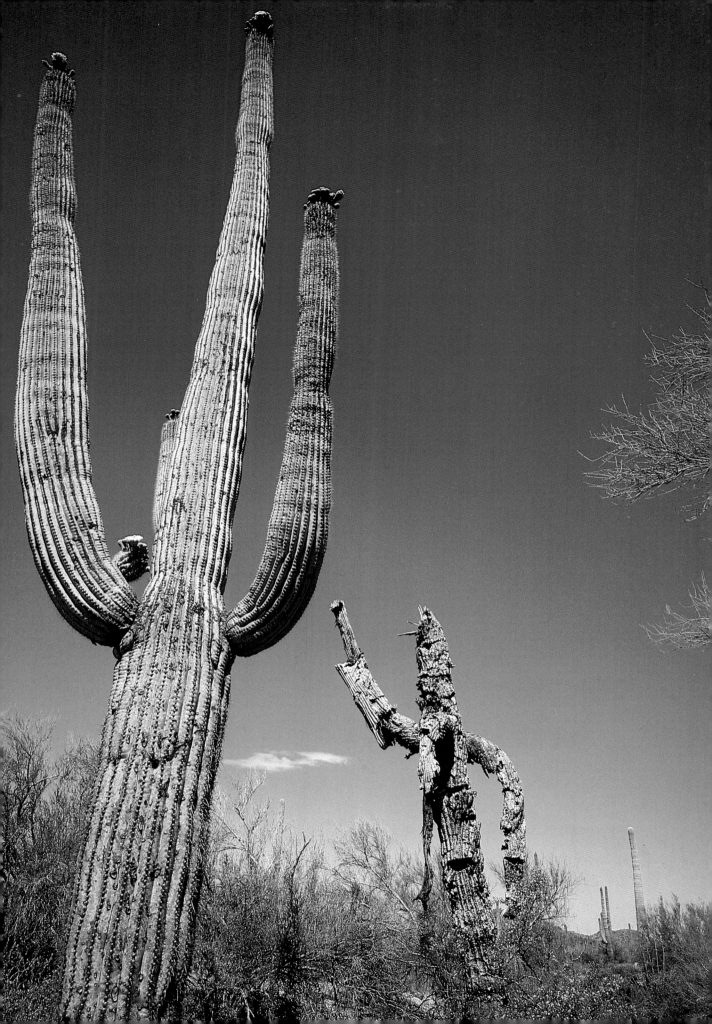

Of the smaller canyon areas my favourite is Bryce Canyon, Utah. This has been formed not by a river but by the erosion of an escarpment giving an incredible variety of colours and shapes in the rock faces and pillars. It is an area of about twelve miles by two miles (twenty by three kilometres), so that the scale is much more human and comprehensible. It can be enjoyed without being overawed, and there are so many opportunities for the keen landscape photographer that you can visit and revisit without any fear of running out of new possibilities. Again the key to making the best of the light is to stay close by and rise early. Although mild, Bryce is high, between 7,500 and 9,500ft, and I have seen snow around in April and May. It is accessible in winter too. A good range of lenses is needed. A moderate or even super-wide-angle can be used to set the scene, and medium to long telephoto to capture the detail of the eroded rocks.

Monument Valley, straddling the border of north-east Arizona and south-east Utah, is the stuff of a thousand westerns. It is difficult to know whether it should be described as a valley, a canyon or a desert as it has elements of all three. Whatever, it is certainly worth including in any landscape enthusiast's tour of the South West. Distant views with a long telephoto are impressive, as are closer ones taken with a moderate wide-angle from the ridge above the entrance to the valley. More creative compositions from the valley floor will probably need even wider angles to include interesting and dramatic foregrounds with the famous buttes as a backdrop.

MAPS AND GUIDES

Before travelling to any of the above areas get hold of the excellent literature and maps available from the tourist offices in Arizona and Utah. Try also to beg, buy, borrow or steal some copies of *Arizona Highways* magazine. The articles provide valuable background material, but above all the photography from some of the leading West Coast landscape photographers is inspiring. Much of it shot on 5in×4in format is of quite stunning quality.

Zabriskie Point, Death Valley, California

The baked ridges and the parched valley beyond, together with its accompanying heat haze, characterise the inhospitable environment of Death Valley. On this day in May temperatures were well over 100°F in the shade.

Hasselblad, 50mm Distagon, ¹/₅₀₀sec f8, Ektachrome 100.

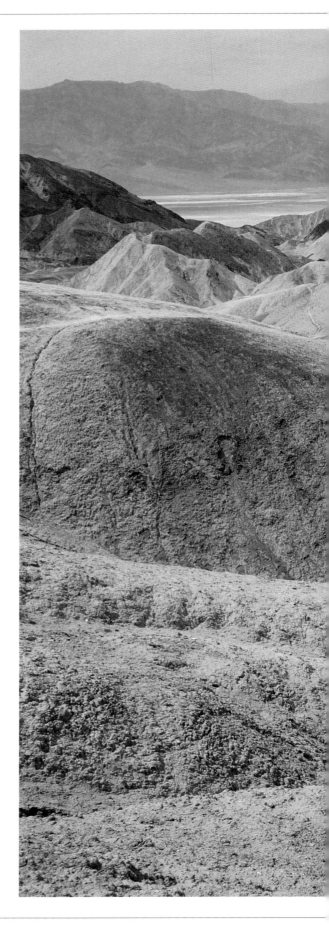

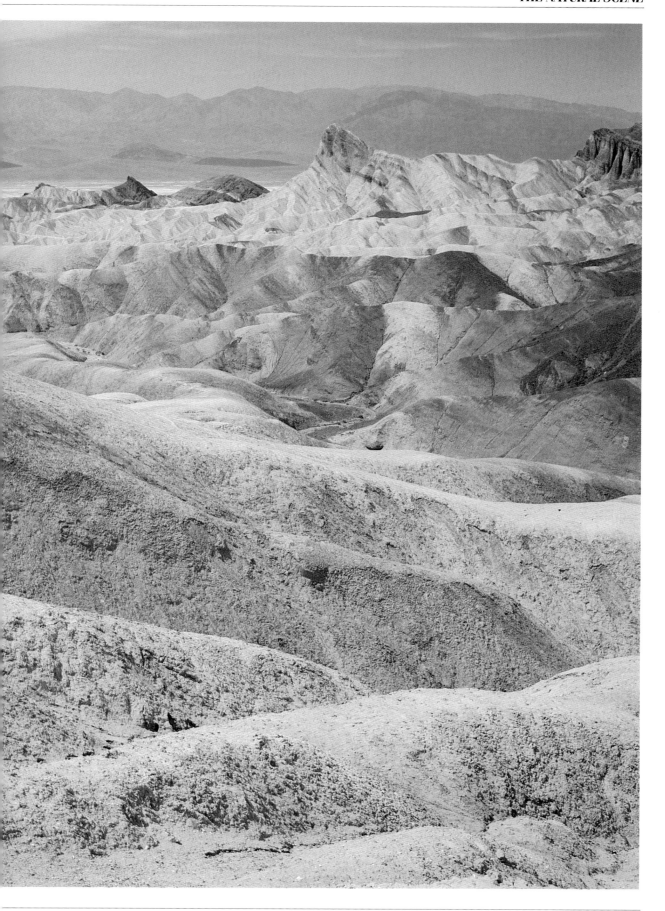

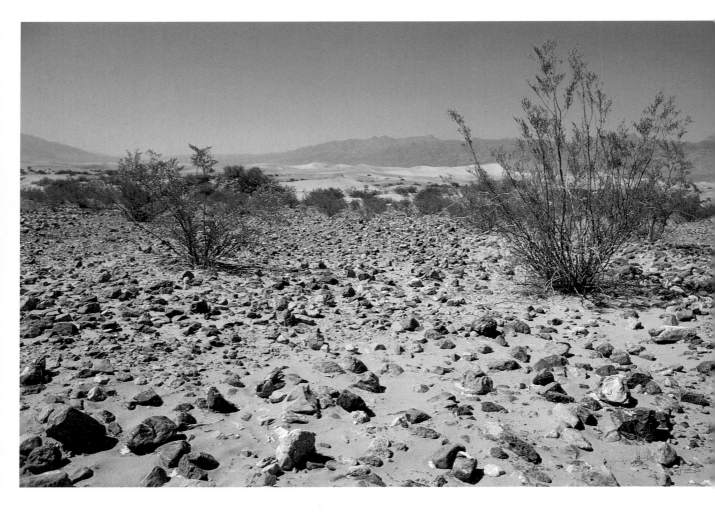

Death Valley, California

The spot where this was taken is very close to the lowest point in the USA. By concentrating on the harsh arid valley floor, I tried to convey the heat of the place. In the distance you can see the famous dunes.

Leica R4 SLR, 28mm Elmarit, ¹/₁₂₅sec f8, Kodachrome 25 Professional.

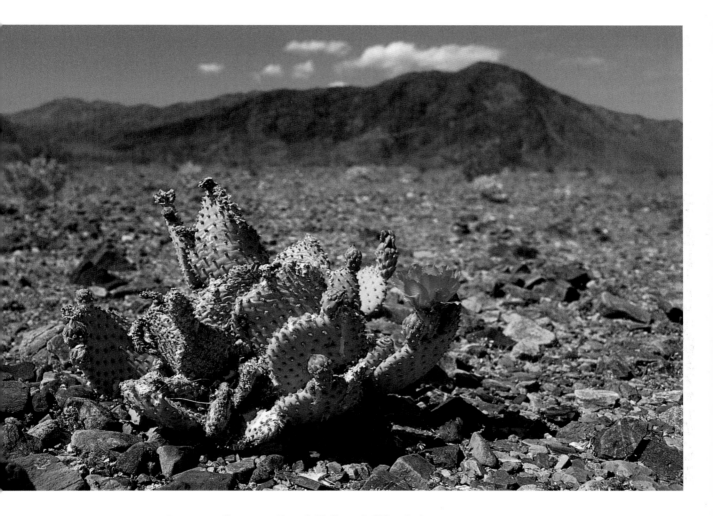

Beaver-tail cactus, Death Valley, California

This is one of those pictures that could be seen either as a plant in its environment or a place with a relevant inhabitant! The wide angle lens enabled me to achieve both objectives.

Leica R4 SLR, 35mm Summicron, 1/125sec f8, Kodachrome 25 Professional.

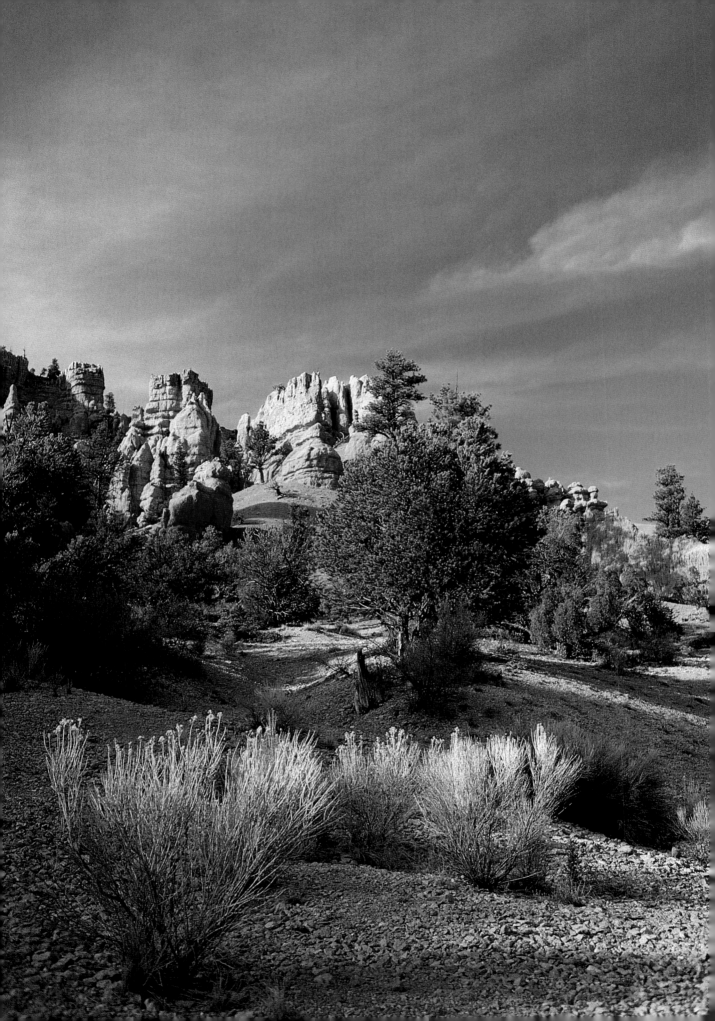

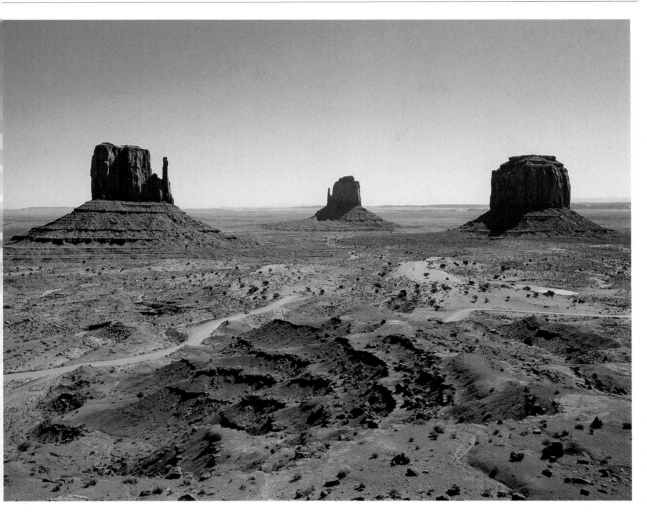

Monument Valley, Arizona

These remarkably eroded buttes rising straight from the valley floor are an incredible sight. Their size can be judged from the tiny vehicle on the road leading into the valley.

Hasselblad, 80mm Planar, 1/500 f5.6, Ektachrome 100.

(Overleaf)
Tree, Bryce Canyon, Utah

The tree may seem precarious but it was there in 1984 when I first visited Bryce and still there when I went again in 1991. It is somewhat smaller than it appears as I was using an ultra-wide-angle lens so as to set it in context with the whole scene.

Leica M6, 21mm Elmarit, 1/60sec f5.6, Kodachrome 25 Professional.

Red Canyon, Utah

The canyon lies between Zion National Park and Bryce Canyon. Less well known and less spectacular it is nevertheless very photogenic. The skies in the American West are usually very deep and a polariser is usually neither necessary nor desirable. In this case, however, the clouds which I wished to emphasise were very pale. With the polariser, I was struggling hard for depth of field and had to risk a slowish shutter speed.

Leica R4 SLR, 35mm Summicron, Polariser, 1/60sec f5.6, Kodachrome 25 Professional.

(Following pages)
Shapes, Bryce Canyon, Utah

This shot was made from almost the same position as the previous picture. Switching to a medium telephoto allowed me to concentrate on the shapes and colours of the rock pinnacles. The low evening sun emphasised these. The light level was getting low and I had to use a wide aperture in order to be able to use a high-enough shutter speed to avoid camera shake.

Leica M6, 90mm Summicron, 1/250sec f2.8, Kodachrome 25 Professional.

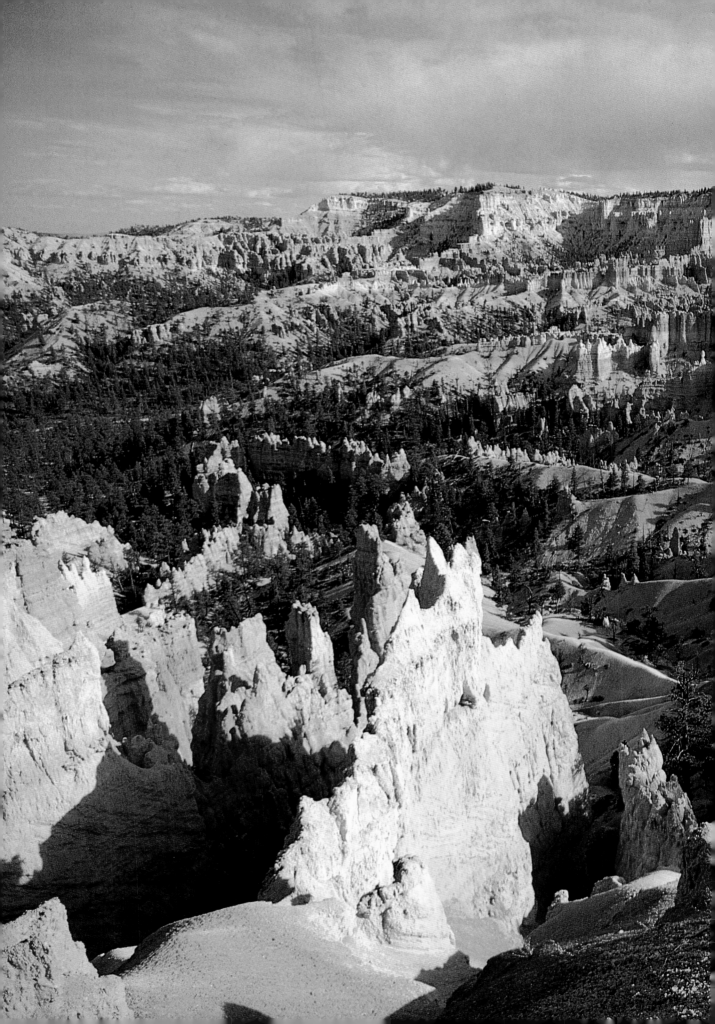

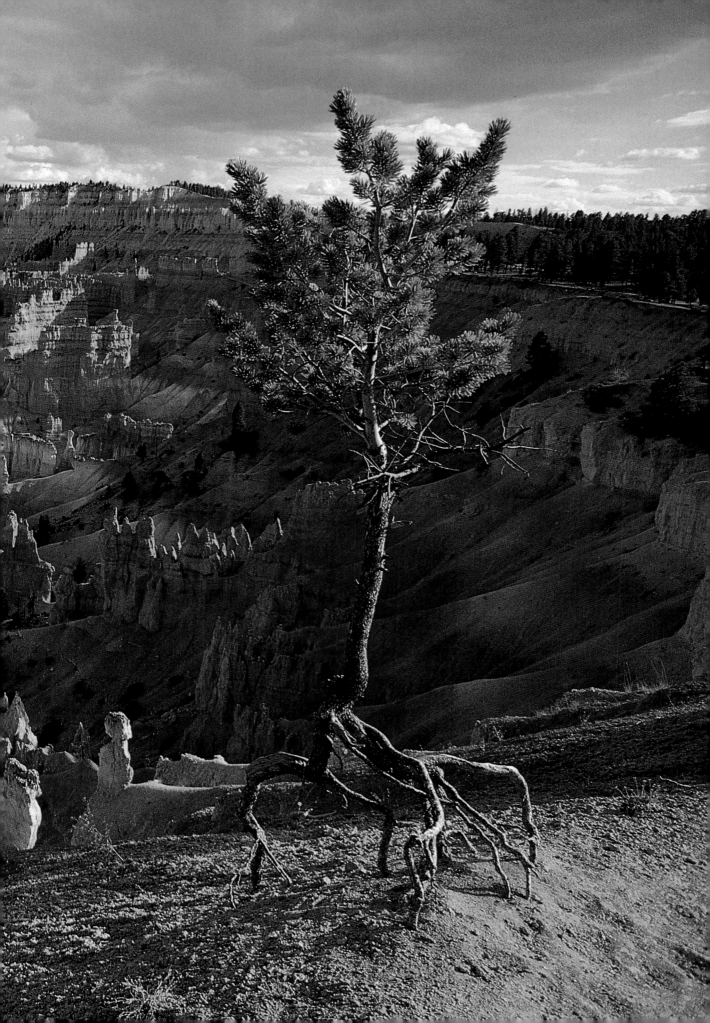

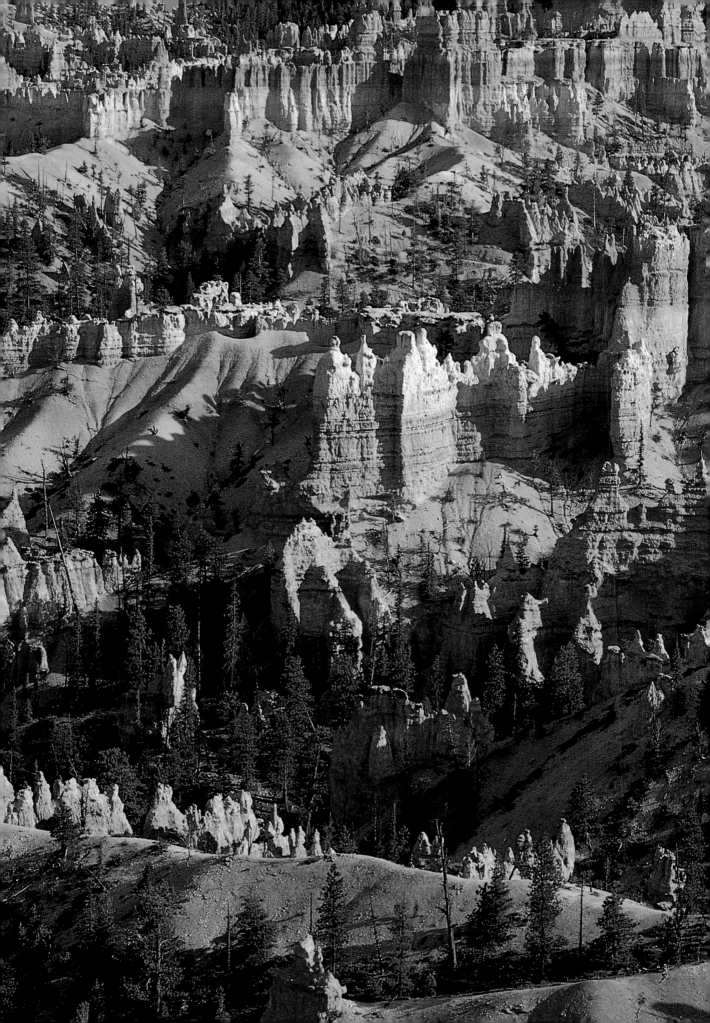

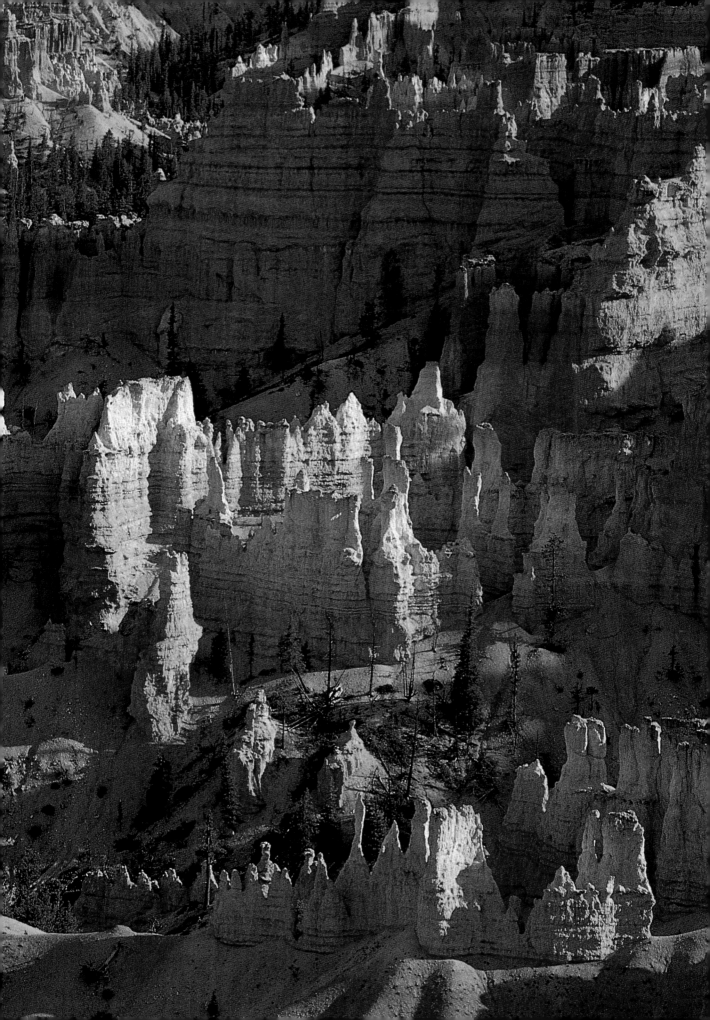

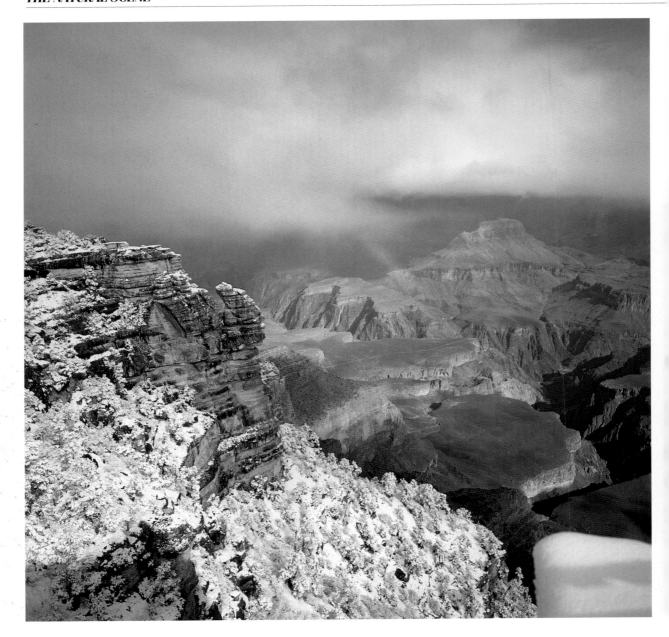

Winter, Grand Canyon, Arizona

This view was taken from the South Rim in February. Access to this point is possible in winter but you have to be lucky with the weather. All the previous day and up to half an hour before this picture was taken, the canyon was totally hidden in cloud. The cloud cleared for no more than an hour, providing a quite spectacular display of the canyon.

Hasselblad, 50mm Distagon, ¹⁄₅₀₀sec f5.6, Ektachrome 100.

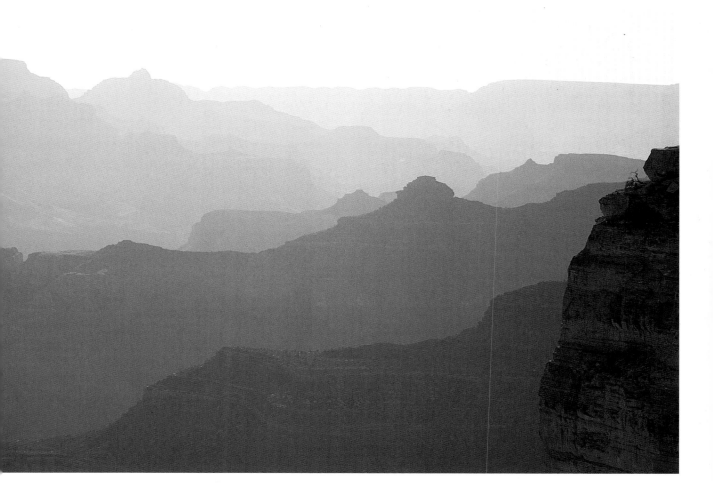

Morning, Grand Canyon, Arizona

Another view from the South Rim. Taken an hour or so after the sunrise, the light has lost its early redness, but there is still sufficient mist in the canyon to provide a marvellous recession of tone and colour through the different planes of the picture.

Leica M4, 90mm Summicron, ¹/₁₂₅sec f5.6, Kodachrome 25.

RIVERS AND COASTLINES

As we have already seen with lakes, a stretch of water adds an attractive contrast of colour as well as sparkle to a landscape. Whilst lakes are basically static, rivers whose function is to drain water from the land to the sea are in constant flow and at a rate that can vary enormously according to the time of year, or in response to weather patterns occurring great distances upstream from the photographer's location. Rivers also have a profound effect on the surface of the landscape, washing material away and down from the mountains and eating away at the high plateaux to create valleys and canyons. Where the level of the land drops sharply there are exciting areas of rapids and sometimes great waterfalls when the river charges over a cliff, often changing direction through 90° as at Niagara and Victoria Falls.

RIVER MOODS

In scenic photography the river can be used as a foil to the total subject, as in the picture of the Snake river and the Tetons or as a subject in its own right as in the picture of the Merced. In the latter case the objective will be to capture its mood and movement – slow and peaceful or rushing and powerful. Wide-angle lenses will allow the river to be the dominant subject yet still place it within the context of the landscape. Shutter speeds need to be chosen carefully. Very slow speeds – ⅛sec and even slower – produce some fascinating flowing effects, but the real trick is to select a speed that captures the movement and surface texture without giving the frozen effect that comes with very high shutter speeds or high-speed flash. Depending on the closeness of the water to the camera as well as its speed of movement, an exposure time between ¹⁄₆₀ and ¹⁄₅₀₀sec seems to work most satisfactorily. A good starting-point is ¹⁄₁₂₅sec, but with all the variables mentioned above it is always worth experimenting to try the effect of different shutter speeds.

Snake River and the Tetons, Wycoming

The great curve in the river with the mountains beyond providing a magnificent backdrop makes an irresistible view. The weather was dull with occasional weak sunshine and intermittent light rain. I waited for over an hour for some slightly brighter light on the foreground for this shot.

Hasselblad, 50mm Distagon, ¹⁄₁₂₅sec f5.6, Ektachrome 100.

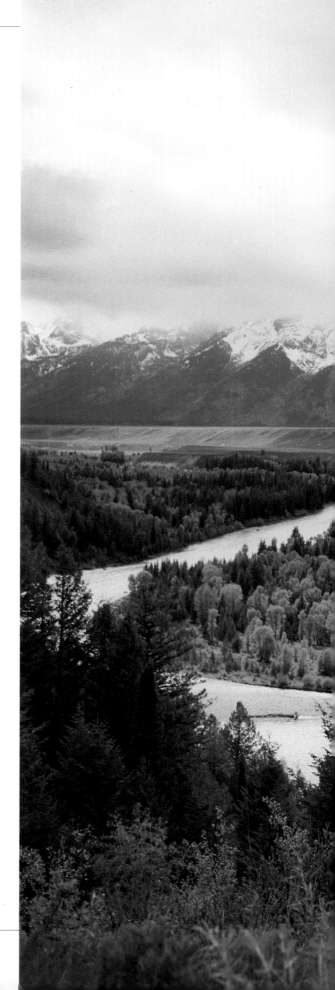

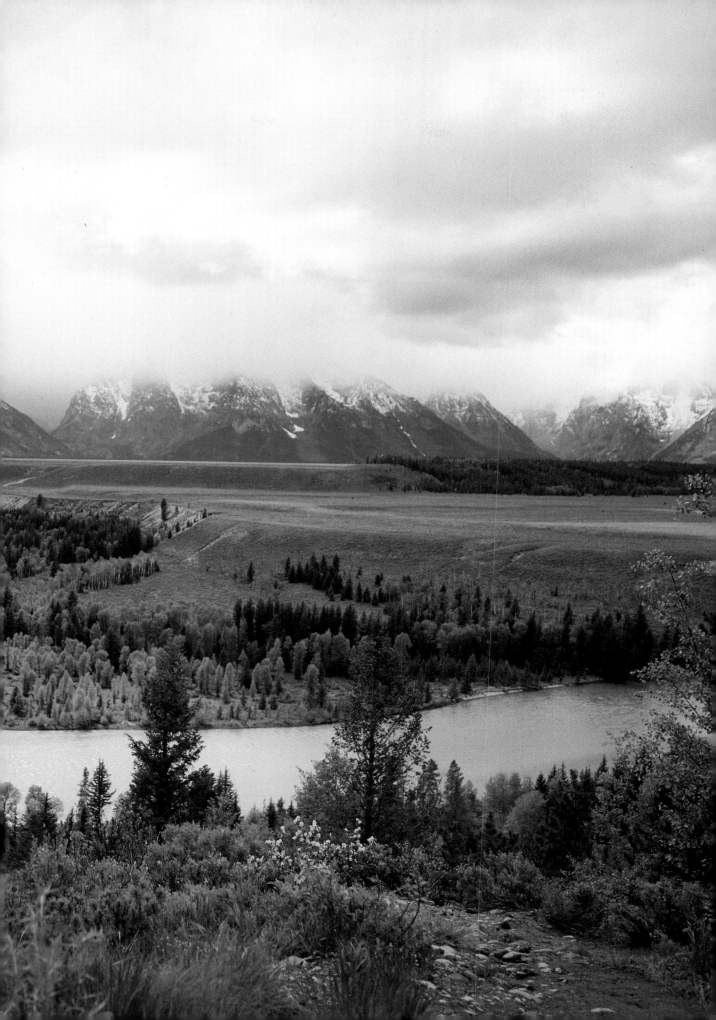

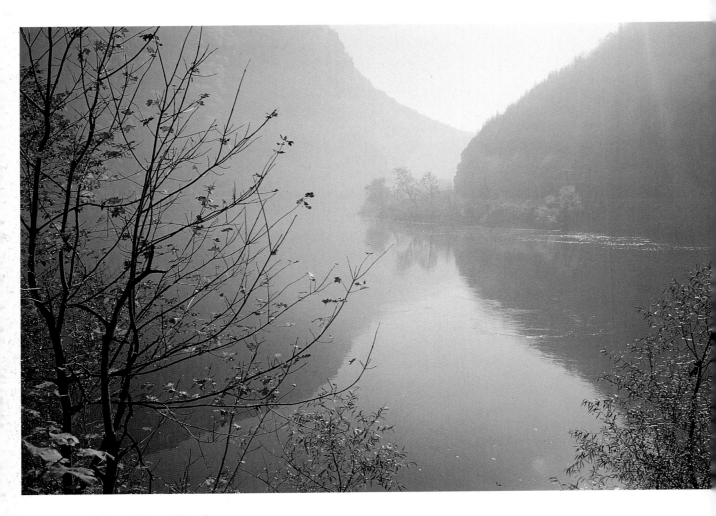

Delaware River, New Jersey

The Water Gap is an attractive section of this river. I was fortunate to visit it on a quiet October morning, with a little mist still lying around to provide a little mystery and mood. There was little wind to disturb the reflections of the bluff.

Leica M4, 35mm Summicron, ¹/₁₂₅sec f5.6, Ektachrome 64.

Merced River, Yosemite, California

I wanted to capture an impression of this fast-rushing section of the Merced with its fresh, clear water at the time of the spring melt. An ultra-wide-angle lens gave me the composition I wanted, and I experimented with different exposures and shutter speeds to retain detail in the water and spray without completely freezing the movement.

Leica M6, 21mm Elmarit, ¹/₂₅₀sec f8, Kodachrome 25 Professional.

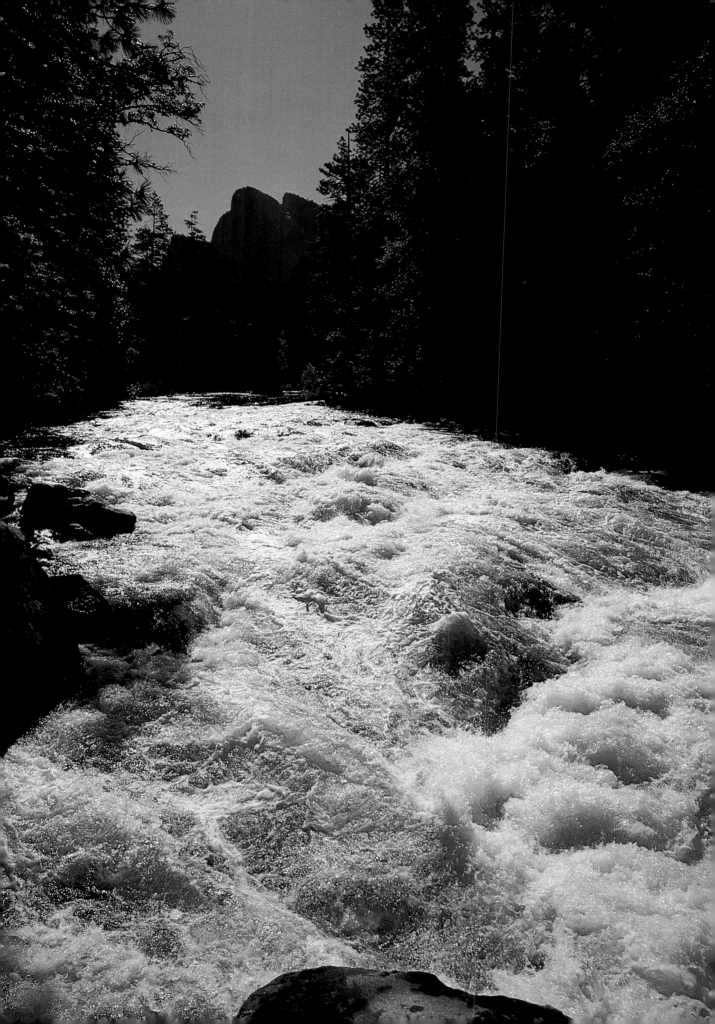

LIGHTING AND VIEWPOINT

The constantly changing and varying pattern of a river's surface and the multitudinous reflections cry out for viewpoints that enable shots to be made against the light. This can present some tricky problems of correct exposure. There is no simple answer as the pictorial effect is what matters, not necessarily a technically perfect result. The answer is to 'bracket', ie, make a series of exposures at plus and minus a half stop and also, in this case, one-stop intervals. Choose the frame that gives the best overall result. An example of this technique is my picture of the Merced river in Yosemite. I was shooting directly into the light, and the brightness range from the white water spray to the shadows was impossible to contain. I bracketed with the primary purpose of retaining detail in the water and was able to select a shot that did this; yet I still kept some minimal detail in the rest of the picture. Here too I was trying different shutter speeds as described earlier.

Quiet stretches of a river are great for attractive reflections of the sky, boats and buildings. In this case the lighting is probably best coming very strongly from one side so that the water itself is dark, but the brightly lit objects will be reflected strongly. A high viewpoint will enable the river to be been within its setting in the landscape and you will often be able to use it compositionally as a 'lead in' to the overall scene. A medium wide-angle or standard focal-length lens is likely to be the most effective. Pictures depicting the river itself and the effects of the water will demand a very low viewpoint, and in my experience a medium or very likely an ultra-wide-angle lens will provide the most dramatic results.

COASTLINES

Just as rivers have eaten away and affected the earth's topography inland so the pounding of the sea has constantly reshaped the coastlines. Most spectacular are the areas where steep rocks and cliffs act as the forward bastion of the land, but fascinating pictures can also be made of low-lying areas where only a few feet above the high tidemark there is fertile land and civilisation, with much transportation by water as in Holland and parts of Norfolk in England. Big skies and colourful houses are a feature of this kind of land/seascape, and the light often has a special clear yet soft quality beloved of painters as well as photographers.

There are many spectacular coastlines around the world. Amongst those that I have enjoyed and photographed I would particularly mention Scotland, where almost the entire coastline, east and west, is

Winter, Niagara Falls, Ontario, Canada

The Horseshoe Falls on the Canadian side of the river are a magnificent sight at any time. Seen in winter they make a refreshingly different and stunningly pictorial image. The temperature was minus 25°F, and the spray was freezing onto the trees and other objects near the falls. Testing conditions for the camera.

Leica M4, 21mm Super Angulon, ¹/₂₅₀sec f5.6, Kodachrome 25.

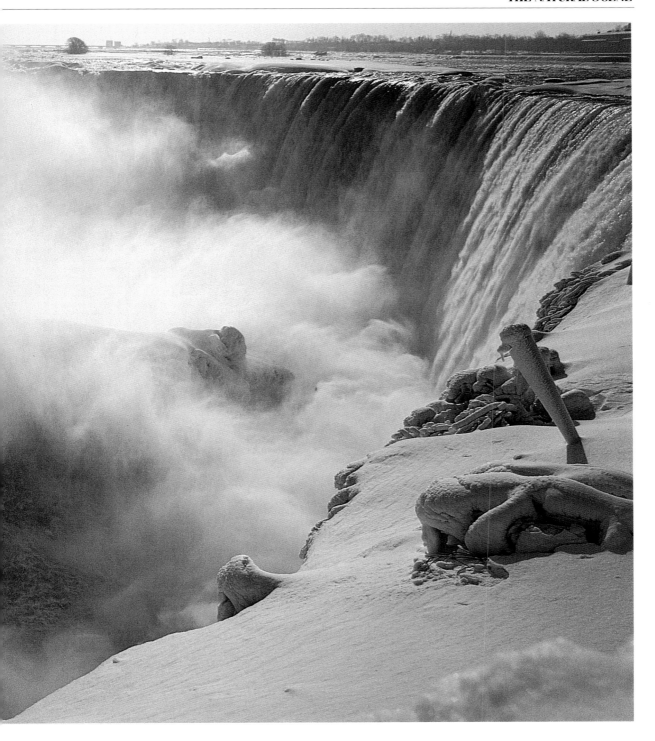

(Overleaf)
Lingmell Beck, Wasdale, Cumbria

Occasional breaks in the cloud driven by strong winds allowed the sun to come through and spotlight the autumn colours. Each opportunity only lasted a few seconds and it was necessary to anticipate and work quickly. The speed of a 35mm camera is a great help in these conditions.

Leica M6, 21mm Elmarit, ¹/₁₂₅sec f4, Kodachrome 25 Professional.

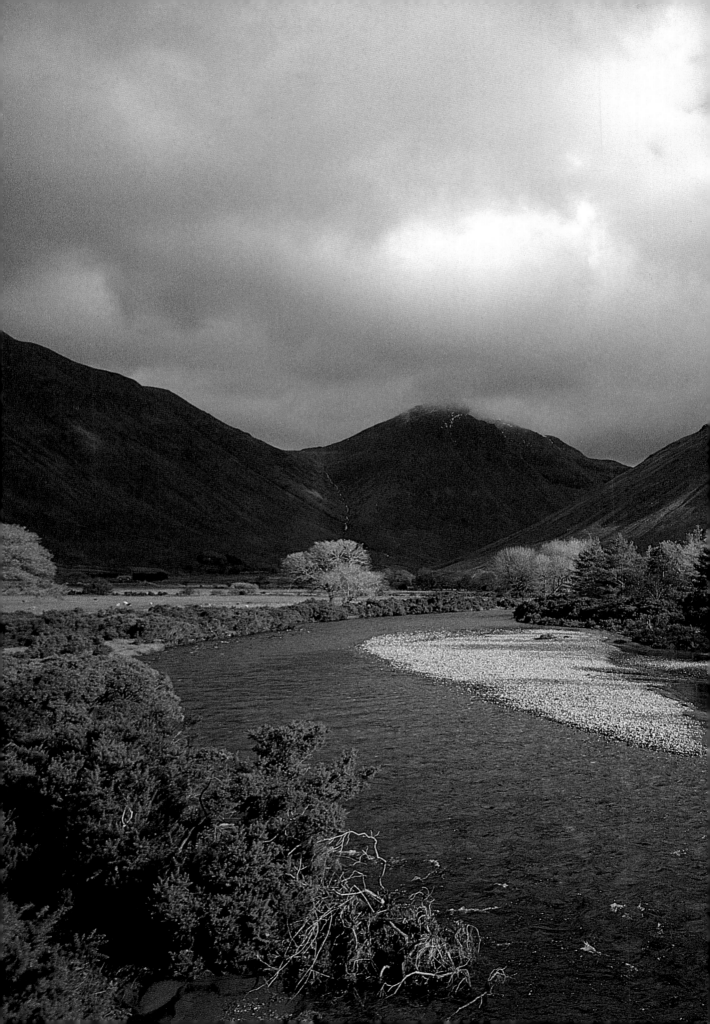

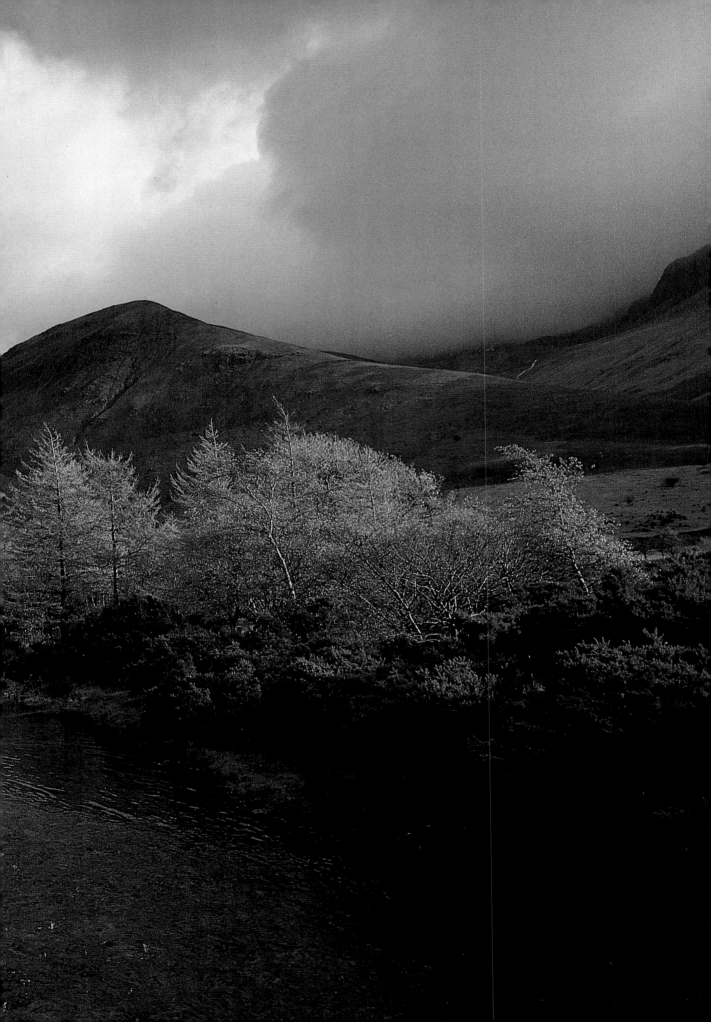

ruggedly photogenic; Northern Ireland, which has the quite incredible Giant's Causeway; Cornwall in England; Brittany in France; and the Algarve in Portugal. In the USA the Californian coast southward from San Francisco and down beyond Monterey, Carmel and Big Sur is splendid. Like many coastal areas, however, this Pacific coast is very prone to early morning sea frets (low mist) which the sun may not burn off until well into the day. This is another instance where a little forward planning and trouble taken to listen to the local weather forecasts can avoid many disappointments.

LENS CHOICE

Coastlines are best photographed from an elevated position, a high point on a cliff or some rising ground. In flat areas, a relatively small gain of height can make a picture dramatically better and it is worth making the effort to find a good viewpoint. A small hill, a church tower or some other building is each a possibility worth exploring. Very often a standard lens will prove to be the most suitable, but given the right viewpoint a medium or even longer telephoto will allow a tightly composed shot with a dramatic compressed perspective. Occasionally a wide-angle will enable you to include foreground detail that is quite large whilst retaining the view of the location. It is always worth trying different viewpoints and different lenses, since the subject is not going to run away, and you can enjoy exploring all the different possibilities.

When photographing by the sea where there is spray from the rocks or blown by the wind, do remember that salt water and/or sand are not at all compatible with precision mechanical and electronic equipment! Take good care to protect your cameras and lenses. A UV or Skylight filter on the latter is worthwhile protection. Be especially careful when scrambling around rocks and cliffs, and watch that you do not get cut off by the tide; it is all too easy to become preoccupied with that ultimate seascape and not notice!

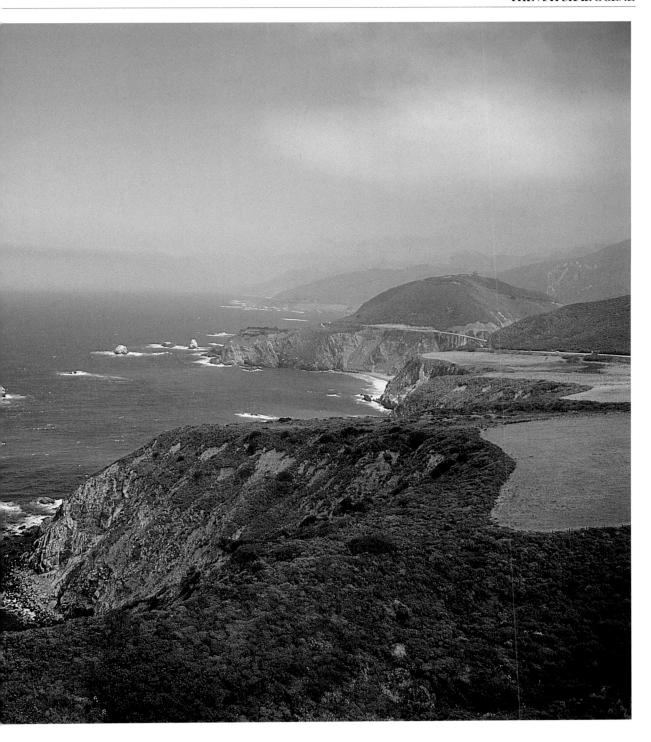

Coastline, California

*The coast road south from Carmel and Monterey is a most enjoyable
drive with some great photographic opportunities. Sea fog and mist
can be a problem but in this case they were clearing by mid-morning.
A standard lens gave a nice perspective here.*

Leica M4, 50mm Summicron, ¹/₁₂₀sec f4, Kodachrome 25.

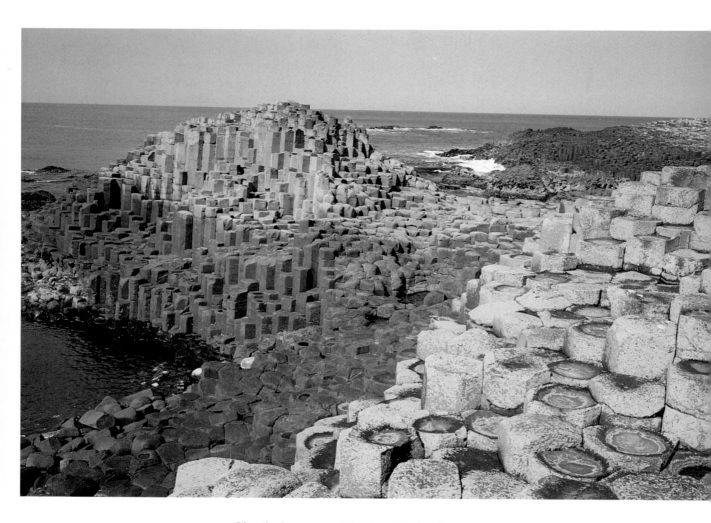

Giant's Causeway, Northern Ireland

*An incredible rock formation, the result of ancient volcanic activity.
The coastline of Northern Ireland is very beautiful and it is a great
pity that the 'troubles' discourage visitors. A wide-angle lens allowed
me to show some close-up detail as well as the formation as a whole.*

Leica M2, 35mm Summicron, ¹/₆₀sec f8, Kodachrome 25.

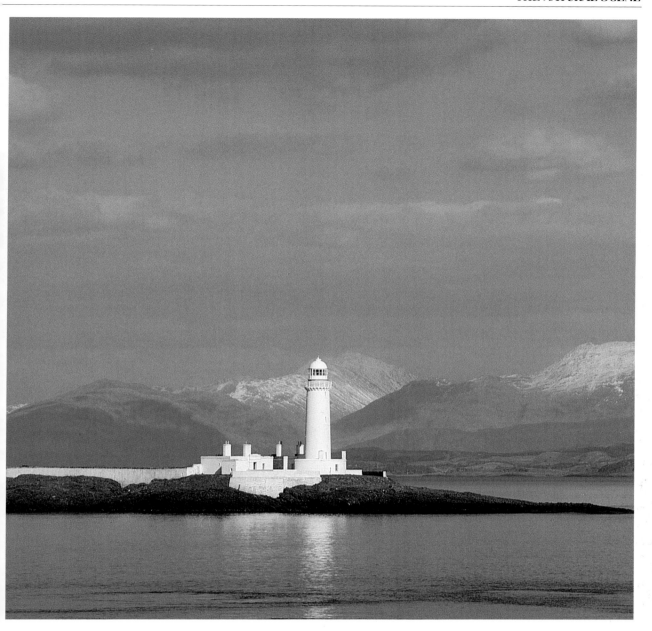

Mull, Scotland

A view looking towards the mainland from the Island of Mull. The perspective of a long-focus lens kept the distant mountains reasonably large in relation to the lighthouse although they were many miles away.

Leica R4, 180mm Elmar, ¹/₅₀₀sec f5.6, Kodachrome 64.

(Overleaf)
Firth of Forth, Scotland

It was the clouds that first attracted me and it was then a case of achieving a suitable composition of the coastline to incorporate them. The small islet with the old chapel was a useful centre of interest and an ultra-wide-angle lens was used to include the sweep of the shore.

Leica M4, 21mm Super Angulon, ¹/₁₂₅sec f8, Kodachrome 25.

THE IMPRINT OF MAN

CASTLES, GRAND HOUSES AND FARMS

DOMINATION AND DEFENCE

Frequently of great historical importance, castles (or châteaux or Schlösser) are often highly photogenic subjects. Their very age – almost one thousand years old in some cases – makes them interesting as structures, but the location – especially of those that originated as medieval fortresses – is an important part of their story. Strategically placed at river crossings or to command the surrounding countryside or as the nucleus around which a town grew and gathered for protection, they make a natural focal point for a picture. For defensive reasons they have high walls and are often placed on a steep hill, thereby practically ensuring a dominant position in any composition. Just as valuable for the photographer is the fact that this carefully selected, commanding position is also ideal for views of the surrounding area. England, Scotland and Wales together with Germany are particularly rich in attractively located fortress castles of this period. These were the strongholds from which the powerful local barons ruled their fiefdom and defended the country against invaders. In Germany the many Schlösser located on the Rhine, Mosel and their tributaries are a testimony to the importance of these rivers to communication and its control. Finding suitable viewpoints for these and the others in the countries mentioned above means researching guidebooks and getting good large-scale maps. Where available the Michelin Green Guides are highly recommended. In Britain the Ordnance Survey maps are superb; the contoured 1/50,000 series is an essential planning tool for this and other aspects of landscape photography.

As the techniques of war developed and gunpowder was invented, the defensive stronghold was rendered obsolete, and later castles and châteaux became grand houses and palaces rather than fortresses. Still, however, they are usually found in dominant and photographic locations whilst the buildings themselves have an elegant rather than a functional attractiveness of design. Many of the French châteaux fall into this category and their locations in pleasant country surroundings, often by a river, can be readily appreciated. The Loire and its tributaries the Vienne and the Cher are particularly rich in these subjects for scenic photographers. If you are tempted to visit this area there is an excellent Michelin Green Guide which will be an invaluable aid to planning a visit.

As with any architectural photography, good sidelighting will bring out the shape of these subjects and the texture of the stonework. It is best if there is plenty of interesting cloud around so that you can choose the moment when the castle is highlighted, perhaps against a shadowed background. The clouds will also reflect sufficient light into the shadow areas of the building, thereby ensuring that adequate detail is discernible there. If you possibly can, try to show the building within its environment, the river or the surrounding landscape. Medium wide-angle and standard lenses are likely to be the most useful in this respect, with a medium telephoto also needed if you wish to concentrate on the castle itself or some of its detail.

TAMING THE LAND

Just as castles demonstrate the power to control and protect an area so do farms represent the human race's attempt to civilise and work with nature for its benefit. Often a farm is the only sign of civilisation within a

Burg Runkel, Germany

A fifteenth-century castle built on a rock overlooking a crossing of the Lahn river (a tributary of the Rhine). The small village of Runkel has grown around the foot of the castle. It was necessary to be at Runkel early in the day in order to get the buildings with sidelighting rather than backlighting, which is not generally suitable for this kind of subject.

Leica M6, 35mm Summicron, 1/60sec f4, Kodachrome 25 Professional.

(Overleaf)
Kilchurn Castle, Argyllshire, Scotland

This fifteenth-century castle stands by Loch Awe, close to the road from Oban to Inverary. Like most of the Scottish castles it was the stronghold of a local clan chieftain, in this case a Campbell. It stands at a strategic point on the route to Skye and the other Western Isles.

Leica M4-P, 90mm Summicron, 1/500sec f4, Kodachrome 64.

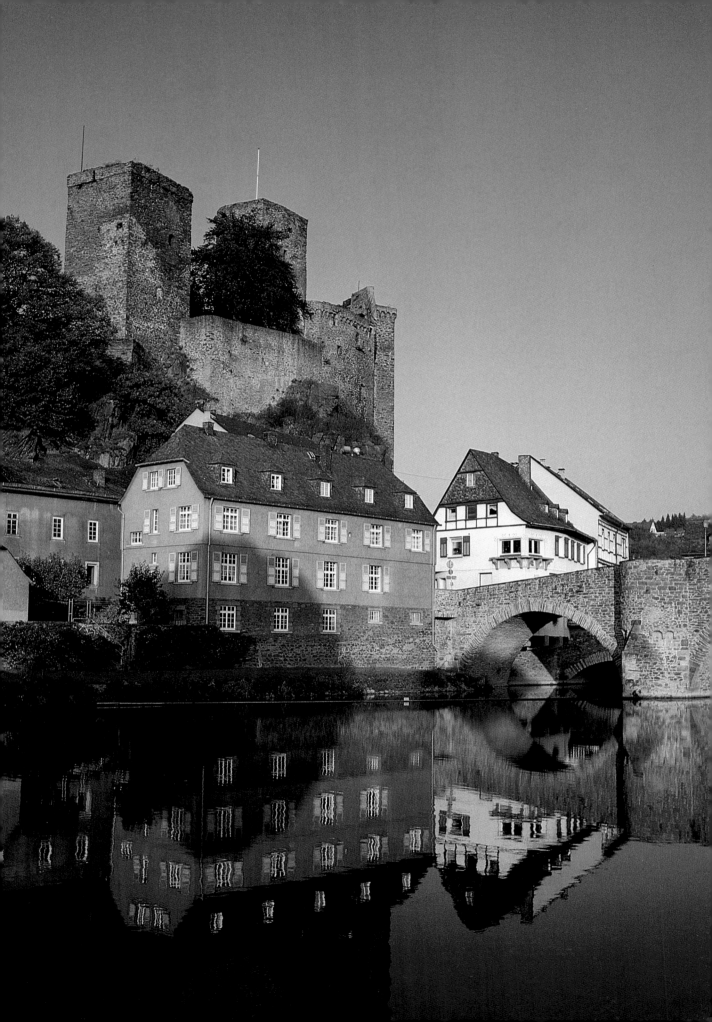

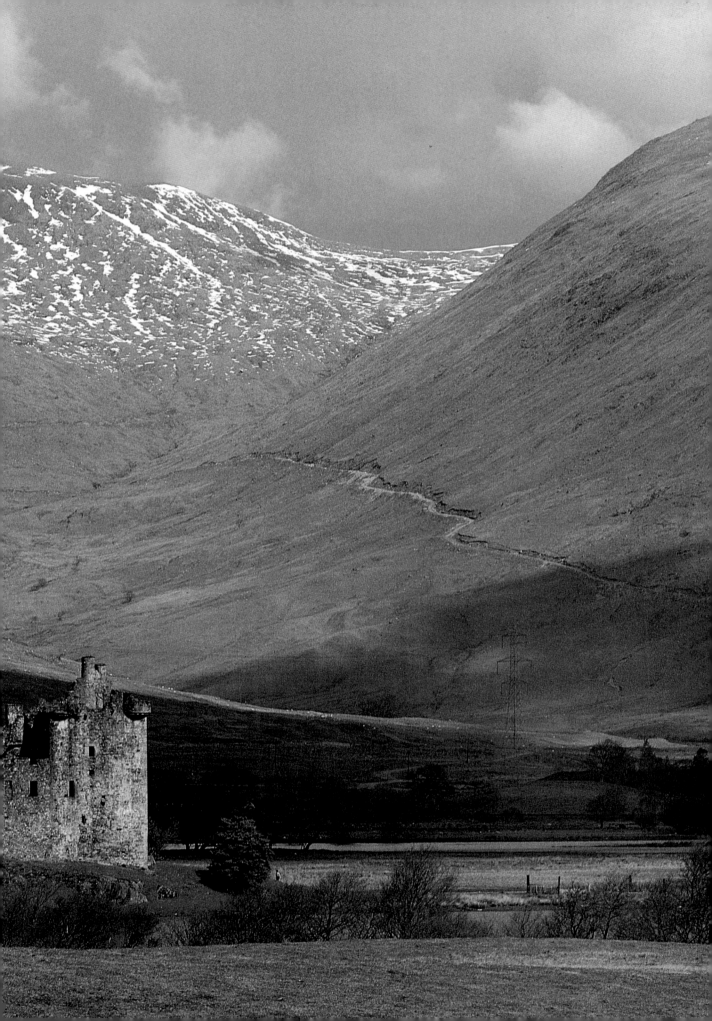

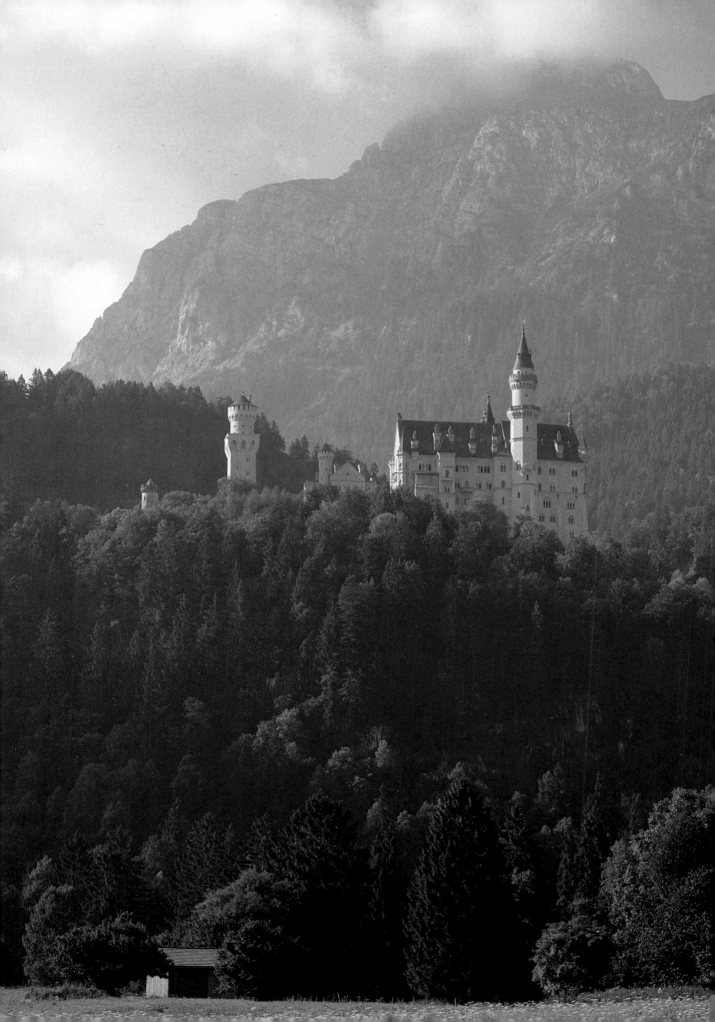

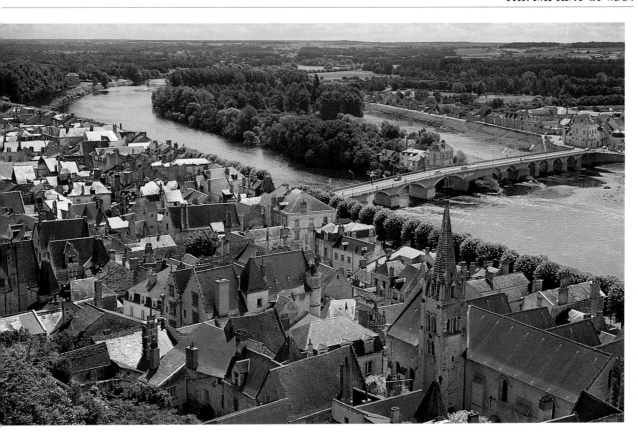

very large or even harsh landscape, and just as we have mentioned previously it will be a powerful eye-catching element within the overall scene. From a pictorial point of view a centre of interest towards which the eye can travel or from which it can explore the rest of the picture is important. A single point of habitation, such as a farm, in the landscape serves this purpose very well indeed. Not only does it act as the focal point but it emphasises the isolation of the scene.

Although every region has its characteristic fields and farm buildings, this is a universal subject. It may be a ranch in the American West, a sheep station in Australia, a farm in the great prairies of North America or a hill farm in the English Peak District. Each has its part to play in identifying that landscape.

A worthwhile picture of such a landscape will be about light and weather, shapes and colours, but the farm building and its immediate surroundings will act as the reference to bring the whole composition together. I live close to the Peak District and a number of the illustrations in this book are drawn from my regular excursions into this area. Usually such excursions are prompted by a promise of interesting weather and lighting conditions, which are what I am trying to capture, but it is amazing how often the motif of the isolated farm serves to set off the impressions of the landscape.

Chinon, France

The medieval fortress of Chateau de Chinon provides a commanding view of the small town and the important crossing of the River Vienne. Strong cross lighting emphasises the shapes of the many buildings and the texture of the roofs and stonework.

Leica M4, 50mm Summicron, ¹/₂₅₀sec f4, Kodachrome 25.

(Left)
Schloss Neuschwanstein, Bavaria

'Mad' King Ludwig built this fairytale castle near Fussen close to the border of Germany and Austria. This early morning shot gains atmosphere from the mist and clouds clearing from the mountains behind.

Hasselblad, 150mm Sonnar, ¹/₅₀₀sec f4, Ektachrome 100.

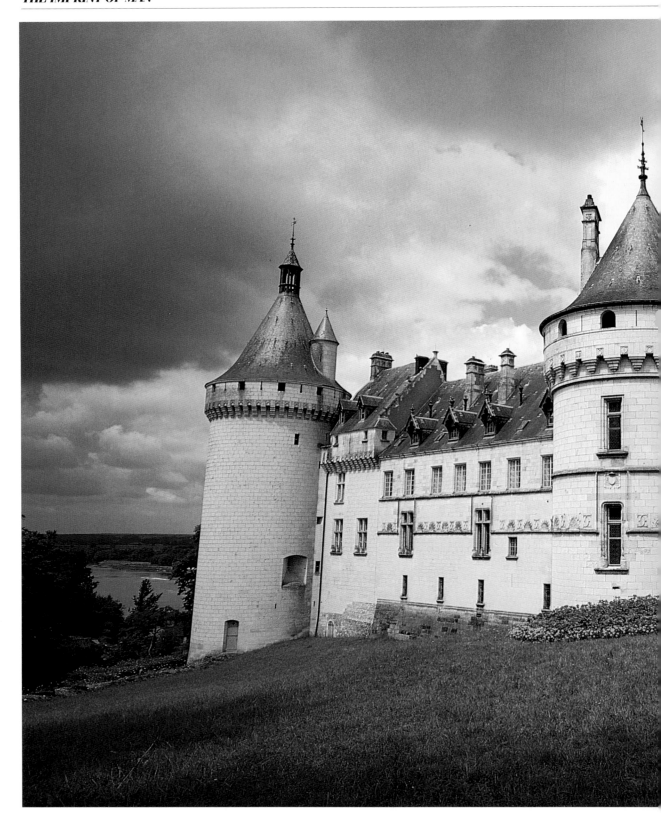

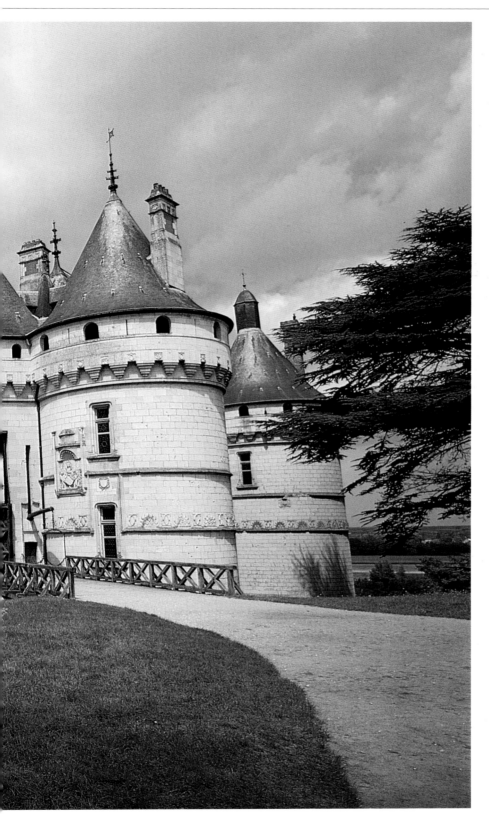

Chaumont, France

An especially elegant fifteenth-century château built on the site of a previous fortress by the Loire river. It is associated with Catherine de' Medici. As the sky might indicate, the sunshine was very fitful and some patience was needed to get reasonable light for the picture.

Leica M4, 35mm Summaron, ¹/₁₂₅sec f4/5.6, Kodachrome 25.

(Overleaf)
Burg Cochem, Germany

Another castle built on a hill overlooking a river crossing, in this case the Mosel. Using a long focal length concentrated the view on the castle itself and strong sidelighting brought out the texture and detail of the structure.

Leica R5, 180mm Apo Telyt, ¹/₅₀₀sec f4, Kodachrome 64 Professional.

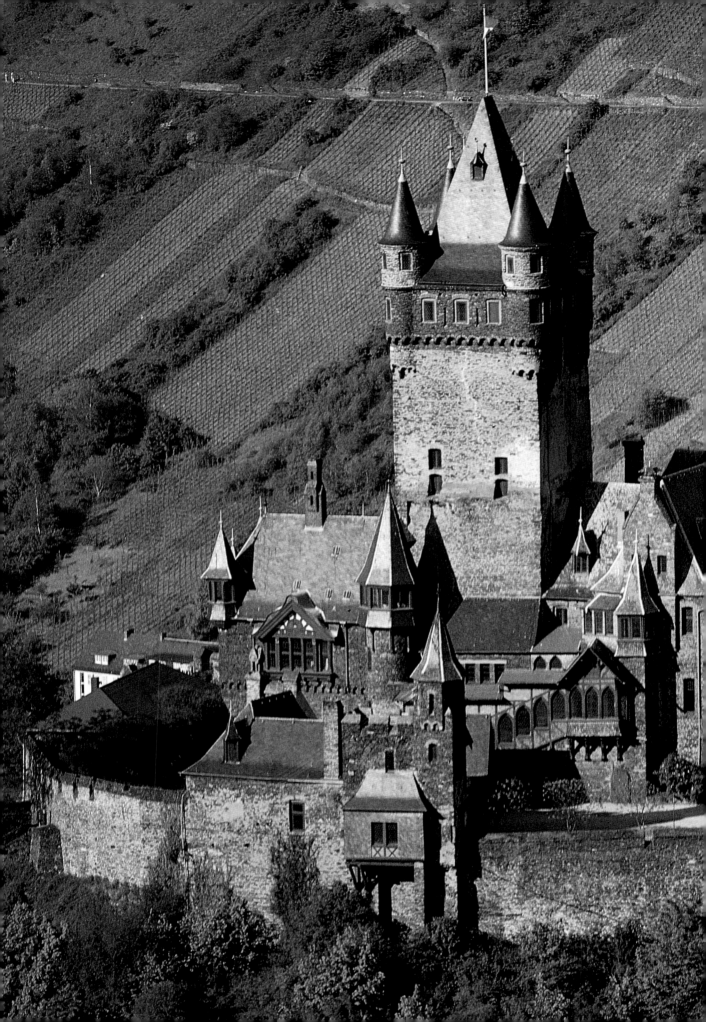

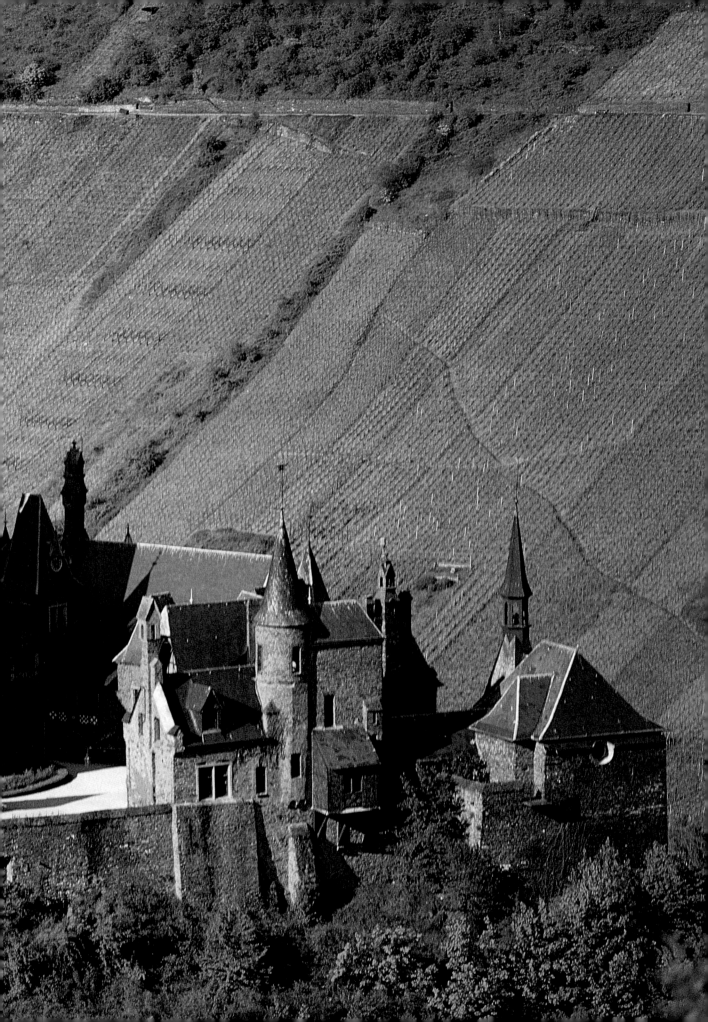

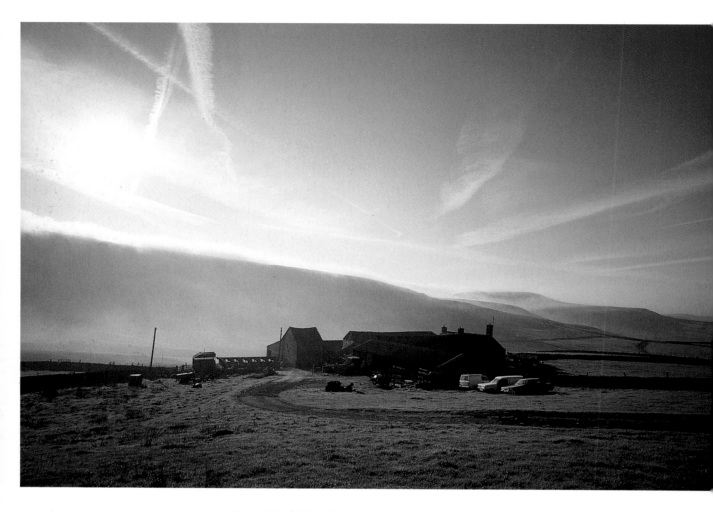

Farm, Peak District

This is an area not far from my home and if the light and weather look interesting I often have a quick photographic excursion. On this particular morning there was some mist around that was dispersing quickly as the sun rose. I was particularly fascinated by the mist literally pouring down the side of the hill beyond the farm. The backlighting helped to emphasise this.

Leica M6, 21mm Elmarit, ¹/₁₂₅sec f5.6, Kodachrome 25 Professional.

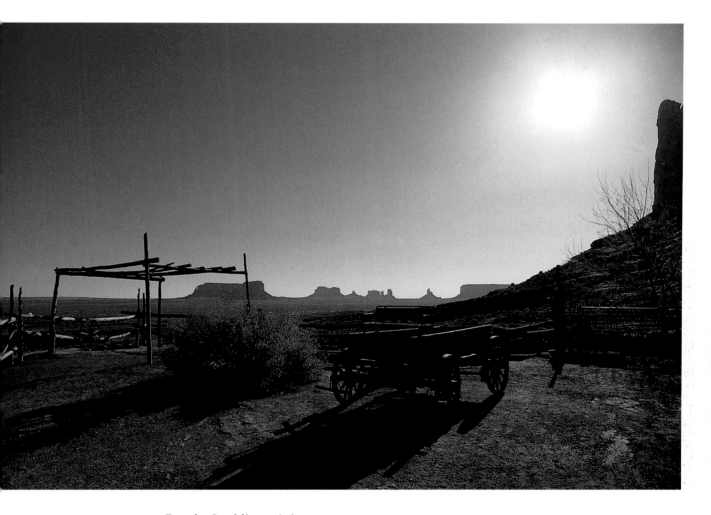

Ranch, Gouldings, Arizona

This is actually part of the set remaining from an early John Wayne film. It is just outside Monument Valley. An ultra-wide-angle lens allowed me to capture the environment and the backlighting gave me a strong foreground to frame the scene.

Leica M6, 21mm Super Angulon, ¹/₁₂₅sec f8/11, Kodachrome 25 Professional.

(Overleaf)
Bowderdale, Cumbria

Odd patches of sunlight were racing across the fells, spotlighting the warm autumn colours and the small farm. A medium telephoto compressed the perspective, emphasising even more the minuteness of the farm buildings.

Leica M3, 90mm Summicron, ¹/₂₅₀sec f2.8, Kodachrome 25 Professional.

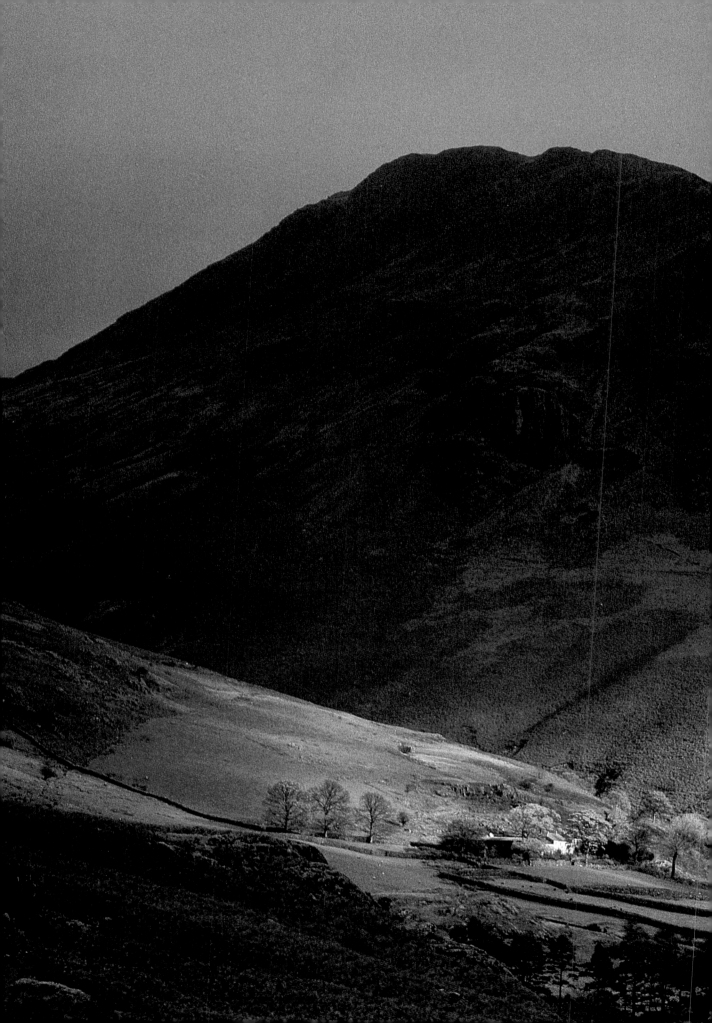

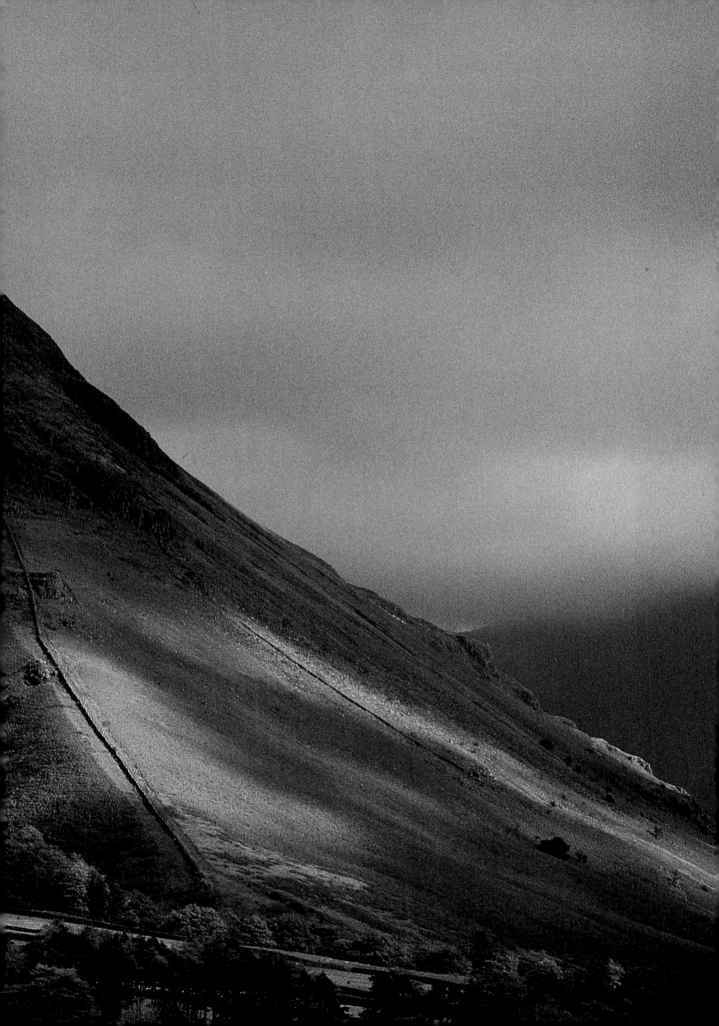

CITIES

Cities are exciting places. Whether ancient or modern, they are the visible expression of civilisation and organisation. Whatever you may feel about some parts of certain cities, they are as relevant a part of the landscape as any other artifacts and at the right time in the right lighting they can impose strikingly beautiful images. This is the case whether you are photographing the skyscrapers of Manhattan or the medieval glories of Venice and whether you are seeking the grand view or concentrating on significant details.

No less interesting to the observant photographer are small-town sights and surprises in suburbia. It is all a matter of having an alert eye so that through the magic of lighting or intelligent selection of detail you can capture an evocative image.

GREAT CITIES

Whether it is London or New York, Paris or Hong Kong, when visiting a great city it is difficult to avoid the well-known view. Indeed so many photographers will have trodden the same path to these sights that it can be extraordinarily difficult to achieve a fresh viewpoint. Nevertheless you will inevitably want to record such a view for yourself. The techniques to apply are first to concentrate on working out when you might get some interesting light, secondly to work hard to find an interesting suitably composed viewpoint and finally to look for suitable storytelling foreground elements against which to set off the general scene. All of this requires patience, persistence and sometimes not a little local knowledge. The latter is hard to come by and in unfamiliar places I find it both helpful and enjoyable to study guidebooks and postcards. In some of these the quality of the photography is outstanding, and if something catches your imagination it is a valuable exercise to work out just when, where and how the photographers achieved their image.

It may not even be other photographs that encourage ideas. Paintings, films, even television commercials can be valuable sources. Paris is one of my favourite cities; I have visited it many times and I like to think that I know it fairly well photographically. Nevertheless, just prior to a recent visit my photographic eye was very much stimulated by a book of watercolours by an English artist, David Gentleman. He saw familiar Paris locations differently and included many very interesting yet unfamiliar views. When I arrived there full of ideas from his book, it was almost

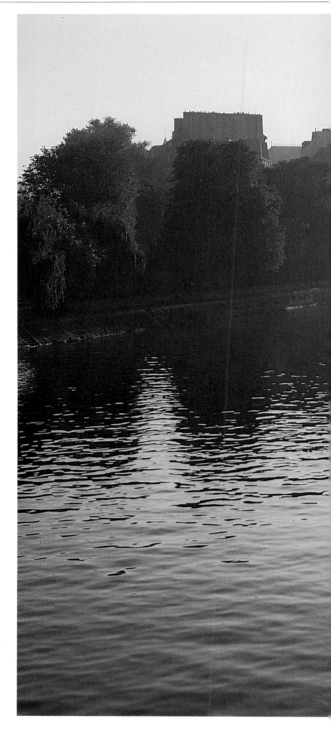

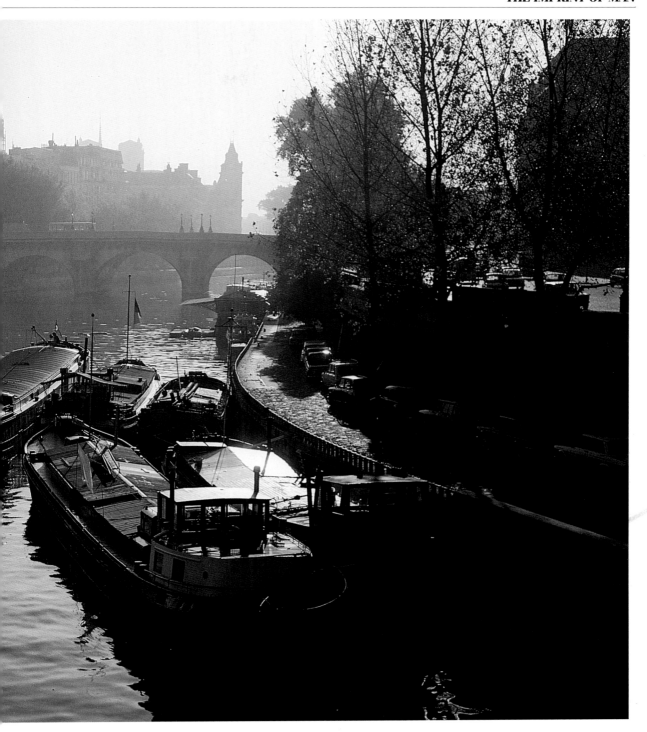

Paris, France

A view of the Île de la Cité from the Pont des Arts. Getting out and about early in the day gave the opportunity to gain mood from the slight trace of morning mist which was enhanced by shooting into the light.

Leica M4, 50mm Summicron, 1/125sec f5.6, Kodachrome 25.

like seeing Paris with the fresh eyes of my first visit all greedy for the sights of a new place.

At the risk of being repetitious, I can only emphasise the virtues of early morning light. Not only is the often slightly hazy warm colour particularly kind to buildings but the early hour often means that you will be less hampered by people crowding you or spoiling your perfect compositions. The light and the people are also a good argument for planning photographic expeditions out of season. In my experience, in the Northern hemisphere early May and late October are often the best times.

CITIES AT NIGHT

It was Ian Nairn who wrote that he could think of no better place for an assignation than the top of the Eiffel Tower in Paris with that marvellous view of the most romantic of cities spread out below.

I would add that the right time would be dusk when the lights come on from the Seine across to Montmartre, with Sacré-Coeur and other buildings such as the Arc de Triomphe picked out with floodlights. A close second to this view must be Manhattan from the viewing platform of the Empire State Building, the lights coming on in the surrounding skyscrapers, the head and tail lamps of the traffic streaking the already dark canyon of Fifth Avenue, yet the sky still luminous where the sun has set beyond Staten Island.

Cities at night are fascinating and dusk is the magic time. The techniques required to obtain good pictures are not difficult – it is a matter of commonsense and being prepared.

The prime requirements are fast film and/or fast lenses together with some support for the camera. Taking the last point first, this does not mean that it is essential to carry a heavyweight tripod all the time. Generally, the most useful item I carry for this purpose is a small Leitz table tripod with a ball-and-socket head. It is usually possible to find a suitable wall or post on which to position it so that slow films can be used to ensure quality results. Even without the tripod it is often possible to wedge the camera against a railing or lamp post. Using the self-timer to obtain a smooth release, sharp results are possible even with exposures of several seconds. It is best to take several frames to ensure this.

With fast films it is often practical to use sufficiently short exposures for successful hand-held shots. In bright areas, such as Piccadilly Circus, exposures of around 1/30sec at f2 or f2.8 are often practicable. In very bright areas like Las Vegas, even an ISO 64 film will permit exposures around 1/30 or 1/60sec at f2. Ideally you

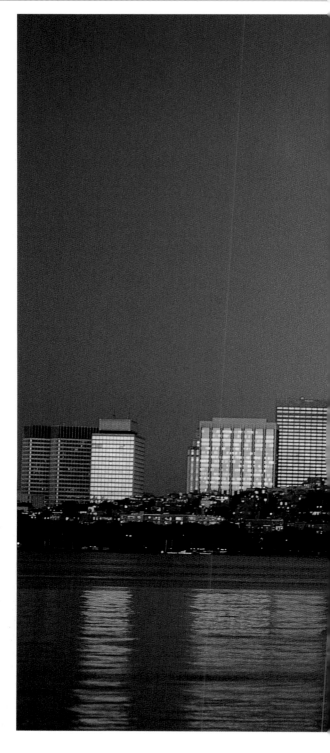

Boston

This photograph was the result of sheer luck and opportunism. Leaving Boston I missed the turn for the bridge to cross the river and had to carry on to the next one. As I crossed the river, I saw in my driving mirror this beautiful lighting on the downtown skyscrapers. As soon as I reached the other side I parked the car as quickly as possible and grabbed a few shots. The light level was very low and I had no tripod with me, so I just wedged the camera against some railings and

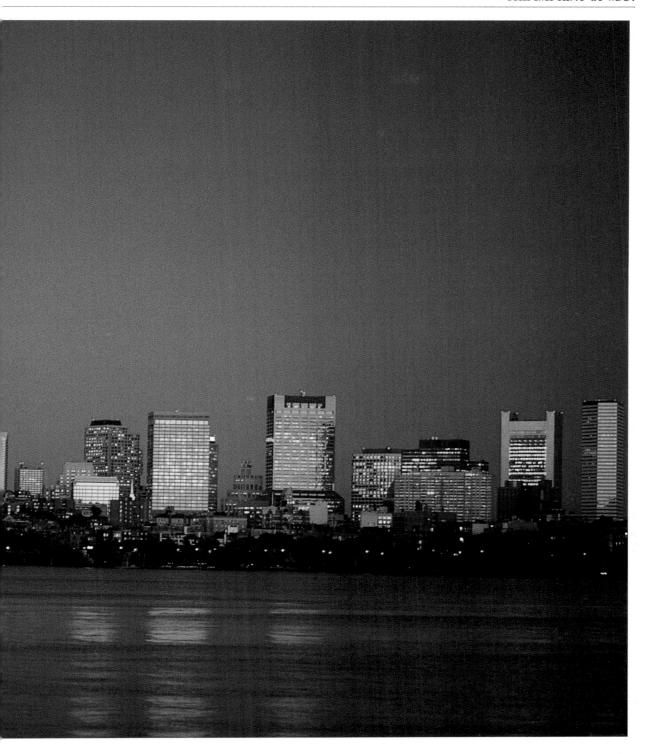

hoped for the best. It was worth it – three out of eight frames were adequately sharp.

Leica M6, 90mm Summicron, 1/4sec f2, Kodachrome 64 Professional.

New York City (Overleaf)

This view from the Port Authority buildings over the East River takes in the Wall Street area, Manhattan and Brooklyn Bridges, and Brooklyn with Queens beyond. I was shooting through thick plate glass which fortunately has less effect on image quality with wider angle lenses than longer focal lengths.
Leica SLR, 21mm Super Angulon, 1/125sec f8, Kodachrome 64 Professional.

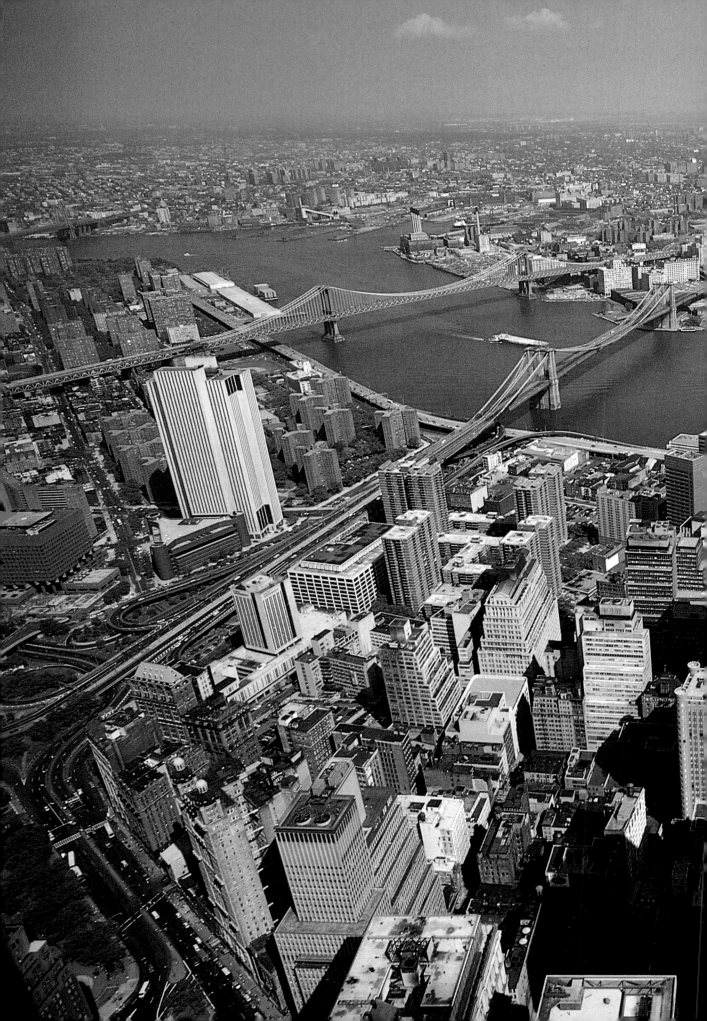

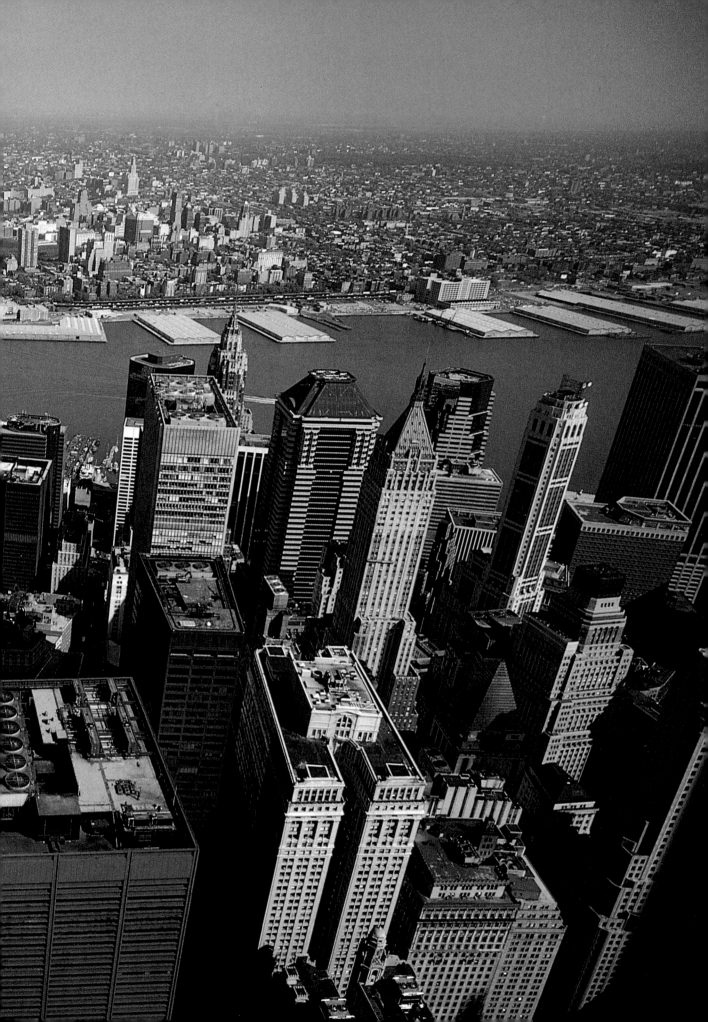

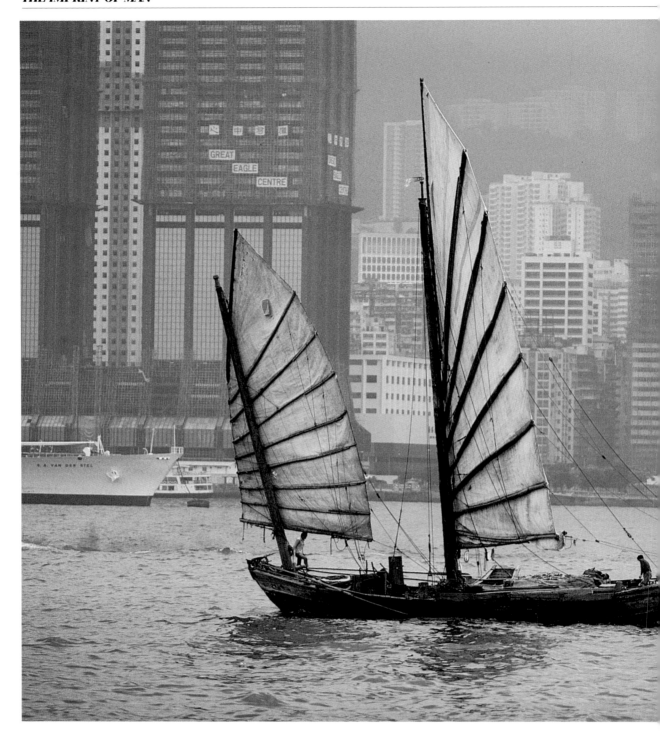

Hong Kong

Photographing from Kowloon across to Hong Kong Island I was fortunate to be able to include a genuine working, sailing junk as these are now a rare sight. The light was from a very weak patch of sunlight in an otherwise overcast sky.

Leica SLR, 180mm Elmarit, ¹⁄₅₀₀sec f4, Kodachrome 64.

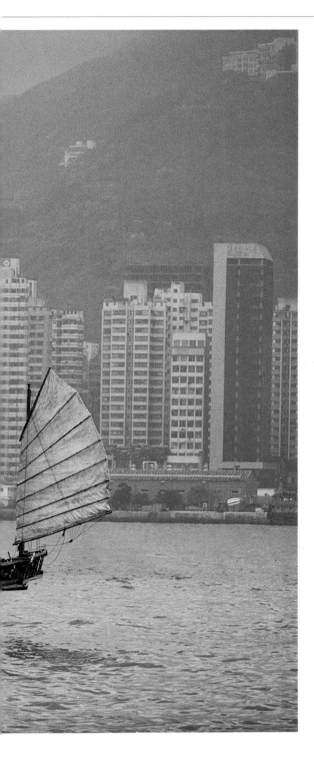

need higher speeds than this to avoid camera shake, but it is always worth a try. With longer focal-length lenses and/or smaller stops needed to gain depth of field, some support would still be necessary.

URBAN AND INDUSTRIAL LANDSCAPES

The most accessible scenic subjects for the majority of photographers are the urban landscapes of their immediate environment. Often too, industrial scenes, ports, bridges, roads and railways are convenient, ready fodder for the camera. This is our world just as much as the pastoral scene, and an eye for detail and careful composition combined with the right lighting can provide many worthwhile images. In fact, in documentary terms such pictures are very likely to be of far greater validity than just another well-taken view of a popular subject. Much contemporary photography is concerned with the urban landscape, which certainly offers an enormous range of subjects.

URBAN DETAILS

The big view or the panoramic scene is rarely applicable here. Often the best impression can be conveyed with selected detail. This can be true of part of a quaint, attractive building typical of the old town as in the shot of Monschau in Germany, or the more contemporary and down-to-earth tobacconist's shop in Congleton, England. In the latter case it was the colours and behind-the-times window decor that attracted me. A slightly more comprehensive view of an interesting environment is the back alley in Ramsbottom, a small industrial town in Lancashire. In this case the cat was a highly fortuitous but important detail in the composition. To take advantage of such random opportunities you need equipment with which you can work quickly and relatively unobtrusively. You are very much in the same world as the candid people pictures of the 'street photographer'. The ideal is an unobtrusive 35mm SLR or rangefinder camera fitted with a fairly wide-angle lens. A fastish film such as Kodachrome 200 can be useful as this will cover most situations, although some subjects do require the quality of a slower film for the best effects.

INDUSTRIAL SCENES

Although environmentally they may not be very acceptable, there is a perverse attraction in scenes that look back to smokestack industry. The wealth of the developed countries was built up on heavy industry and

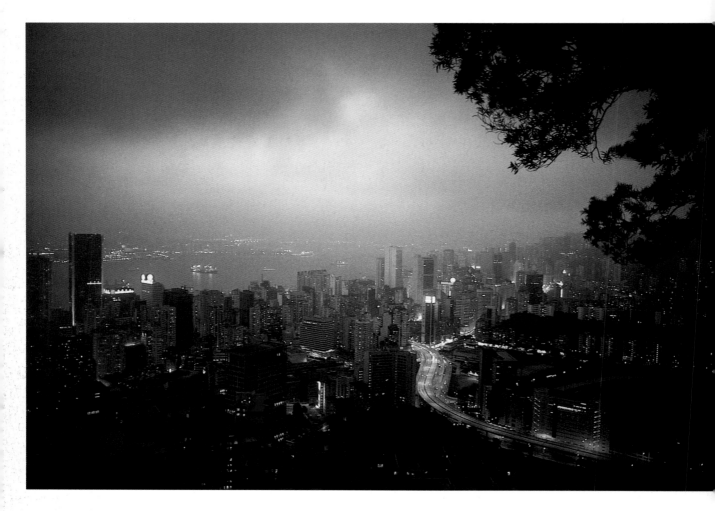

there is a certain romance in views of steel plants and shipyards and the smoke, grit and grime that go with them. Changes in markets, different production methods and tight environmental controls in most countries have eliminated much of this, but occasionally you will come across a view that is a reminder of it all. As ever of course, light is everything. The lime works in Derbyshire offered a subject that I had passed by several times without any idea of a picture occurring until one day there was a clear blue sky and all the plant covered in lime dust was gleaming white against it. After experimenting a little with different lenses and viewpoints, the close view with an ultra-wide-angle gave the dramatic effect that seemed to suit the subject.

With so many changes taking place, pictures of industrial scenes can have considerable documentary value. The picture of the gasholders and other industrial buildings in Manchester, to be found on page 92, was

Hong Kong Harbour

Another picture taken at dusk so as to retain detail in the view whilst showing the fascinating effect of all the lights looking out over Hong Kong at the harbour towards Kowloon. The camera was on a table tripod and in the absence of a cable release the delayed action was used to fire the shutter in order to ensure a smooth release.

Leica R4 SLR, 28mm Elmarit, 2sec f2.8, Kodachrome 64.

Manhattan by night

Taken from the viewing platform at the top of the Empire State Building. Dusk is the best time for night scenes, and this picture was taken just as it was dark enough for the lights in the buildings and from the traffic below to show up whilst retaining detail in the distant view. The camera was supported on a table tripod.

Leica M4, 90mm Summicron, ½sec f2, Kodachrome 64.

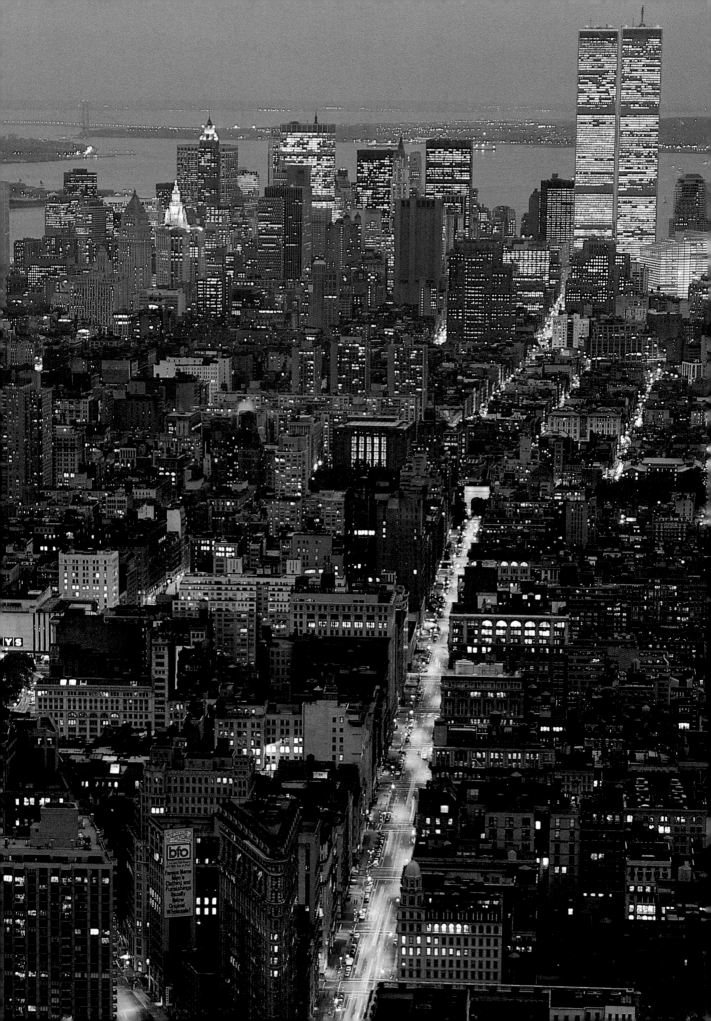

taken in 1981. It was the gasholders and the light on them that fascinated me. The decrepit building belonging to a small oil company and the some-what murky Medlock river alongside were entirely appropriate supporting elements.

When 11 years later I was photographing local rivers for a calendar, I remembered this view and went back to the same spot for a possible picture of the Medlock. Again it was the splendid light that day and the possibility of using the gasholders as a background this time that attracted me. I was absolutely astonished to see the way that trees and other greenery were well established along the river bank. It made me realise how much places can change in a relatively short period, and it was encouraging also to me to see how quickly nature can reassert itself in such unpromising surroundings.

BRIDGES

Of the many necessary engineering structures that impose on the landscape, bridges are probably the ones that best combine function with elegance. There are plenty of ugly ones around, but you only have to think of Thomas Telford's suspension bridge over the Conwy in North Wales, Pulteney Bridge over the Avon at Bath, magnificent Sydney Harbour Bridge or San Francisco's Golden Gate Bridge in order to appreciate the assertion that a first-class example of engineering has its own beauty. Not only are the bridges themselves photogenic but their location over a river, between headlands at a harbour entrance or across a valley in the mountains is often very attractive too. Many great cities are built alongside rivers, and the bridges that cross them are important scenic references, and often highly photogenic.

Finding viewpoints to encompass the whole scene is not easy, and this is another instance where studying the work of the postcard and guidebook photographers, together with a good local map, will give useful pointers. The map will also help you to determine the time of day when the light will be in the right direction. You will also be looking for a day with a good sky and maybe some interesting clouds to help it along. Of course it takes patience and persistence to get just the right shot. The classic picture of the Golden Gate Bridge is an early morning one with the towers and the car deck just clear of the sea fog rolling in below. Four visits and four attempts so far have yielded me conditions ranging from dull and rainy to totally clear, from being totally obscured by fog to some hardly discernible wisps drifting by. Such is the landscape photographer's lot!

Golden Gate Bridge, San Francisco

The design of suspension bridges is particularly harmonious. The structure and the location of this bridge are especially attractive.

Leica R4 SLR, 28mm Elmarit, 1/125sec f5.6, Kodachrome 25.

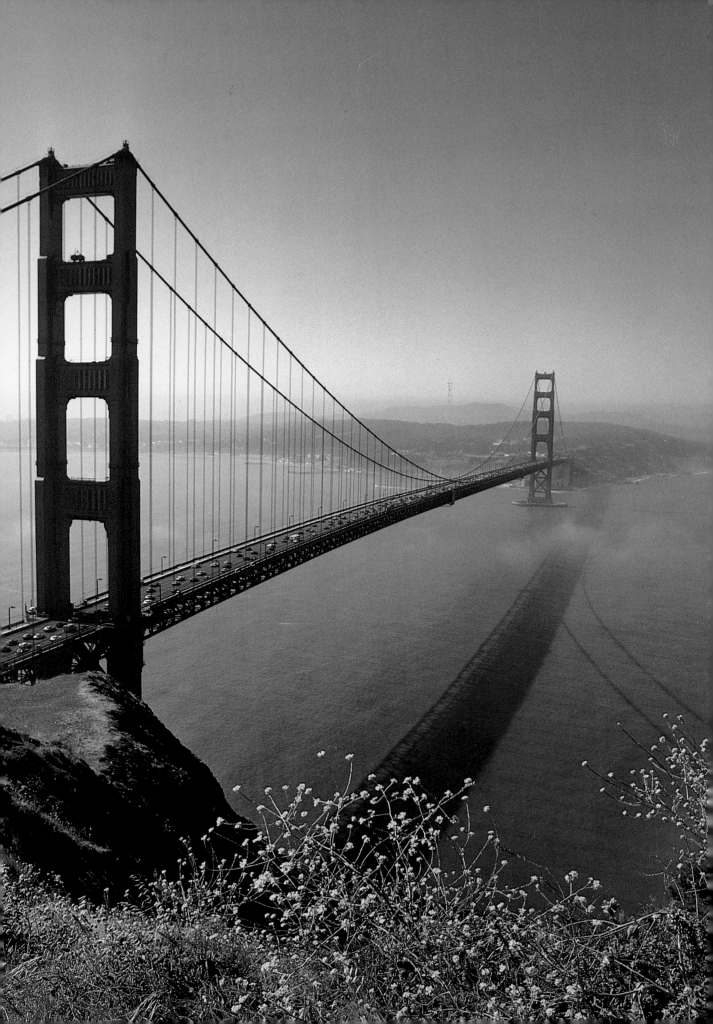

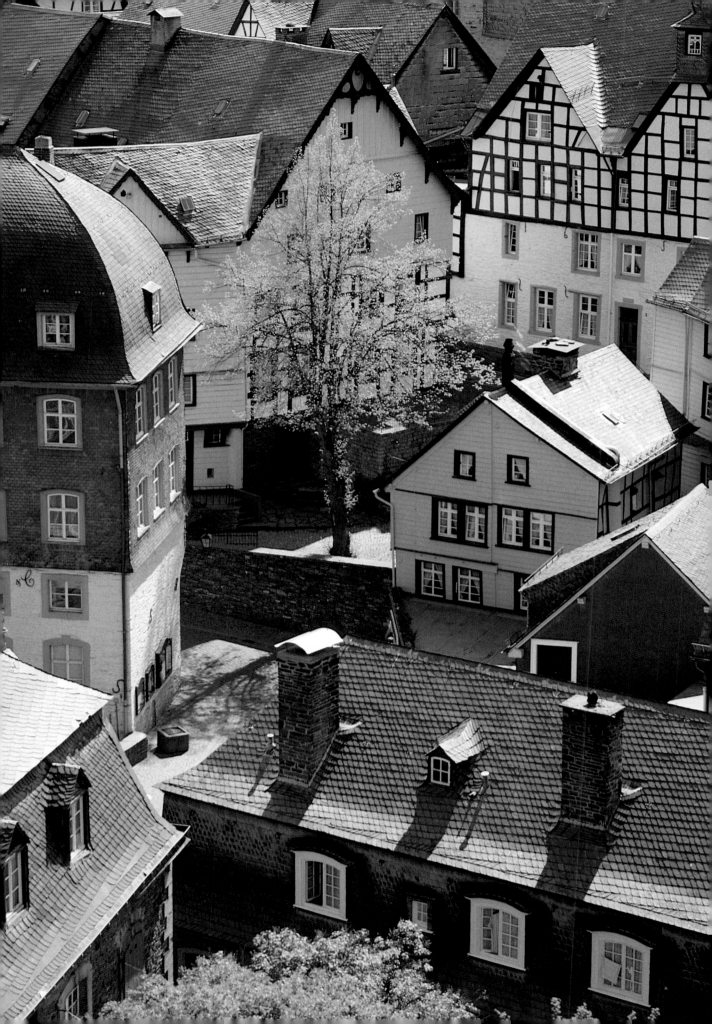

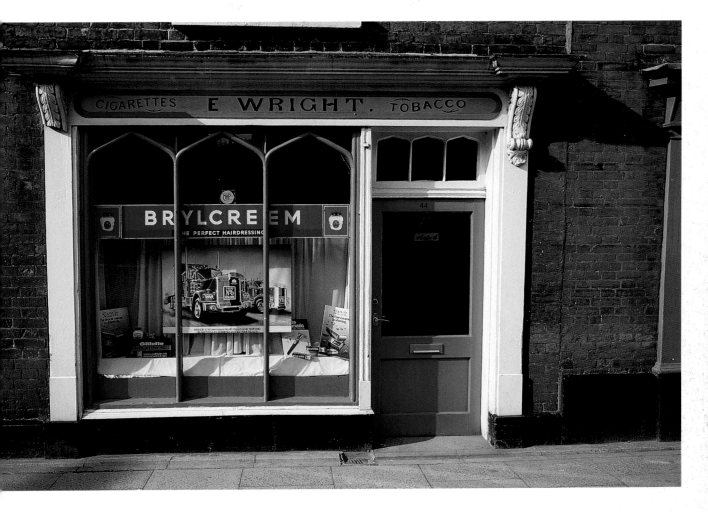

Tobacconist's shop, Congleton, Cheshire

I was attracted by the colours and the old-fashioned simplicity of the window décor. It was a quiet Sunday so I was able to get my picture undisturbed.

Leica M4, 35mm Summicron, 1/125sec f5.6, Kodachrome 25.

Monschau, Germany

In urban photography the detail is often as informative as the wider view. The architecture of the building is characteristic of the old town. The early morning light from the side gives shape and form to the houses and sparkle to the tree in the square.

Leica M6, 90mm Summicron, 1/250sec f2.8, Kodachrome 25 Professional.

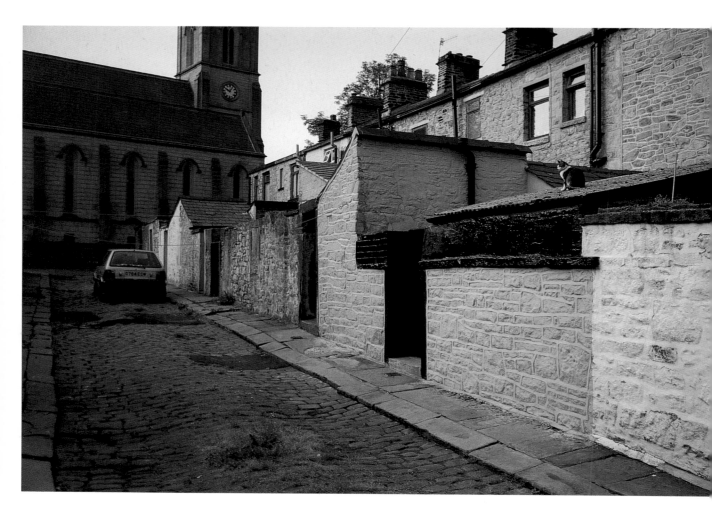

Ramsbottom, Lancashire

This alley between two rows of nineteenth-century stone cottages fascinated me. Some interesting shapes, textures and colour were given something extra by the fortuitous appearance of the cat on the shed roof.

Leica M6, 21mm Elmarit, ¹/₁₂₅sec f8, Kodachrome 200 Professional.

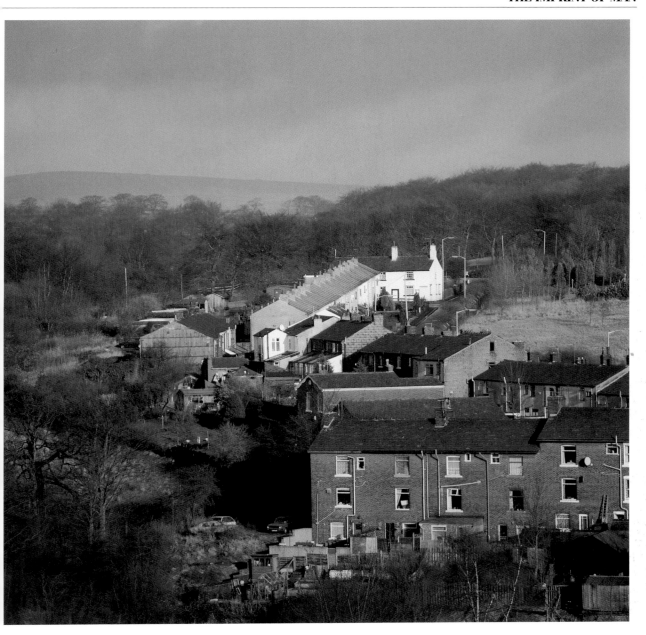

Lancashire

A typical view where the old mill towns encroach upon the Pennine moors. This strong graphic effect with the houses looking close to the hills was the result of using a long telephoto lens.

Hasselblad, 250mm Somnar, ¹/₅₀₀sec f5.6, Ektachrome 100.

(Overleaf)
Limeworks, Buxton, Derbyshire

I had passed this industrial scene a number of times without seeing a picture but on this particular occasion it was gleaming white with the lime dust against a deep blue sky. I tried a few different viewpoints and lenses but settled on the 21mm.

Leica M4, 21mm Super Angulon, ¹/₁₂₅sec f8, Kodachrome 25.

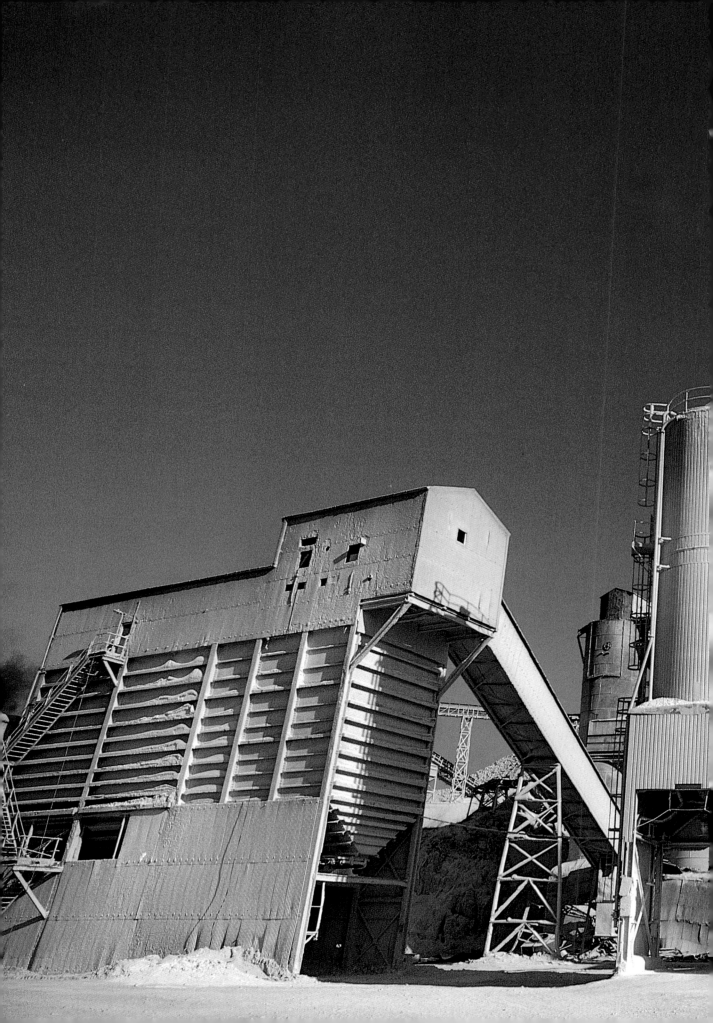

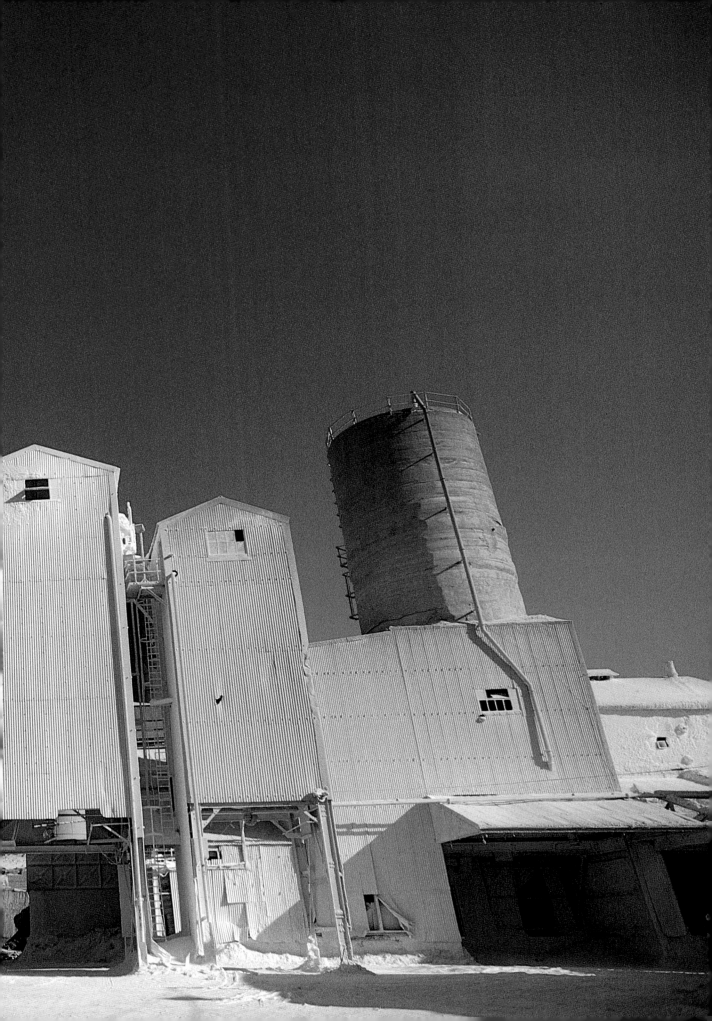

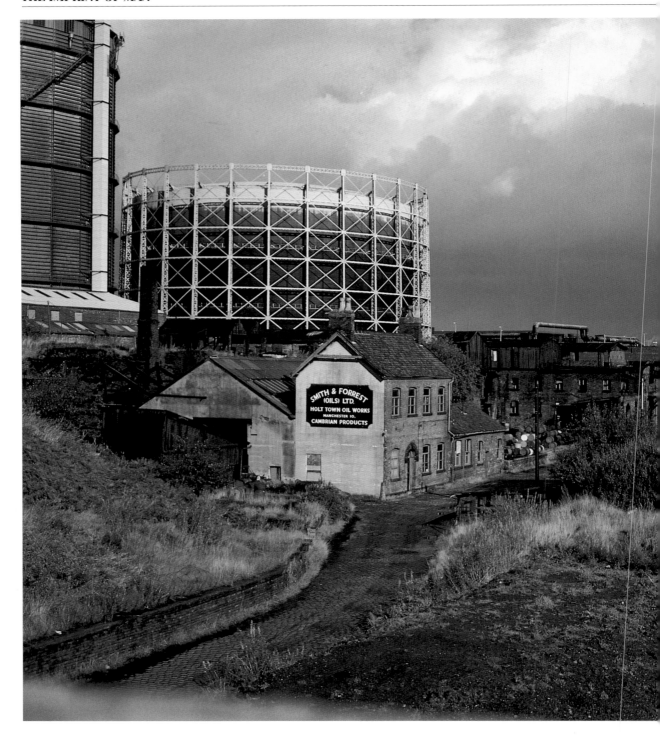

Bradford Gasworks, Manchester

*Gasholders have always fascinated me, the shape, the colours, the play
of light, and this group with the derelict industrial surroundings and
the murky Medlock river appealed strongly.*

Leica M4, 35mm Summicron, $^1/_{125}$sec f4, Kodachrome 25.

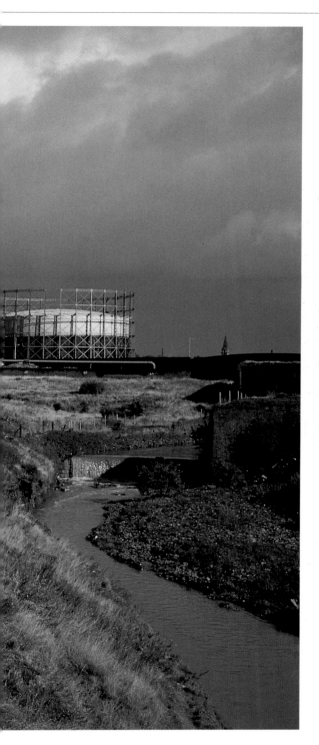

Medlock River, Manchester

This was taken in 1992 from almost the same viewpoint as the previous picture made in 1981. I was astonished at the change that had taken place over a relatively short period. Sunshine and showers provided me with a brightly lit foreground and dark sky.

Leica M6, 21mm Elmarit, ¹/₁₂₅sec f5.6, Kodachrome 25 Professional.

(Overleaf)
Pulteney Bridge, Bath

This bridge over the Avon river is both elegant and functional. There are shops built onto either side of the roadway it carries. The mellow coloured stone harmonises perfectly with the buildings in this Georgian city. In this shot I used a polariser to deepen the blue of the sky.

Leica R4 SLR, 35mm Summicron, Polariser, ¹/₁₂₅sec f4, Kodachrome 25 Professional.

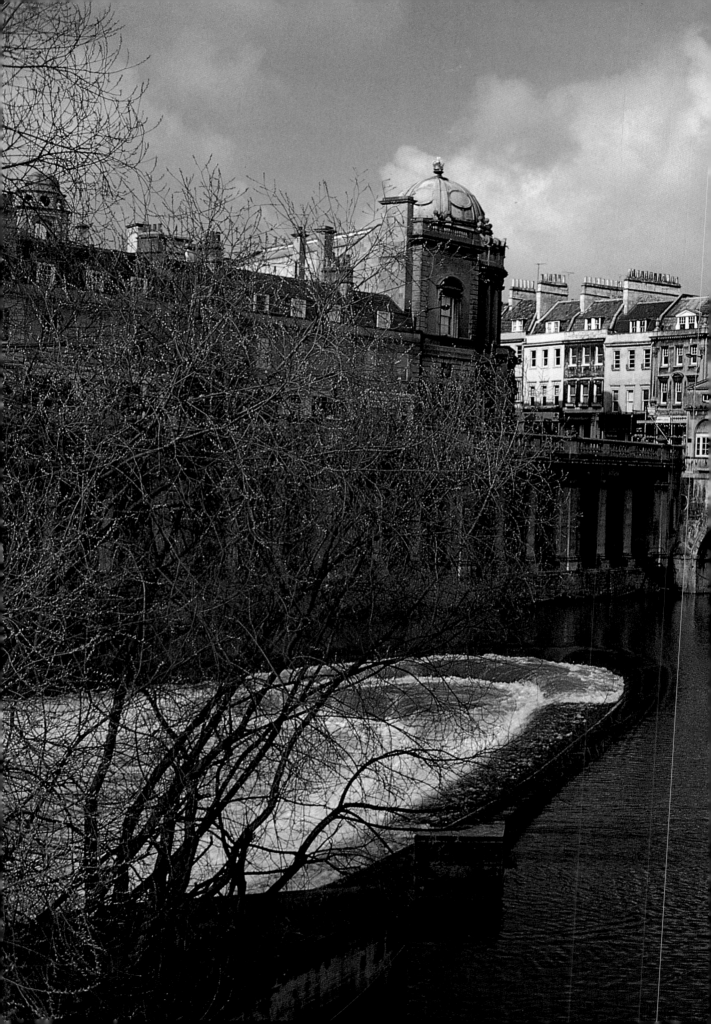

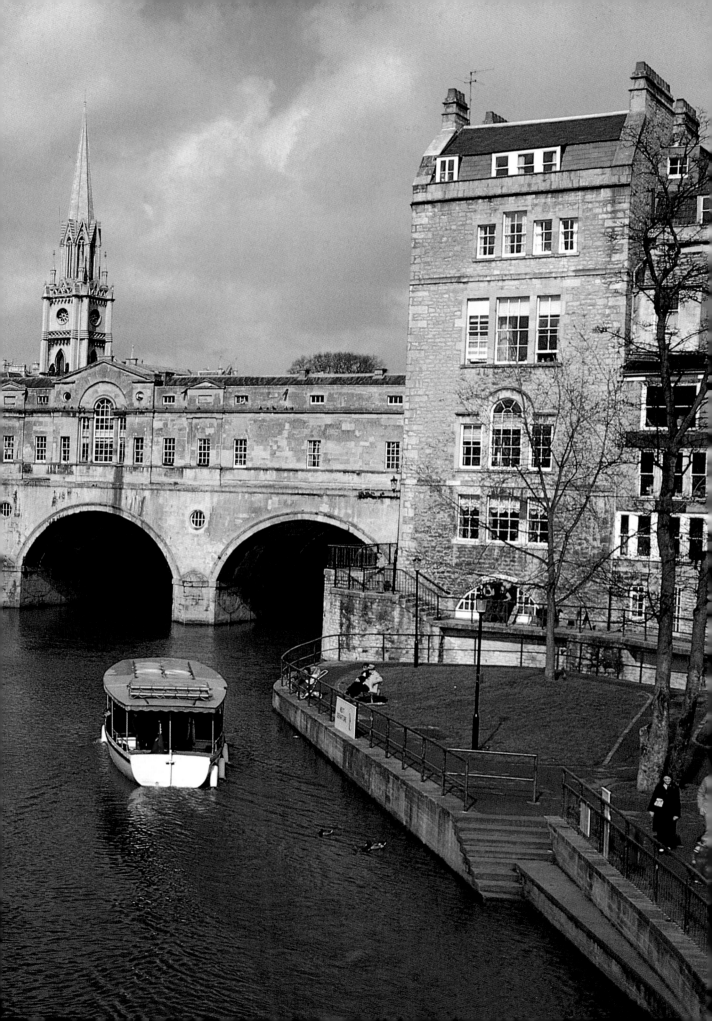

4

VIEWPOINT, PERSPECTIVE AND LENSES

Landscape photography is certainly possible with a camera with a non-interchangeable lens of standard (or, preferably, slightly wider than normal) focal length. There is no doubt, however, that the facility to interchange lenses in a range from ultra-wide-angle to long telephoto allows much more control over perspective and provides the means to frame accurately the required image from different viewpoints, thereby allowing greater scope to the photographer.

PERSPECTIVE

Perspective is the apparent relationship between the different elements of a scene: the foreground objects, the middle distance and the far distance. Go close to an object and it appears much larger in relation to the background than if you stand well away from it. This is the perspective effect and it is controlled by the camera's distance from the foreground object and the latter's distance from the background. So long as you stay in the same position, this relationship remains constant whatever lens you have on the camera, although obviously if you fit a longer focal-length lens you will include less of the subject or you will include more of the scene if you fit a wide-angle.

The photographer controls perspective by changing position. The image size of the foreground object can be maintained by changing to a wide-angle lens if you get closer or to a narrower angle telephoto as you move away. By moving the camera in this way the relationship between the foreground and background elements is changed, sometimes quite dramatically. This can be very important when a landscape photographer is trying to capture a particular impression.

As an example, a farmhouse can be made to appear larger in size and importance in relation to a distant mountain by photographing closer to it with a wide-angle lens. Conversely the mountain can be made to appear to dominate a farm by photographing from a distance with a telephoto lens. A particularly useful technique when trying to show a subject in relation to its environment is to move in close with an ultra-wide-angle lens. This maintains the image size of the main subject, but the wide angle includes much more of the background. The inherently greater depth of field of the wide-angle lens also allows the whole scene to be kept sharply in focus, thereby ensuring that the full pictorial 'story' can be appreciated.

A zoom lens with the popular 28–70mm range will allow considerable opportunity to explore interesting and distinctively different perspective relationships without the exaggerated effects obtained with ultra-wide-angle (20/21mm or wider) or telephoto (over 200mm) shots. These more extreme focal lengths can certainly produce strikingly different pictures, but sometimes the striving for effect overpowers the real subject matter, thereby defeating the photographer's objective. Time spent experimenting with different focal-length lenses and perspective effects is both fascinating and a worthwhile practical exercise. It will pay dividends when unexpected opportunities for pictures present themselves and you need to make immediate decisions on the best way to approach the subject.

CHANGING THE VIEWPOINT

A change of viewpoint does not necessarily mean just moving closer or further away. It is often well worth exploring a complete new angle – perhaps viewing the main subject from above or to one side. This could be a convenient way to avoid foreground distraction, improve the background or show the key elements in a better relationship to their surroundings. Often a change of lens will be needed to facilitate this. The illustrations show a situation where a relatively minor change of viewpoint using a wide-angle lens allowed the elimination of considerable foreground clutter (Hard Rock Café, Las Vegas) whilst another (White House Ruin, Canyon de Chelly National Monument, Arizona) demonstrates how a radically different view was obtained by returning to the entrance to the canyon and then driving some ten miles along its rim for a bird's-eye view. I felt that this latter picture gave a much better impression of the important defensive

position of the Anasazi Indian dwellings and was well worth the time and effort involved.

Very low viewpoints can sometimes be a help to hide distracting background elements or to emphasise an interesting foreground. Inevitably this will involve some tilting of the camera in order to frame the scene precisely. The resulting converging verticals can be objectionable and in such cases the use of a perspective-control (PC) lens (or appropriate movements on a field camera) will avoid the problem. In my experience the most generally useful PC lens for a 35mm format camera is one of 28mm focal length. Most leading manufacturers have good-quality examples in their lens range.

A slightly higher viewpoint – obtained perhaps by walking only a short way up a hill – can make a dramatic difference to the scene included by the camera lens. Interesting middle-distance objects become apparent and the sky assumes less importance. On hazy

Near Winnatts Pass, Derbyshire

A medium wide-angle lens and a slightly elevated viewpoint provide steep perspective with a dominant foreground leading into the distant view. In spite of a very cold wind it was necessary to wait patiently for the cloud shadows and patches of sunlight to be in the right places for the composition.

Hasselblad, 50mm Distagon, 1/500 sec f5.6, Ektachrome 100.

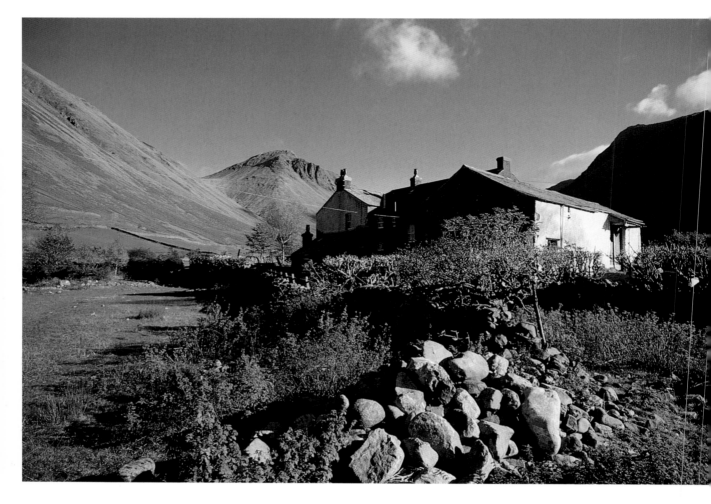

Wasdale and Great Gable, Cumbria

*Two views showing how a change of lens and viewpoint can change
the relationship between the different elements in the scene. In the
first, the farm taken close-up with the ultra-wide-angle lens totally
diminishes the distant mountains. In the second, taken from much
further away with a medium telephoto, the mountain dominates the
farm.*

Leica M6, 21mm lens, ¹/₁₂₅sec f5.6, Kodachrome 25 Professional.

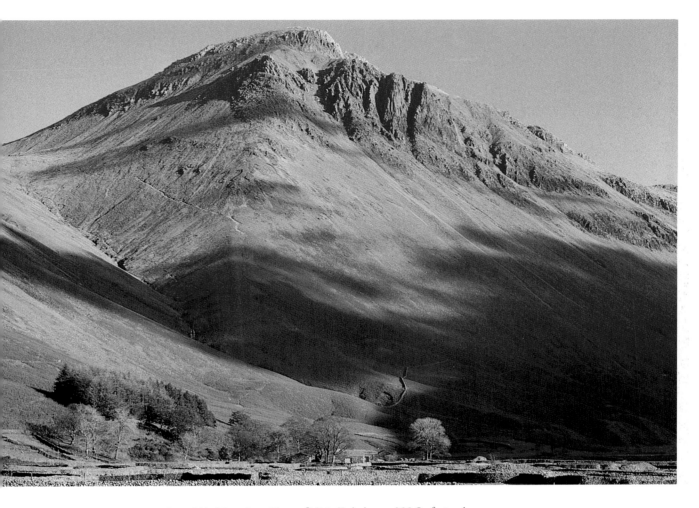

Leica M6, 90mm lens, 1/500sec f8/11, Kodachrome 200 Professional.

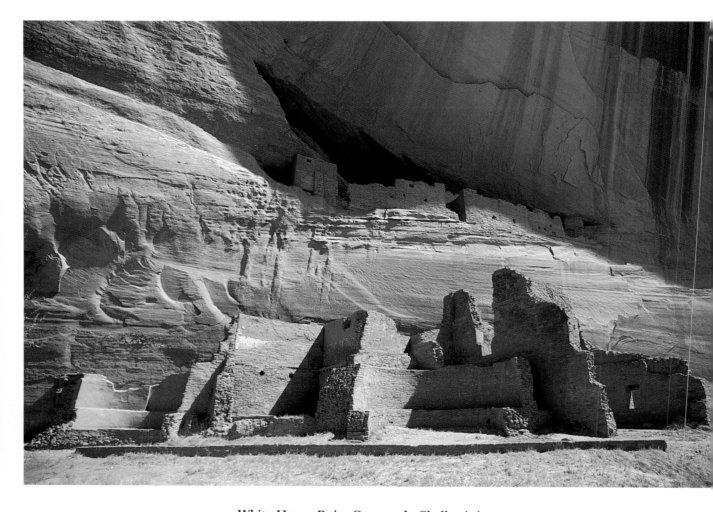

White House Ruin, Canyon de Chelly, Arizona

These two photographs show how a completely different effect is obtained by a change of lens and a change of viewpoint. In the first view from the canyon floor, taken relatively close with a 35mm medium wide-angle lens, the ruin is seen close up in detail and is dominant relative to the canyon wall. The second, taken from the canyon rim and from a much greater distance with a longish telephoto (180mm) the ancient Indian dwelling is placed much more clearly in context with its surroundings, demonstrating its particularly well chosen location for defensive purposes. The comparison shows how a change of lens and viewpoint can emphasize different aspects of a subject.

Leica R4 SLR, 35mm Summicron, ¹/₁₂₅sec f5.6, Kodachrome 25 Professional.

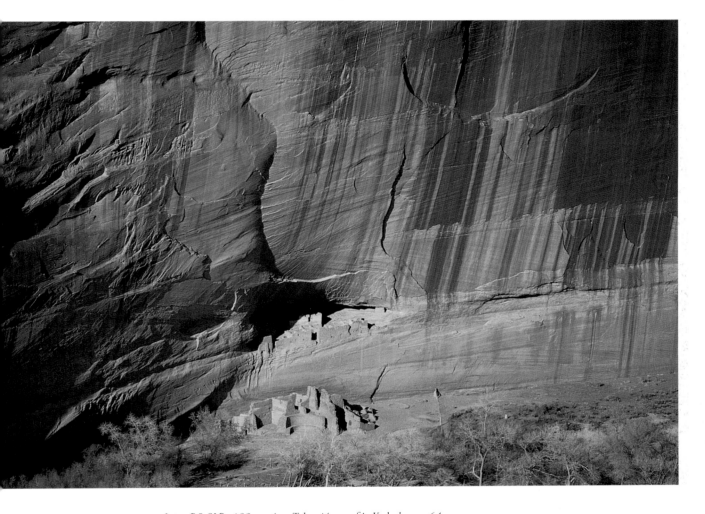

*Leica R5 SLR, 180mm Apo Telyt, 1/500sec f4, Kodachrome 64
Professional.*

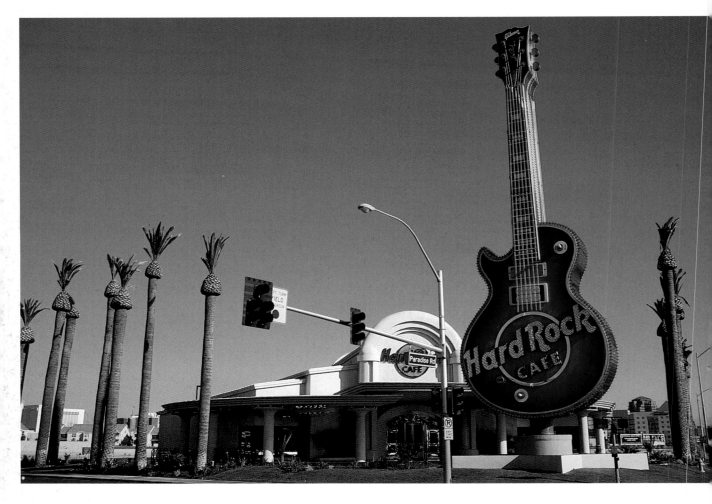

Hard Rock Café, Las Vegas

I spotted this scene as we were leaving the city. My first attempt to include the whole view from across the street with a medium wide-angle included lots of distracting street signs and power lines. Moving in close with an ultra-wide-angle and concentrating on the outsize Gibson guitar produced a much more satisfying result.

Leica RE SLR, 35mm Summicron, ¹/₁₂₅sec f5.6/8, Kodachrome 25 Professional.

Leica RE SLR, 21mm Super Angulon, ¹/₁₂₅sec f5.6, Kodachrome 25 Professional.

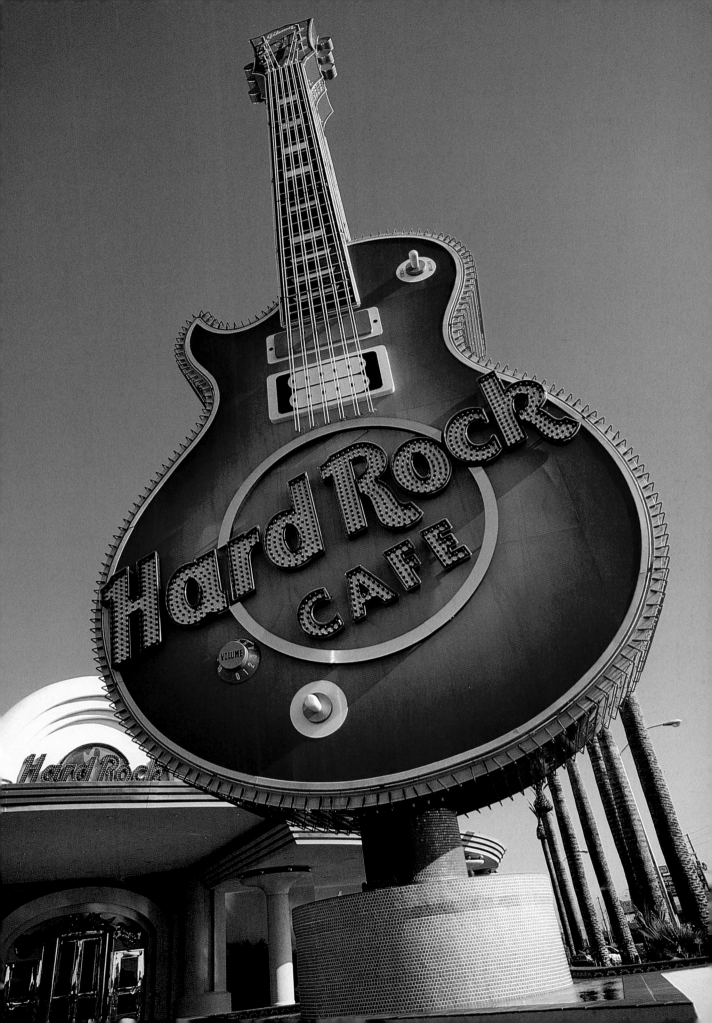

or dull days it may even be appropriate to eliminate a rather bald sky from the picture altogether.

Searching out appropriate viewpoints is one important part of landscape photography. Even with good advance planning using good maps and a reasonable knowledge of an area, it can be very time-consuming, not to say frustrating. However, I am frequently amazed at how a relatively minor change in camera position can significantly improve a picture. In fact, one of the best arguments in favour of a 35mm camera system is that its portability and versatility as well as the large film load encourages the photographer to explore different viewpoints and perspectives. It allows this to be done quickly, easily and relatively cheaply. Large-format cameras and tripods are at times quite inhibiting. They can act as a serious deterrent to the mobility that may be essential to make the most of an interesting location.

COMPOSITION

Composition is perhaps most easily defined as the design arrangement and combination of all the different elements in the picture. Mass, shape, tone and colour and their placement all contribute to the impression that the image conveys so that the advantage falls to a photographer who develops an understanding for the way that different designs work.

Whilst it would be quite wrong to encourage anyone to follow slavishly the so-called 'rules of composition', it is worth knowing that there is a well-established acceptance that different arrangements of the picture elements work differently. Knowing this, you can create or add to a sense of peace and beauty in an image, or strengthen the effect of an image that is intended to provoke, to disturb or even to shock.

THE CENTRE OF INTEREST

Landscapes inevitably have a tendency to contain a great deal of detail and can sometimes be very complex compositions. It is important therefore that they have a clear centre of interest that can instantly attract the viewer's eye and then lead that person naturally into other parts of the picture. From the point of view of first gaining attention, the 'hot spots' in an image are the absolute dead centre and the 'thirds'. This latter may sound complicated, but in fact a 'third' is one of the points where, if you divide a picture horizontally into three spaces and then vertically also into three spaces, the dividing lines intersect.

Blue Boar Farm, Cheshire

The classic S-curve of the road leads the eye to the lonely farm set against the distant hills.

Leica M6, 35mm Summicron, 1/125sec f5.6, Kodachrome 25 Professional.

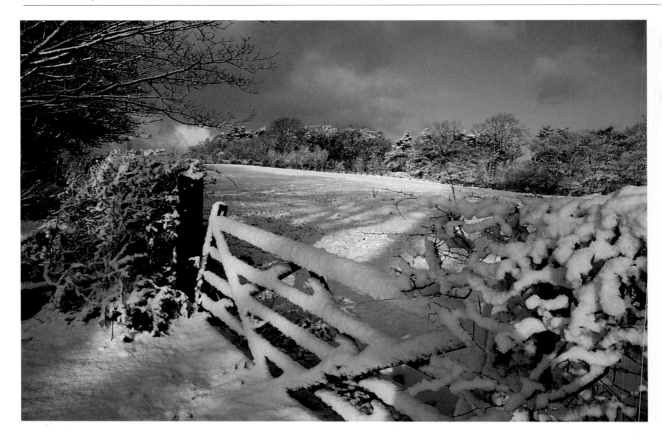

Gate with snow

The gate is an invitation to enter further into the picture. The viewpoint from above the gate allows the viewer into the rest of the picture area, helped by the strong diagonal composition. A small stop was needed for adequate depth of field.

Leica R4, 28mm Elmarit, 1/60sec f8, Kodachrome 25.

Although the absolute strong point is dead centre, the difficulty with placing the main interest there is that the eye then has no obvious direction to travel towards the secondary interests, as all the space is equally spread from the centre. If one of the thirds, or thereabouts, is used for the main element however, the 'follow up' is naturally towards the greater area diagonally opposite, and from this the eye can be led back to the centre or opposite side again so that the whole of the picture area is explored in a rational sequence. This sort of S curve through the scene is the classic 'Hogarth line of beauty'. It is a common denominator of a great many successful landscape paintings and photographs.

It is not necessary to be overconcerned about precise geometry. The 'centre' and the 'thirds' are an approximation and the 'weighting' of an element in terms of size, colour and contrast will be important, as will be the need for individual style and variety.

MASS, COLOUR AND CONTRAST

The main element in a scene can be dominant because of its size, its colour, or its contrast with what surrounds it. Size is self-explanatory. As we have seen already in the section on perspective above, when required a wide-angle lens can be exploited to make foreground objects large in relation to the background.

Size, however, has also to be related to colour. As any advertising expert will tell you, certain colours are much more eye-catching than others. Red is an obvious example, but so are all the warm colours – oranges and yellows as well as red. Also the brighter a colour is the more it commands attention, but blues and greens have to be very bright to overcome their natural acceptance as background colours.

Contrast in both tone and colour are important factors. A small bright area in an overall dark scene immediately becomes the centre of attraction. The tiniest bit of bright red against a subdued blue or almost any bright colour against an overall greyish tone is similarly effective. Research has shown that, for advertising, the highest visibility is gained by yellow lettering on a black background although this combination is somewhat unlikely to occur naturally!

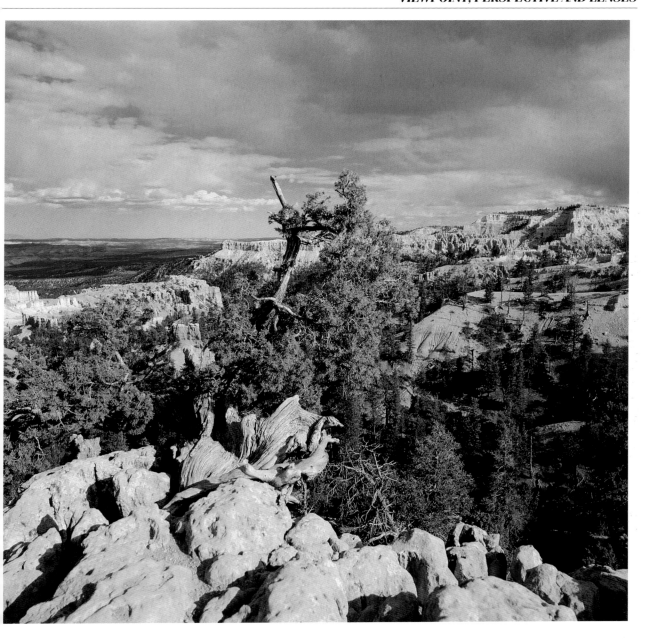

PEOPLE

The viewer is always drawn to people in a picture so that the landscape photographer has to be very careful when the human element is introduced. Unless great care is taken the human interest will itself become the subject matter rather than a foil to the scene. The ultimate cliché in attention grabbing is the pretty girl with a red umbrella or yellow dress located precisely on the thirds! Generally therefore a person or persons in scenic photography should be quite small in the frame and not too brightly lit or colourful. Certainly they can be useful to add interest and in some cases quite important to give a sense of scale, but do remember to be very careful not to allow them to dominate.

Ponderosa pine, Bryce Canyon, Utah

One of the arguments for the square format is that it can be cropped vertically or horizontally to suit an editor's requirements. In fact most photographers consciously or unconsciously compose their pictures to fill the frame. It would be difficult to alter the proportions of this picture significantly.

Hasselblad, 50mm Distagon, ¹/₂₅₀sec f8/f11, Ektachrome 100.

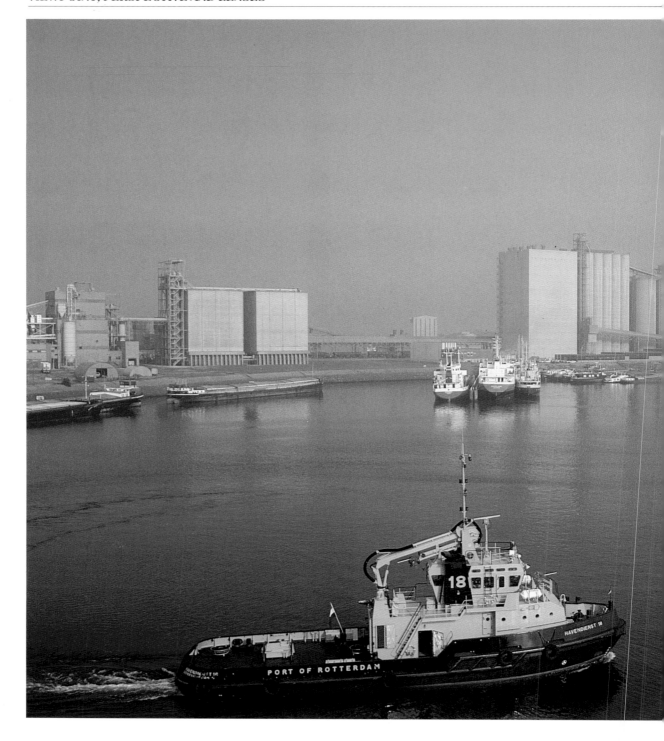

Europort, Rotterdam, Holland

Colour is an important element in the composition of a picture. As can be seen here, reds and yellows command attention strongly, whilst blues and greens are receding or background colours.

Leica M4-P, 35mm Summicron, ¹/₁₂₅sec f4, Kodachrome 25 Professional.

FORMAT

Picture formats can be a horizontal or vertical rectangle, they can be square, and they can even be round or oval, although it is very rare indeed to see a round landscape photograph!

The horizontal rectangle is often referred to as landscape format and most scenes are pictured like this as it is the way we see with our eyes. The proportions can be varied enormously, however, from the 5:4 ratio common in view cameras through the 3:2 of 35mm to the 3:1 of some panoramic equipment. Photographers who make their own prints can make even longer and thinner 'letter box' images. There are no rules, but anything outside the range 5:4 to 3:2 is likely to be regarded as unusual and there is a danger of it being considered gimmicky unless the image is particularly suitable for the purpose.

A vertical rectangle is referred to as portrait format, but there is no reason why it should not be a basis for perfectly good landscape images. In fact, because most books and magazines are produced this way, the vertical arrangement is fully accepted as appropriate for scenic photography. It is psychologically less restful than a horizontal image, but this is a matter of what the photographer wishes to convey and if a scene naturally calls for a vertical picture that is the way it should be made.

The popularity of the medium-format 6×6cm image has brought an increasing trend to square images. One of the arguments for the cameras using this format is that the photographer (or art editor) has the choice of vertical or horizontal when the picture is printed. Commercially, this flexibility can be very useful for the producer of a brochure or magazine. It presupposes, however, a fairly loose composition by the photographer allowing plenty of spare space around the main subject to give that flexibility. Loose composition is not an easy or even a good habit to get into and in practice most serious landscape photographers who use 6×6cm compose to the full format. This is not so easy as with the rectangle, but it is entirely possible to produce satisfying arrangements within a square as the work of many excellent landscape photographers who work exclusively in this format will testify.

FRAMING THE IMAGE

Most photography for publication is taken on transparency film. There is thus little or no opportunity for the photographer to crop his work at a later stage as the transparency rather than a print is the finished product. The photographer is in the hands of the art editor and/or the production editor who in very many

cases will have neither the time nor the inclination to read or listen to complicated instructions for cropping an image. The photographer needs to get the composition and framing right at the time of taking, making full use of the chosen format. For the photographer who is looking to make prints as well, this is good advice. Maximum quality will always come from using the entire negative. This is particularly important with 35mm where you just cannot afford not to use every square millimetre of film available to get essential sharpness and tonal quality.

In the case of reflex cameras, composing fully and accurately to the format can be facilitated by fitting a plain screen with grid lines, assuming of course that your camera allows this. One of the disadvantages of a standard screen is that the focusing aids (split image, microprisms etc) are centrally located. Having focused on the main subject there is an inevitable tendency to leave it in the centre of the frame – not at all the best place as we have seen above. Auto-exposure and autofocus cameras are even worse in this respect, and a serious conscious effort is needed to lock the focus or exposure and then recompose the picture.

PICTURE CONTENT

Remember that elegant compositions are no substitute for interesting and worthwhile picture content. A well-thought-out arrangement – a strikingly simple one to get over immediately a strong message or perhaps a more complex one to encourage thought and exploration of the photographer's ideas – can help enormously, but it should reinforce what the photographer wants to convey through the image, not be a substitute for content.

CHOOSING LENSES

Without doubt the most important items of equipment in a photographer's armoury are the lenses. The quality of the image is utterly dependent on the quality of the lens that makes it. Sophisticated cameras with brilliant

Birkenhead Docks, Merseyside

A powerful diagonal composition with strong interesting shapes. Although an ultra-wide-angle lens was used, the perspective is not noticeably exaggerated. A tripod was necessary because of the low light.

Leica M6, 21mm Super Angulon, ⅛sec f8, Kodachrome 64.

autofocus systems and with intelligent exposure metering count for nothing if the lens(es) are below standard. On the other hand, if you have good lenses a soundly built but straightforward manual camera will enable you to get results of the highest quality.

Fortunately, modern computer-aided design methods and automated manufacturing processes have ensured that the majority of lenses now available reach a good standard at sometimes astonishingly low prices. The more expensive products from such companies as Leica, Nikon and Zeiss do have a quality 'edge', but this is more likely to do with critical performance at wide apertures or better correction, particularly with extremely wide angles or with long fast-telephoto lenses. In more normal situations, the performance advantages of superior optics will not be so obvious and will be most apparent as subtle qualities of colour gradation and 'correctness' of the image coming from careful control of aberrations. The immediately obvious difference with the top lenses will be the 'build' quality of mechanical components intended to maintain accuracy despite hard professional use year in and year out. As an example, several of the lenses that I use regularly on my Leica and Hasselblad cameras are over ten years old and performing as smoothly and accurately as when they were new.

For the non-professional, or even an enthusiast who perhaps exposes twenty or thirty films a year, such levels of mechanical excellence are by no means essential although they do give a nice feeling of confidence in use! Speaking generally I would always tend to buy the lenses from the camera manufacturer's own range. This is not to decry the many excellent and innovative products from the 'independents', but the camera maker is the one who has a vested interest in ensuring that its whole system performs well. The maker will want to ensure compatibility and maintain a consistently high level of quality and if there are any problems of function it is much easier for you to complain to the one source than to several.

The situation is somewhat different with large-format cameras where the lenses are always bought independently of the camera and come from leading manufacturers such as Schneider, Rodagon and Nikon. Photographers working with this kind of equipment will almost certainly have established their own preferences and have their favourite lenses chosen because the image quality suits their style and method of working. It is interesting that with users of these cameras there is a far greater appreciation of the subtle differences between lenses. Although they may be of the same focal length, they can have quite different

glasses and coatings, and the designer may have concentrated on eliminating or reducing one particular aberration more than another. All this has a very subtle but important effect on the rendition of the image, particularly in the out-of-focus areas and its tonal gradation. In smaller formats too there is a recognisable characteristic quality from certain leading manufacturers. For example, with the Zeiss lenses for the Hasselblad, the Leica lenses, the Nikkor prime lenses, each group has an identifiable rendition which photographers may find particularly appropriate to their style.

Landscape photography does not impose extreme requirements of speed or focal length. Photojournalists need wide apertures, sports photographers long fast-telephotos, and wildlife and natural history enthusiasts require quality macro-lenses as well as high-quality long telephotos. The most demanding requirement for scenic photography, however, is probably that for high-quality ultra-wide-angle lenses. For 35mm format we are talking in terms of 21mm and wider, for 6×6cm 40mm and wider, and for 5×4in 65mm. The angle of view of these lenses is exceeding 90° and the demands on optical designers are very considerable. They have to maintain resolution and contrast to the edges of the frame; they have to avoid distortion of the image in order to ensure that straight lines at the edges of the frame stay straight; and they have to minimise vignetting, which is the tendency for the image to get progressively less light (and, therefore to be darker) towards the corners.

STANDARD FOCAL-LENGTH LENSES

These are the lenses that are considered to give an angle of view that corresponds most nearly with the angle of sharp vision of the human eye. They give the most natural view, neither excessively wide angle nor obviously telephoto, and they are particularly useful in landscape photography. The focal lengths commonly accepted as 'standard' for the various formats are:

Format	Lens focal length
35mm	50mm
6×4.5cm	75mm
6×6cm	80mm
6×9cm	105mm
5×4in	150mm
7×5in	210mm
10×8in	300mm

According to the particular camera/lens manufacturer involved, the precise focal length may vary slightly, eg

55mm or even 60mm is still considered to be standard for 35mm format and 180mm for 5×4in.

Most 35mm and medium-format cameras are supplied with a standard focal-length lens, and because it is probably the one manufactured in the greatest quantity and also something of a flagship in the camera maker's range the cost will be relatively low and the optical quality high. It will also be one of the widest aperture lenses in a range, eg f2 or f1.4 for 35mm cameras, f2.8 for medium format and f5.6 for large format. Such wide apertures may not often be important for scenic pictures, but they are a great advantage with single-lens-reflex and view cameras because their relative brightness is a considerable aid to accurate focusing.

In summary then the standard lens may be recommended as a good buy. Even if at some point you acquire a zoom lens that spans this focal length it will not be as fast, and the optical quality in terms of distortion, aberrations and vignetting will be inferior to the prime lens so it is worth retaining.

Piesport, Mosel river, Germany

Two views of this village, the centre for the famous Piesporter wines. The first shot – taken relatively close with a medium wide-angle lens – is perhaps the most conventional. The second – taken from the ridge on the far bend of the river with a long telephoto – places the village in the midst of the vineyards and their sunny slopes above the river.

(Above) Leica R4 SLR, 35mm Summicron, ¹/₂₅₀sec f4/f5.6, Kodachrome 25 Professional.

(Below) Leica R5 SLR, 180mm Apo Telyt, ¹/₅₀₀sec f5.6, Kodachrome 64 Professional.

Yosemite Valley, California

The famous view of the valley is so naturally photogenic that an attractive picture can be made with a range of focal lengths. The five photographs which follow show the effect of lenses from 21mm ultra-wide-angle to 180mm telephoto on a 35mm SLR.

Leica R4 SLR, 21mm Super Angulon, ¹/₁₂₅sec f5.6/f8, Kodachrome 25 Professional.

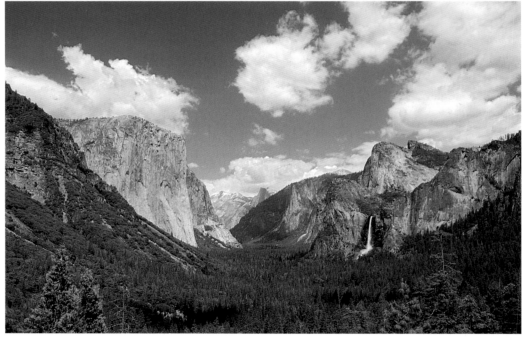

Leica R4 SLR, 35mm Summicron, ¹/₁₂₅sec f5.6/f8, Kodachrome 25 Professional.

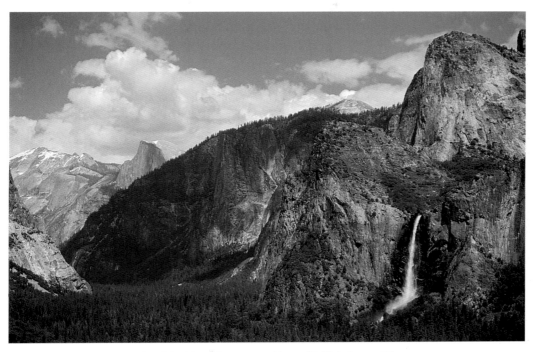

*Leica R4 SLR, 90mm Summicron, ¹/₅₀₀sec f4, Kodachrome 25
Professional.*

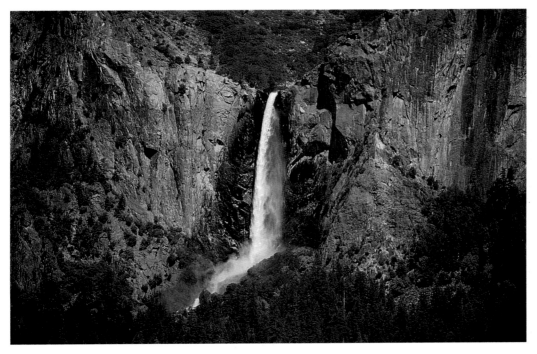

*Leica R5 SLR, 180mm Apo Telyt, ¹/₅₀₀sec f5.6, Kodachrome 64
Professional.*

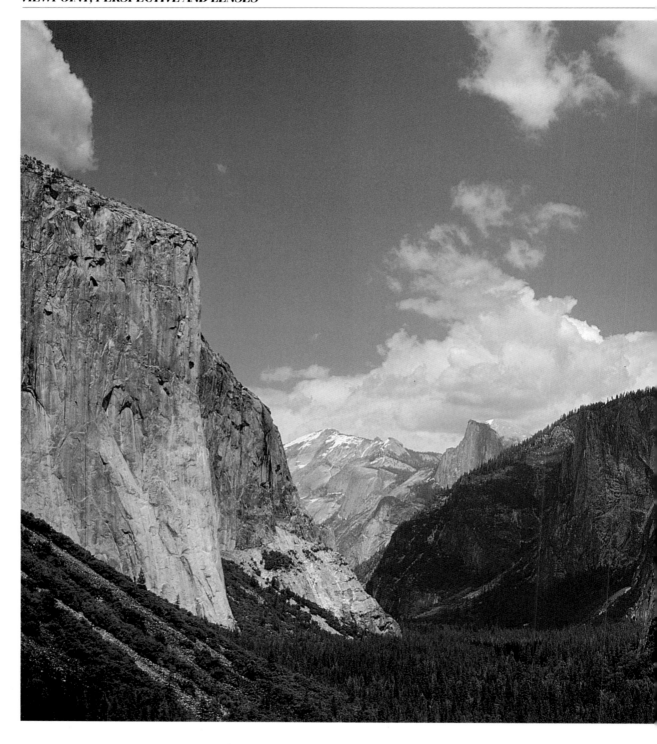

Leica R4 SLR, 60mm Elmarit, ¹/₂₅₀sec f5.6, Kodachrome 25 Professional.

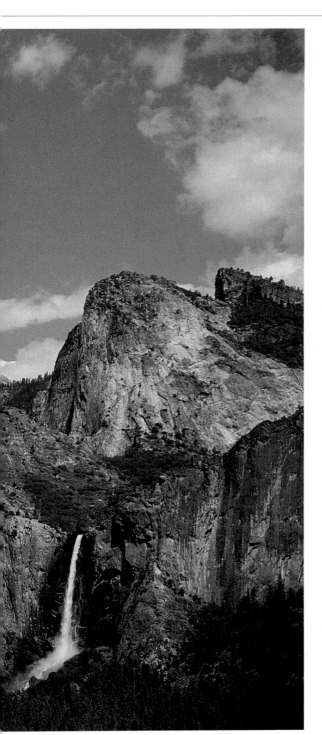

WIDE-ANGLE LENSES

These can conveniently be divided into two groups: moderate or 'standard' wide-angle and 'ultra'-wide-angle. The focal lengths for the various formats are:

Format	*Standard wide-angle*	*Ultra-wide-angle*
35mm	24/28/35mm	18/20/21mm
6×4.5cm	45/50/55mm	35/40mm
6×6cm	50/60mm	38/40mm
6×9cm	60/65mm	50mm
5×4in	105/135mm	65/90mm
7×5in	120mm	90mm
10×8in	210mm	120/165mm

A standard wide-angle is essential equipment. Many scenic photographs depend on being able to include significant foreground material leading into the main picture area and a moderate wide-angle is the most often used lens to facilitate this. Whether you need to go for the wider angle in this range depends very much on whether you own or intend to purchase one of the ultra-wide-angles. As an example, the lens I use most with my 35mm camera is a 35mm focal length. This is because I also carry a 21mm and use this quite extensively so that for me a 24mm or 28mm would be a much less useful focal length. On the other hand, for my 6×6cm outfit I only have the one wide-angle lens so that the 50mm was a more logical choice than a 60mm.

Similarly, if I had to choose just one wide-angle for 35mm format it would be the 28mm. Without the availability of the 21mm my 35mm lens is sometimes just a little restrictive and I have always felt that 24mm is just a bit too wide for comfortable use as a general purpose wide-angle. Nevertheless, there are some very good 24mm lenses around and many photographers seem to be comfortable with this focal length. The equivalent for 5×4in is the 90mm or the 105mm.

The ultra-wide-angles for 35mm start at 21mm and you can get as wide as 15mm without having the problems of a fish-eye. I find that the most practical focal lengths are in the 18–21mm range giving an angle of view of 90° or a little wider. The table indicates equivalent focal lengths in other formats. Remember that, with large-format cameras, to get full coverage of the image you may have to stop down to f16 or f22 especially if the shift movements have been used. As we have shown in our discussion of perspective above, such tremendous wide-angles offer the photographer great opportunities for dynamic compositions that embody dominant foregrounds together with enormous depth of field. These lenses, however, are not easy to

Pfronten, Bavaria, Germany

A medium wide-angle and a medium telephoto are the two most useful lenses in the landscape photographer's outfit. For the 2¼in sq medium-format user these are the 50mm and 150mm focal lengths.

Hasselblad, 50mm Distagon, ¹⁄₅₀₀sec f5.6, Ektachrome 100 Professional.

*Hasselblad, 150mm Sonnar, ⅟₅₀₀sec f5.6, Ektachrome 100
Professional.*

use effectively. You do have to remember to make *all* the picture space work for you. It is all too easy to finish up with masses of blank foreground area. The best way to learn of course is to go out and take lots of pictures, constantly reminding yourself to include interesting foreground elements in your compositions. With reflex and view cameras, just studying the image on the focusing screen and trying different viewpoints without necessarily taking a picture provide excellent practice and are naturally somewhat cheaper with larger film formats!

TELEPHOTO LENSES

Strictly, the term telephoto applies to a lens whose optical construction gives a back focus shorter than its focal length – in other words, the lens can be made shorter. Most photographers, however, use telephoto or the abbreviation 'tele' to describe lenses that are of longer focal length than the normal standard lens for their camera and that is the sense in which it is used in this book.

Just as a standard wide-angle in the range 24–35mm or its larger-format equivalent is practically essential for scenic photography, so a medium tele in the 85–105mm range is also highly desirable. This lens forces concentration on the most important elements of the picture, thereby ensuring the exclusion of unnecessary or distracting detail. At the same time the angle of view is not so narrow as to produce an obviously telephoto perspective and scenes appear quite natural. Depth of field is more limited and should the need arise it is also possible to achieve distinct planes of sharp focus so that a subject can be clearly emphasised against an out-of-focus background. It is also true to say that the leading manufacturers have some outstanding lenses in the medium tele category.

The range of appropriate focal lengths in the 'medium' telephoto category are:

Format	Lens focal length
35mm	85/90/100/105mm
6×4.5cm	120/150mm
6×6cm	150/180mm
6×9cm	210/250mm
5×4in	270/300/360mm
7×5in	360/400mm
10×8in	600mm

The next range of useful long focal lengths is approximately double that of the medium one described above. Lenses in this category will be used very much less in scenic than in other branches of

photography and they should be considered much lower on the priority list than a quality wide-angle. For reference purposes, the focal length range in this 'longer' telephoto group are:

Format	Lens focal length
35mm	180/200/250mm
6×4.5cm	250mm
6×6cm	250mm
6×9cm	360/400mm
5×4in	500/600mm
7×5in	720mm
10×8in	1,200mm

Although it falls in between the medium and longer telephoto ranges described above, a long-time favourite for the 35mm format is a lens of 135mm focal length. These lenses are usually of excellent quality and very reasonably priced. One could well be considered as a worthwhile alternative to the longer-telephoto group described above.

It is very rare indeed that the ultra-long 'super' telephotos have any application to scenic photography. Just occasionally the amazing compression of perspective that can be achieved will provide an opportunity for a strikingly different image. A convenient way to be prepared for such eventualities with 35mm or some medium-format systems is to carry a two-times converter. This will double the focal length of your longer tele, and if used with care to avoid camera shake it will not only prove to be entirely adequate but be very much easier to carry around with your outfit.

ZOOM LENSES

Enormous effort has gone into the development of zoom lenses for 35mm SLR cameras. The sales volumes of these lenses are such that the extremely high research and production setup costs can be spread over many units, thus keeping selling prices reasonably low. Competition in this area is also very keen and the result has been to bring to the market some zoom lenses whose performance is of a standard approaching that of the better prime (single focal-length) lenses.

The shortcomings of zooms are that generally they are slower, ie their maximum apertures are less, and

Zion National Park, Utah

The ultra-wide-angle lens allows the decayed log to be used as a dominant foreground interest whilst still keeping the surrounding environment sharply in focus.

Leica M4, 21mm Super Angulon, 1/60sec f8, Kodachrome 25.

that there is more distortion and vignetting of the image. A slower lens is not usually a problem with landscapes, except in poor light or when using slow fine-grain transparency films. If need be, the problem can be overcome by using a tripod. Similarly vignetting can usually be minimised by stopping the lens down to at least f8 or f11 if it is likely to be noticeable in a scene. This will be mainly when there is a large area of clear sky which will show up the darkening towards the corners of the image. Stopping down will involve slower shutter speeds and again a tripod may be necessary if camera shake is to be avoided.

Unfortunately there is no way to overcome distortion in a lens. With zooms this manifests itself as 'barrel' distortion at the shorter end of the focal-length range and 'pincushion' distortion at the longer end. These two terms are descriptive of the way that straight lines near the edges of the frame bow outwards or inwards towards the centre. This distortion can become quite apparent when subjects such as buildings that include obvious straight lines are positioned near the edges of images. Fortunately most landscapes are not so critical and the many conveniences of a zoom, ie fewer lenses to carry, quicker operation and more precise composition, can be enjoyed fully.

Zoom lenses are very complex, optically and mechanically. The focusing and zooming actions involve various groups of lenses moving differentially so that accurate, hard wearing construction is needed. This is especially important for lenses destined for heavy professional use. A poorly built lens quickly becomes sloppy with use and will not hold focus or zoom settings. Build quality should be a serious consideration when buying a zoom.

Optically the best zoom lenses are in the medium-to long-tele category such as the 80–200mm or 70–210mm. One of these combined with a 35–70mm or 28–70mm will cover practically any scenic photography requirements. Do be warned, however, that zooms that include the wider angles and/or a wider range will have noticeably more distortion than a more modest lens so that there is always a trade-off between quality and convenience. A possible compromise to combine good quality and retain convenience is to carry 28mm and 50mm prime lenses and a 70–210mm zoom.

There are a very few zooms available for some 6×4.5cm and 6×6cm format cameras, but these tend to be bulky, heavy and expensive. Generally, medium-format users are very quality-conscious and prefer anyway to rely on prime lenses. Zooms are neither available nor appropriate for larger formats.

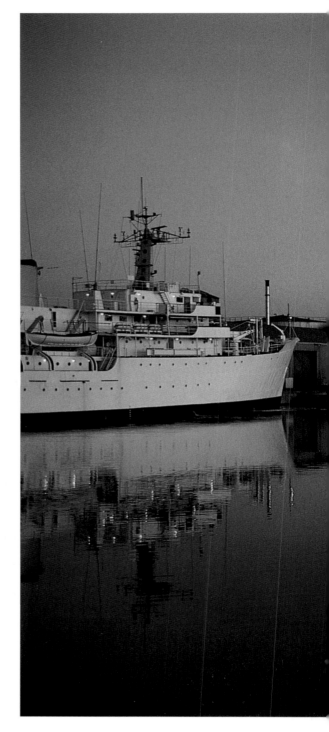

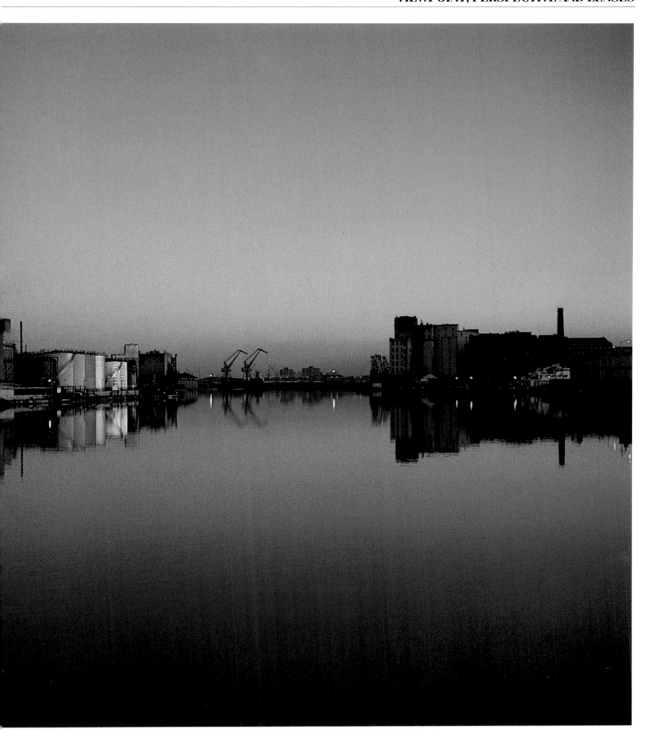

Dock, Wallasey, Liverpool

*High-speed lenses are rarely necessary in landscape photography.
They are a help, however, in low-light situations such as this,
sometimes permitting hand-held shots or facilitating focusing with an
SLR.*

Leica M4, 50mm Summilux, 1/30sec f2, Kodachrome 64.

DEPTH OF FIELD

Controlling depth of field so as to ensure that all the important points of the picture are sharp is important in scenic photography. It should always be remembered that the only part of an image that is absolutely sharp is that on which the camera lens has been focused. It is a fact, however, that there is an area in front of and behind the point of precise focus that is still acceptably sharp. This area of acceptable sharpness is the 'depth of field'.

Depth of field varies according to the focal length of the lens, the distance of the main subject on which it is focused, the aperture to which the lens is set, and the standards of sharpness that the photographer requires. In simplistic terms, wide-angle lenses have greater depth of field than normal focal length and telephoto or long-focus lenses considerably less. Taking some examples of typical lenses and the 35mm format we get the following table:

(Right)
Cotton Mills, Lancashire

This industrial view was taken with a medium wide-angle lens. The point of focus was carefully chosen so that the depth of field available at the stop chosen would include the distant objects and the grasses in the foreground.

Leica M6, 35mm Summicron, ¹/₆₀sec f5.6, Kodachrome 25 Professional.

The same view (below right), taken with different lighting and using a medium telephoto lens with the longer focal length. Focusing on the grasses in the foreground meant that the background was well out of focus but still recognisable.

Leica M6, 90mm Summicron, ¹/₂₅₀sec f2.8, Kodachrome 25 Professional.

		Depth of field			
		At f2.8 (metres)		*At f11 (metres)*	
Lens	**Focus distance**	*From*	*To*	*From*	*To*
21mm	5m	2.46	inf	1.07	inf
	Infinity	4.74	inf	1.35	inf
35mm	5m	3.60	8.00	2.00	inf
	Infinity	13.20	inf	3.40	inf
50mm	5m	4.30	6.00	3.00	14.80
	Infinity	29.00	inf	7.40	inf
90mm	5m	4.74	5.29	4.10	6.40
	Infinity	86.90	inf	22.10	inf
180mm	5m	4.94	5.07	4.76	5.27
	Infinity	343.14	inf	85.93	inf

The influence of the various factors is clearly apparent. Note particularly how increasing focal length rapidly diminishes the depth of field. The figures are taken from published tables using the conventional standard of acceptable sharpness (¹/₃₀mm circle of confusion). In practice, when critical applications such as large prints or large-screen projection are involved, it may be necessary to apply higher standards. In such cases the lens should be set to one stop smaller than the tables or depth-of-field scale indicated (eg use f16 instead of f11).

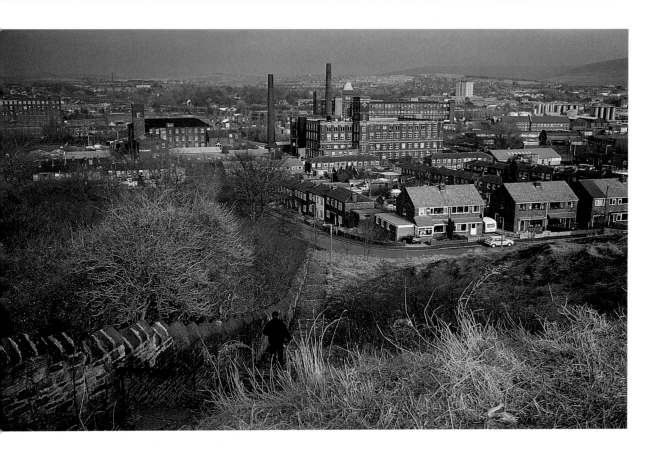

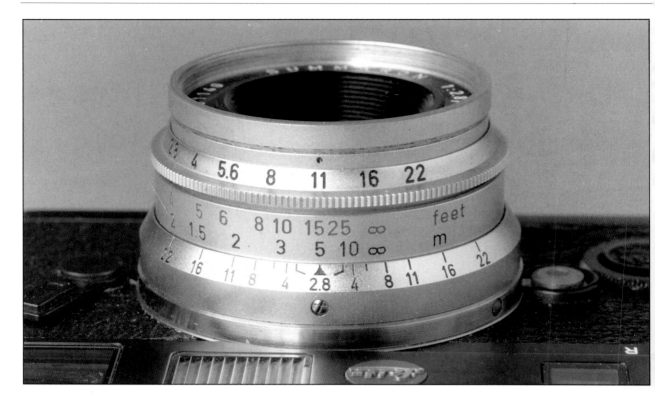

A close-up view of the depth-of-field scale on a 35mm lens on a Leica camera. With the lens focused at 5m it can be seen that the depth of field at f11, the stop to which the lens is set, extends from 2m to comfortably include infinity.

With large-format view cameras it is possible to examine the sharpness of the image on the focusing screen, although when the lens is well stopped down and the screen rather dim this requires some experience. Most medium-format SLRs and some 35mm ones have a preview button that stops the lens down to the taking aperture in order that depth of field can be visually checked. However, beware that, with the relatively low magnification on the focusing screen and the darkened image at all stops, it can be quite difficult to be certain just how sharp parts of the image are. Generally speaking it is wise also to check with the depth-of-field scale on the lens.

USING THE DEPTH-OF-FIELD SCALE

With fairly static subjects, as is often the case with scenic photography, this procedure is simple. Focus on and check the distance of the furthest part of the scene that is required to be sharp (usually infinity). Next focus on and check the distance of the nearest part required to be sharp. Then, using the depth-of-field scale on the lens, set the infinity or other distant setting against the stop on the scale that ensures that the closest distance required to be sharp is within the same stop marking as the other side of the depth-of-field scale. (See illustration.)

AUTOFOCUS AND PROGRAMME CAMERAS

Most 35mm compact cameras and some autofocus SLRs have no focusing or depth-of-field scale on their lenses. Compacts too are usually programme mode only so that you do not even know what shutter speed and stop are being set. This is also the case with many SLRs when operated in programme mode. The result is that it is impossible to establish how much depth-of-field there is and exactly which area it covers.

With wide-angle lenses (or the wide-angle setting of a zoom), a film of ISO 100 or faster, and reasonable light, it is safe to assume that if you focus on a foreground object more than 3m away the programme will be such that the picture will be sharp through to infinity. With some automatic SLRs there is a choice of the type of programme, and you should select the one that gives depth-of-field (it may actually be described as 'depth' or even 'landscape') rather than one that biases towards high shutter speeds ('action' or 'sport'). Clearly this is not as satisfying as being able to control aperture settings and to focus manually so as to keep everything just as you wish, but it is certainly convenient. All this does emphasise that non-automatic cameras have advantages!

Although easy to use, 35mm autofocus compact cameras lack any depth-of-field scale or indication of the focused distance. This can be a major disadvantage for landscape photography.

MAXIMUM SHARPNESS

Although there may be occasions when some softening of the image or some out-of-focus elements are appropriate for a particular effect, the normal requirement in scenic photography is for maximum sharpness throughout the image area. As we have already indicated the starting-point is the quality of the lens, but the performance of even the best lenses can only be realised if the photographer takes care. First the lens has to be focused accurately, usually on the ground-glass screen or by some autofocus system or by some manual rangefinder. Autofocus systems are usually quite reliable, but you do need to ensure that they are focusing on the right part of the picture – using the focus-lock facility if necessary. Rangefinder systems (as on the Leica 'M' cameras) are exceptionally accurate with lenses up to about 90mm focal length, but 135mm is their limit. SLR ground-glass-screen focusing is dependent on the three factors of the focal length of the lens, the quality and brightness of the focusing screen, and most especially the eyesight of the photographer. Even with medium-format SLRs it is not at all easy to focus wide-angle lenses accurately. With 35mm format, focusing a 21mm accurately on anything further away than a couple of metres is very difficult indeed. In practice, with lenses of 28mm and wider it is often better to exploit the very great depth of field of these lenses and focus by scale, ensuring of course that the subject is well within this depth. If your camera has interchangeable focusing screens check that you are using an up-to-date one because significant improvements have been made in brightness and quality in recent years. One typical case is the Leica 'R' system where screens available since about 1987 are at least twice as bright as earlier ones. Another case is the Hasselblad where the 'Acute Matte' screen introduced in 1988 is probably four times brighter than the standard one (still fitted to the 500 C/M Classic) as well as being very much less coarse, thus enabling detail to be seen more clearly. The greatest variable, however, is eyesight and if you want good photographs you must be able to see the viewfinder image clearly. Quite apart from any inherent defects such as astigmatism or exceptionally long- or short-sightedness, everybody's eyesight deteriorates with age, and from about age 47 onwards this becomes more and more apparent as a decreasing ability to focus on close objects. As the virtual distance at which most viewfinders are set is around one metre, you really must be able to focus this distance comfortably. If you cannot, you will need to wear your glasses or get a correction lens for the viewfinder. This question of deteriorating eyesight is a serious matter and many older photographers have welcomed autofocus cameras for this very reason.

Having selected a good lens, focused it accurately and selected a stop that provides the required depth of field, it is now vital to ensure that the effort is not wasted as a result of camera movement during the

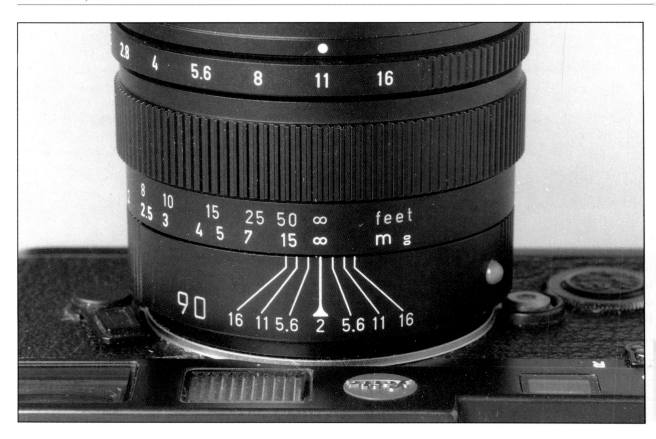

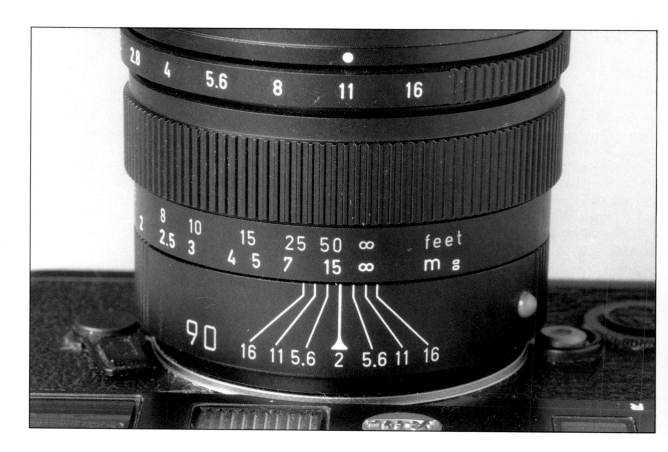

exposure. Obviously, if the camera is being used on a firm tripod this is unlikely to be a problem. However, with an SLR, especially medium format, do use the mirror lock-up facility if available. Vibration caused by mirror movement and the lens stopping down when the shutter is released can be significant. The actual operation of releasing the shutter too can cause unnecessary vibration. Use a decent-length cable release or if this is not available use the delayed action release so that any slight jarring as you press the shutter button will have settled before the exposure is made.

The greatest difficulties usually arise when cameras are hand-held. Most photographers seriously over-estimate their ability to hold a camera steady and much of the advice given in photo magazines on 'hand holdable' shutter speeds is optimistic too. In my experience the following are the minimum speeds for reliable shake-free results:

Wide-angle lens	$\frac{1}{125}$–$\frac{1}{250}$sec
Standard lens	$\frac{1}{250}$sec
Medium tele lens	$\frac{1}{250}$–$\frac{1}{500}$sec
Long tele lens	$\frac{1}{500}$–$\frac{1}{1000}$sec

With medium-format cameras, use the higher speed of the range indicated. If conditions do not allow these recommended speeds by all means have a go with the fastest that it is possible. All may be well especially if you can steady yourself on, for example, a wall, a tree or a gate. Do not, however, rely on such pictures being sharp – take two or three and it is quite possible that one of them will be quite sharp. Even if it is only just acceptable always remember that an interesting picture that is not technically perfect is much better than a boring one that is!

Unless you need to stop down for depth of field reasons do not be afraid to use your lens at quite wide apertures so that you can keep shutter speeds high. Most modern lenses are at their optimum only two or three stops down from wide open and excessively small apertures can actually reduce performance. This applies particularly with lenses for 35mm cameras. Scenic photography with these and medium-format cameras should rarely call for stops smaller than f8 or f11, and as you will see from the details with the illustrations used in this book I regularly work at f4 or f5.6 and sometimes even wider in order to be able to use my favourite Kodachrome 25 film. With medium format using a faster film, my typical stops for hand-held photography are f5.6 and f8. Large-format cameras will always be used on a tripod anyway so that a typical stop setting of f22 with its consequent slow shutter speeds will not usually present any problem.

These two illustrations show how use of the depth-of-field scale can help to maximise the area of the picture that is sharp. (Above) With the lens focused at infinity and set at f11 the sharp zone extends from about 18m to infinity. (Below) By setting the focus so that infinity is against the f11 mark on the depth-of-field scale, sharp focus extends from about 10m to infinity.

5

LIGHT

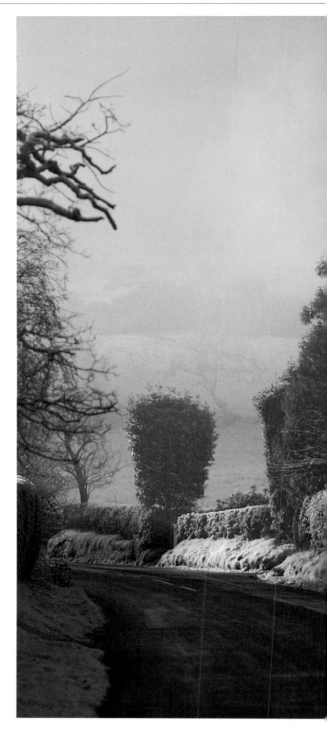

Light is the raw material of photography. The word photography itself means to paint or draw with light and its pioneer William Henry Fox Talbot very appropriately called his discovery of the process 'the pencil of nature'. An understanding of the way the direction of light can affect a scene, and the way light changes throughout the day, the year and in different weather conditions, is a prerequisite to successful landscape photography. All great landscape painters have understood this, and Claude Monet, one of whose works originated the term impressionism, himself said, 'A landscape hardly exists at all as a landscape because its appearance is constantly changing; it lives by virtue of its surroundings, the air and light, which vary continually.' There is no better way to express how much it is the light and prevailing atmospheric conditions that make a landscape picture.

THE DIRECTION OF THE LIGHT

SIDELIGHTING

One of the difficulties faced by both painters and photographers is that they are attempting to depict on a two-dimensional surface a three-dimensional subject. There are many ways of creating an impression of shape and depth to an image, but a primary consideration is the direction of the light. If it comes strongly from one side or the other rather than from behind the photographer, the subject being photographed will be highlighted on one side and in shadow on the other, thereby giving an impression of shape and solidity. This kind of light most effectively comes in the early morning or late evening, or in winter when even at its zenith the sun is relatively low in the sky. A landscape photographed at these times will have every undulation, every structure, every tree clearly delineated. The fissures and gullies in a mountainside or canyon and the architectural details of a building will be readily apparent especially when the light is skimming across almost at 90° to the camera position.

BACKLIGHT

Most magical of all are the effects that you get when shooting directly into the light. Here the shadows are stronger, some of the subject is directly lit and the

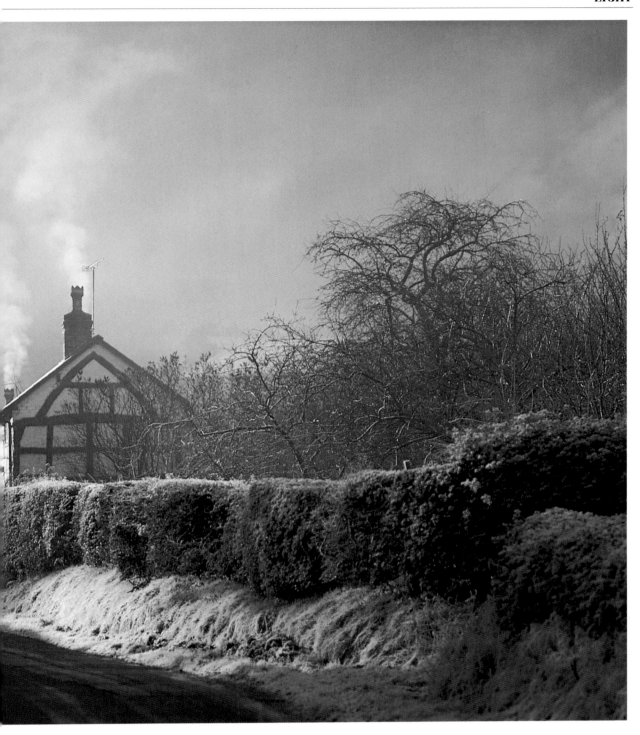

Cottage, Alderley Edge, Cheshire

Leica M2, 90mm Elmarit, ¹/₁₂₅sec f4, Kodachrome 25.

This has been one of my most successful pictures in terms of money earned. It was taken one Boxing Day morning when the sharp frost and some nice light were an excuse to dodge the household chores. The light with just a trace of mist was just right, the chimney smoke was a bonus – I was very lucky. Subsequent efforts to repeat the shot have been totally without success. The trees have grown and obscure the cottage, there is little or no smoke, and the light has never been quite the same!

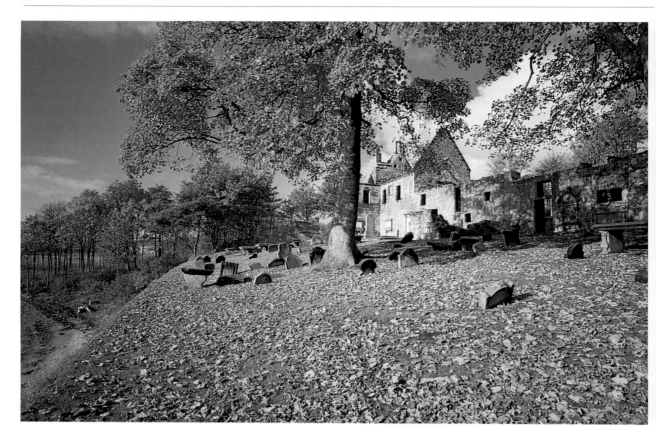

Ruined church, Fife, Scotland

The lighting here is very flat but this is compensated to a large extent by the strong colours and shapes emphasised by the use of an ultra-wide-angle lens.

Leica M4, 21mm Super Angulon, ¹⁄₆₀sec f8, Kodachrome 25.

(Right)
Blue Boar Farm, Cheshire

The strong sidelighting helps to separate the farm from the hill behind and emphasises the curve of the road leading to it. Compare this with the picture of the same farm on page 105.

Leica M4, 90mm Summicron, ¹⁄₁₂₅sec f5.6, Kodachrome 64.

shapes are much more solid. There is an enormous contrast between highlight and shadow area that gives great impact to a picture – although it certainly poses considerable technical challenges. Perhaps the most exciting are the effects of this light reflecting off stretches of water, constantly shimmering, or the way it can rimlight a subject.

There is great sparkle to this *contre-jour* lighting, which together with the strong tonal rendition commands attention from the viewer. The technical demands include a good knowledge of exposure control and methods of minimising the risk of flare and reflections within lenses. Exposure is dealt with in the last chapter of this book. Flare and internal reflections are a perpetual problem, which is certainly not solved merely by multi-coating lenses as the manufacturers would have us believe. Flare – an overall veiling and loss of contrast in the image – is considerably reduced by modern optical glasses and coating methods, but the actual design of the lens, optical and mechanical, has a vital bearing on flare too. Reflections – usually of the lens diaphragm – occur when the sun is directly in the field of view or sometimes just outside it. An effective lens hood will help avoid problems where the sun is just outside the picture area. If it is within the field of view, however, the lens hood serves no purpose whatsoever.

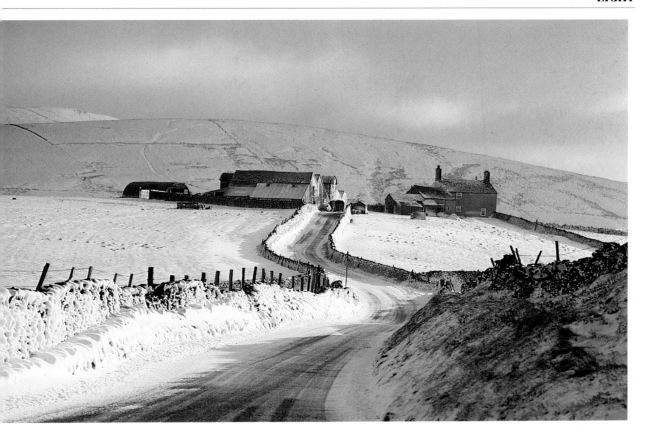

All lenses are liable to flare and reflections in this situation, but good design can minimise the tendency and in some cases eliminate it. Careful optical design, correct use of coatings, and good mechanical design with proper baffling and blackening of reflection-inducing components are the contributions from the best manufacturers. Photographers can do their bit by removing unnecessary filters and then carefully choosing their viewpoint sometimes to mask the sun itself behind an object such as the branch of a tree. Even slight variations in camera position will occasionally change the angle of the light coming into the lens so that a particular reflection can be avoided. This can be observed on the focusing screen of an SLR or view camera.

FLAT LIGHTING

Sidelighting and backlighting are the best ways to give an impression of depth in the picture. Every so often, however, the photographer's objective is a flat two-dimensional effect. This may be to emphasise the effect of a graphic design of colours and shapes or even a semi-abstract creation. In these cases flat lighting either on a very dull day or with the light coming from behind the camera will help to achieve the desired effect. The perspective of a telephoto lens will strengthen the impression.

LIGHT THROUGH THE DAY

Throughout the day the sun moves round from east to west (clockwise in the northern hemisphere, anti-clockwise in the southern). The vertical angle also changes as the sun moves towards its zenith at midday. The maximum angle at the zenith will vary according to the time of year and how far you are away from the equator.

Near the equator, throughout the year, the sun rises and sets in almost the same position every day and rises practically vertically until it is directly overhead at midday, thereafter moving down just as steeply. You have to be quick in some places to catch a sunset. In Zambia, Central Africa, I was photographing the sunset on the Zambezi. At the final stage, as the sun reached the horizon, it was dropping like a stone and I was hard pressed to get the series of shots that I had planned!

The further you are from the equator, the less high the sun gets at midday, and the greater the differences between summer and winter in the time and point of the horizon where it rises and sets, as well as how high it gets at any particular time of day. For the scenic photographer this offers great advantages and opportunities as it means that, with careful planning and maybe some little calculation, a more suitable period of the year and time of day can be established for the picture that is in mind. For example, it may be that a

scene would be ideally composed with the sun setting at a particular point on the horizon. Or a building in a narrow street may only get adequate light in the summer months when the sun gets high enough to avoid casting shadows from ajoining buildings. Perhaps the ultimate example is Stonehenge in Wiltshire where only at sunrise at the summer solstice does the sun shine precisely through the major arch. There are in fact useful little calculators that can be used, with the aid of a map, to work out the sun's direction at different times and seasons. One that I have came as a freebie with a photo magazine.

Few scenes of course demand anything approaching such exactitude. Even with relatively critical situations it is often adequate to estimate that the sun will set in the sector required around the middle of October, say – or that one side of the street will be adequately lit from about 10am in June and July. It is rare, however, that the picture that you are seeking is even this demanding of perfection, and in any case a very likely situation is that you are travelling and will not have an opportunity to return at some extended future date. The main requirement then is to try to evaluate possibilities throughout the day. When travelling it is always worth trying to spend a minimum of two nights at any one location. This allows one day to explore the photographic potential of different scenes throughout the day and then, having perhaps established the most suitable angle of light, there is an opportunity to return at the best time the next day and capture the image that got away the first time round.

MORNING LIGHT

Ask any serious landscape photographer when is a favourite time to take pictures and the reply, almost invariably, will be early morning. The first hour or two after the sun comes up over the horizon can be magical. Sometimes it is a warm soft light skimming across the landscape, sometimes banks of mist hanging in valleys or over water, and sometimes a clear crisp start to the day after a sharp overnight frost. All of these can be relied upon to get the landscapist's adrenalin flowing and the shutter working overtime.

Naturally a certain amount of willpower is needed to drag yourself from a warm bed whilst it is still dark in order to be at some planned location by dawn. The emphasis is on the word planned. Few good landscape photographs are the result of pure luck. More often just a little luck with the lighting or some quite unexpected element in the composition is the final touch to reward the effort to be in the right place at the right time with the likelihood of the right conditions.

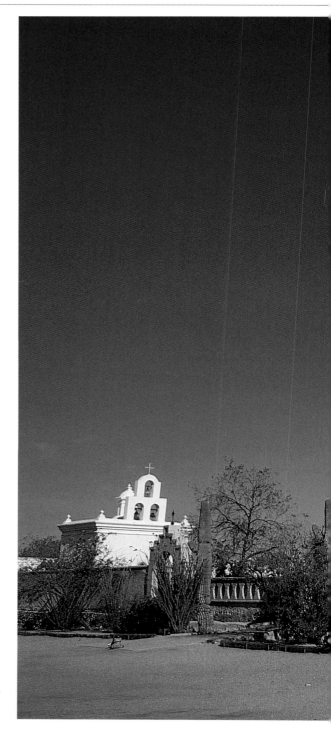

Mission San Xavier del Bac, Tucson, Arizona

One of the most beautiful of the chain of Spanish missions through California and Arizona to Mexico. Sidelighting gives shape and substance to the building, highlighting texture and detail. The sky was a deep blue and no polariser was necessary.

Leica M4, 35mm Summicron, 1/120sec f4/f5.6, Kodachrome 25.

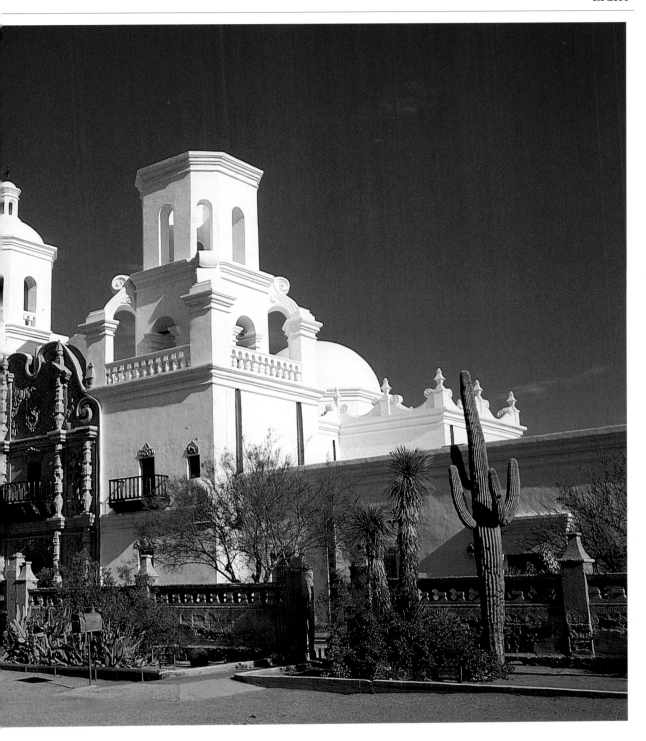

(Overleaf)
Venice, Italy

This was taken one very early morning in October. Although shooting directly into the sun, at this time of year and time of day there is a softness about the light which avoids any harshness in the picture. Exposure was quite tricky and I bracketed to be sure of getting the effect that I wished.

Leica M4, 21mm Super Angulon, 1/125sec f5.6, Kodachrome 25.

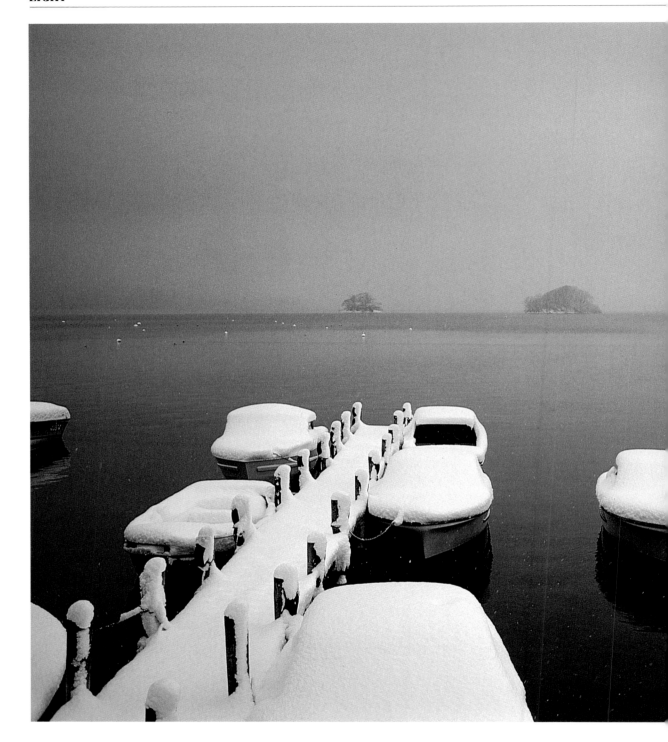

Windermere, Cumbria

A heavy overcast sky often accompanies snow. The lighting is inevitably very flat and the effect is often of a very two-dimensional graphic design.

Leica M4-P, 35mm Summicron, ¹⁄₆₀sec f5.6, Kodachrome 64.

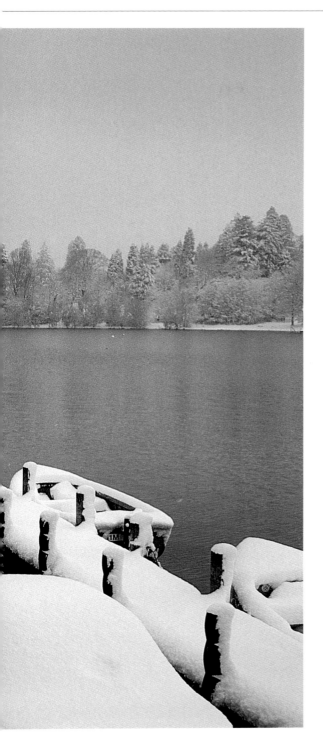

An example is the picture of Ullswater with the drowned tree. I had noticed the tree on a visit to the area in late spring when the weather turned out to be less than co-operative. In the autumn I often watch the weather forecast at the weekend for a situation likely to produce early morning mist, and if things look promising I set off on the two-hour pre-dawn drive to the Lake District. Frequently there are disappointments. Weather in the mountains is always unpredictable: a slight change of temperature or a little wind and the mist is gone. On this occasion I had that bit of luck. The wind was getting up, but there were still some shreds of mist hanging around as the sun rose and I got the picture I wanted.

Sunrise from the South Rim of Grand Canyon was another marvellous morning experience. For the half hour before the sun climbs up over the North Rim the sky glows, changing from deep blue to purple and then red. As the sun breaks the horizon, the rocks, exposing thousands of years of the earth's history, are bathed in a marvellous warm light. The faint trace of mist hanging in the canyon itself glows first red and then gets progressively cooler in tone as the sun climbs higher. Soon the mist has gone, burned off by the heat. The rim is at almost 8,000ft (2,400m) so that the overnight temperature can drop well below freezing for most of the year. This, and the heat retained in the lower levels of the canyon, is what creates the mist and the beautiful recession effects that it provides. The whole wonderful show can be over in less than an hour, which emphasises the need to be staying close by and to get up early.

THE MIDDLE OF THE DAY

The high sun towards the middle of the day such as we get in the summer or in regions near the equator is rarely good for scenic photography. Without any angle to the lighting there is little shape to objects. The light too is usually very harsh with deep dark shadows and a contrast range that is almost impossible to contain satisfactorily on film. Often a heat haze has built up so that distant scenes are difficult to photograph satisfactorily, especially as the deep shadows tend also to be very blue.

The easy advice is to put the camera away for two or three hours. If you want the very best shots this is undoubtedly the right thinking. You may, however, be passing through with no possibility of returning to get a better picture of the location so you need to make the best of the limited opportunity. Accepting that you are unlikely to come up with any outstanding pictures, there are a few things that you can do to get something

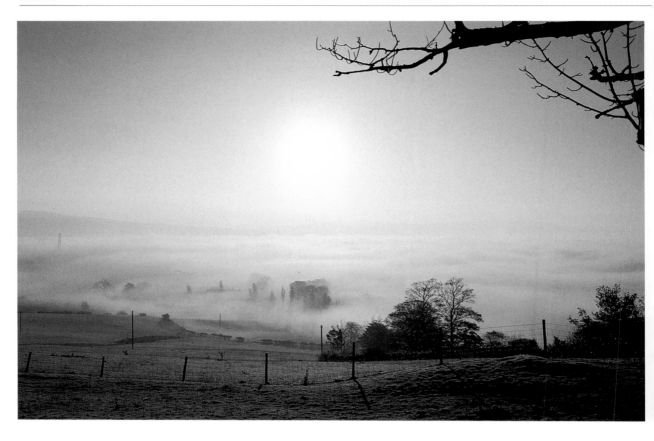

worthwhile. First, look for strong compositions that rely on colour and arrangement rather than shape and dimension. If there are clouds around, wait for patches of cloud shadow in the different areas of the landscape to break up the overall flatness. Use a lens hood to avoid any possible loss of contrast from glare. Filters also will help to eliminate the extreme blueness of midday light – a Skylight or even one of the stronger Wratten 81 series (see the section on useful accessories in the next chapter). This is a situation too when a polarising filter will help. Not only will it help to remove the blueness but it will also help to cut through distant haze, thereby improving colour saturation.

LONGER SHADOWS

Later in the afternoon in summer or throughout the middle of the day from October to March, the shadows are longer, the light is warmer and less harsh, but the air is often very clear. This makes for ideal conditions for those distant views that morning mist and midday haze may have impeded rather than helped. Although there are similarities to the morning light, that of late afternoon and early evening has a distinctive quality and the appearance of the actual landscape, whether urban or pastoral, is different, busier and more active in many ways. Scenics that include buildings are often suited by this quality of light, which brings out

saturated colours and strong shapes without excessively deep shadows. This quality will also suit many against-the-light pictures.

SUNSET

Few photographers can resist a beautiful sunset. Colourful, romantic, an attractive backdrop to almost any location, sunsets are a great stimulus to scenic photography. The low sun gives the whole sky and clouds a marvellous glow and brilliance. This is why the best sunsets occur after a storm or in unsettled weather when there is some interesting cloud around. The west coast of Scotland is especially famed for its sunsets precisely because of the changeable weather and the great cloud formations that result from this. In the mountains and canyons the low warm rays of the sun bring out the many subtle shades in the different strata of the rocks.

Technically, photographing sunsets is easy. The sky is the most important area and exposure needs to be based on this. Take a meter reading from the sky, being careful to ensure that the sun itself is not included in the area covered by the meter. This will give you an entirely acceptable result. If you bracket a half stop either side of this reading, these frames will be acceptable also – it will just look as though the picture was taken earlier or later. Any foreground subjects will

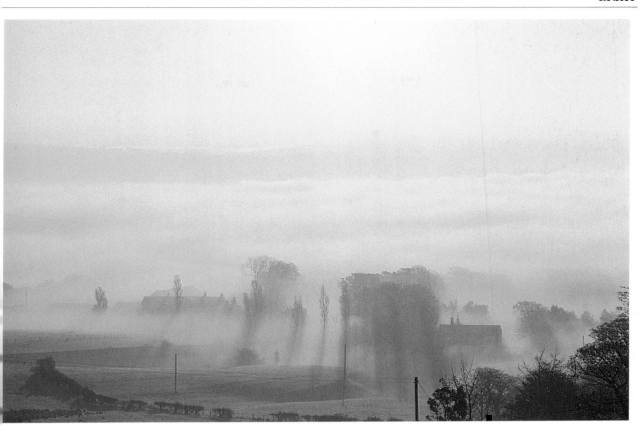

appear very much as a silhouette. Aesthetically therefore, the challenge with sunsets is to find interesting foregrounds that work satisfactorily in silhouette. A certain amount of preplanning can be helpful. Try to have one or two locations in mind before the sunset occurs. Then, as soon as it begins to look interesting, you can get into position without any waste of time. The best phase of a sunset does not last long; therefore you do not want to be running around still trying to find the right viewpoint whilst the sun is disappearing below the horizon.

The sun itself will be included in the image so that there is some danger of reflections within the lens. This risk is highest in the early stages when the sun is much brighter. In this situation a lens hood will not help, but removing any filters will eliminate one likely source of reflections and sometimes you can partially hide the sun behind the branches of a tree or other foreground element.

DUSK

The twilight hour, the period immediately after the sun has dropped below the horizon, is another opportunity for marvellous atmospheric pictures. Immediately after the sunset the afterglow and the high clouds still catching the sun's rays make for fascinating skies. There will be little detail in the landscape itself, but the sky

View from Werneth Low, Cheshire

The valley had a carpet of fog and I knew that there must be a good picture around as I came out of it on the road over the hill. My first effort with a medium wide-angle lens incorporated some darker foreground in order to emphasise the effect. The later shot with a medium tele lost this contrast but gave a more satisfactory composition. Again the exposure was tricky and I bracketed to be sure of getting the best result.

(Above left) *Leica M6, 35mm Summicron, $^1/_{125}$sec f4, Kodachrome 25 Professional.*

(Above right) *Leica M6, 90mm Summicron, $^1/_{250}$sec f2.8, Kodachrome 25 Professional.*

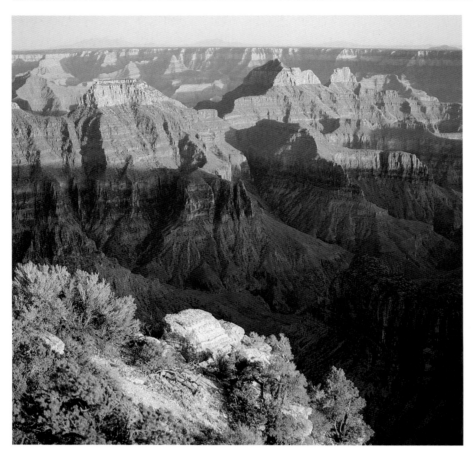

Evening, North Rim, Grand Canyon, Arizona

Compare the lighting here with that in the following two pictures. The low evening sun brings out the colours in the rocks and the longer shadows give them shape.

Hasselblad, 80mm Planar, ¹/₁₂₅sec f4, Ektachrome 100 Professional.

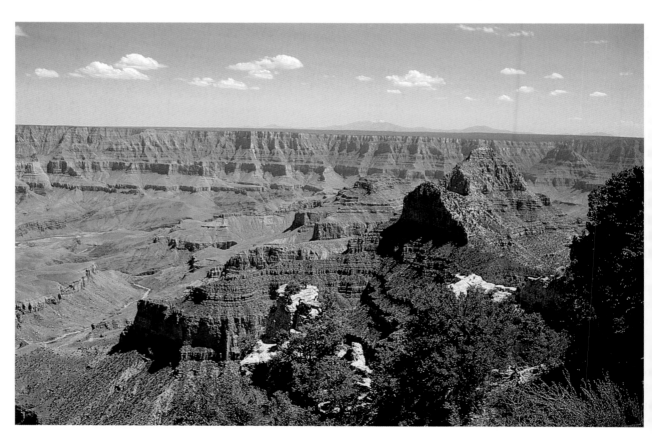

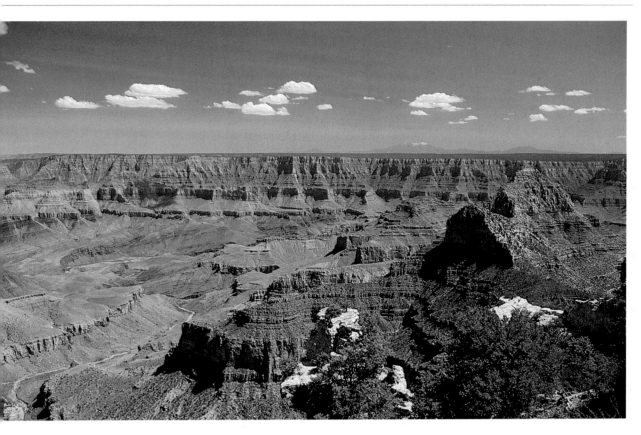

North Rim, Grand Canyon, Arizona

In the middle hours of the day, the light is rarely very good for photography. It is flat, rather blue and often hazy. However, I was not expecting to be able to return to this particular viewpoint and in order to make the best of the situation I fitted a polariser. As well as deepening the blue of the sky — thereby emphasising the white clouds — note how the polariser has cleared some of the haze and improved contrast so that the San Francisco Peaks, near Flagstaff some fifty miles south, are much more clearly visible and also how the shadows on the South Rim across the canyon are clearer and much less blue.

(Below left) *Leica M6, 35mm Summicron, ¹/₂₅₀sec f5.6, Kodachrome 25 Professional.*

(Above) *Leica M6, 35mm Summicron, Polariser, ¹/₁₂₅sec f4/5.6, Kodachrome 25 Professional.*

(Overleaf)
Bowness-on-Windermere, Cumbria

The low light of late afternoon in October beautifully picks out the boats, which provide interesting reflections in the water. The light was sneaking between heavy banks of cloud that helped with the mood of the scene.

Leica M4-P, 35mm Summicron, ¹/₁₂₅sec f4, Kodachrome 25.

can be caught reflected in stretches of water, lakes, rivers etc to great effect. There may be a big difference in brightness between sky and other areas, and this is a situation when a grey graduated filter can be particularly helpful in evening up the tonal variation.

Dusk is also the best time to take 'night' shots of urban and industrial scenes. Whilst there is still some natural light around it will be possible to record a certain amount of detail in the general view, without having to give so much exposure that the lights in the windows of buildings or street lighting are burned out and devoid of their detail. Except in very brightly lit city areas like Las Vegas, you are still likely to be into exposures that really require a firm support for the camera, but with a good quality f2 or f1.4 lens on a 35mm camera and even a medium-speed film, hand-held photography is always worth a try at quite slow speeds. Results may not be absolutely pin-sharp, but with care and maybe judicious steadying from a railing or wall, you can often get acceptable results at ¹/₃₀sec with an SLR and even lower with a non-SLR such as a Leica 'M' or one of the better compacts. Do not forget with a compact to use the button to switch off the automatic flash. Also, if there are very bright lights in the field of view it is worth removing any filter in order to avoid annoying reflections.

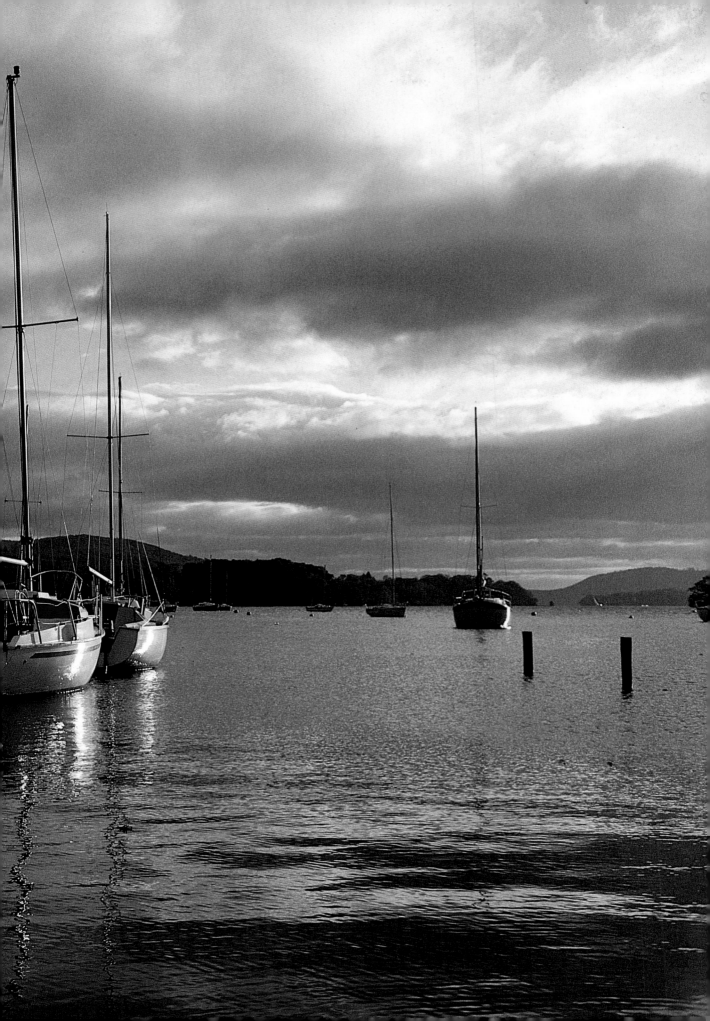

Sunset, Stockport, Greater Manchester

No photographer can resist a good sunset. The trick is to find foreground material that is interesting, yet works naturally with the sunset. As this will be almost in silhouette you need to choose strong shapes. I found this viewpoint and then waited for a train to cross the viaduct.

Leica, 50mm Summicron, 1/60sec f4, Kodachrome 25.

Early spring, Astbury, Cheshire

Astbury is well known for the spring daffodils on the village green. I had worked out the right time of day and it was just a case of waiting for a good day in early spring. A wide-angle perspective control lens enabled me to keep the flowers dominant with a low viewpoint whilst avoiding converging verticals on the buildings.

Leica RE, 28mm PC Super Angulon, 1/30sec f8, Kodachrome 25 Professional.

WEATHER AND SEASONS

The way that light is affected by the time of day and the time of year is predictable. A factor that is much less predictable is the weather. For the photographer this unpredictability and therefore the variability is a great plus, as unusual and spectacular lighting resulting from rapidly changing weather conditions always makes for exciting landscapes. Scenes that are quite ordinary on a normal sunny day can become unexpectedly beautiful or dramatic after a fall of snow or seen brilliantly lit against the backdrop of an approaching storm. Occasional patches of sunlight in an otherwise gloomy countryside can offer enchanting pictures. One of the most important elements in a landscape is the sky. Infinitely variable and endlessly fascinating, skies are the visible indications of air movement, temperature and changes of pressure and humidity. These are all consequential manifestations of changing weather patterns, and just like aircraft pilots or sailors keen scenic photographers will look to have a basic understanding of meteorology so that they can read the skies and appreciate the implications of weather reports. They will more easily be able to

anticipate changes in the weather and the sky as well as how these might provide opportunities for more interesting pictures.

MIST

Early morning mist is generally the result of a high-pressure weather system with very light winds and clear overnight skies. When the air temperature drops overnight, it is unable to hold as much moisture and this condenses out in the form of mist, most commonly over water or low-lying damp areas or collecting in valleys sheltered from the wind that could disperse the mist. Once the sun rises the air is warmed and unless it is very thick the mist will soon disappear so that you will often need to anticipate and be prepared for photography even as early as the dawn. Late spring and early autumn are the most likely times of the year for these conditions, but certainly in Britain early morning mist can occur at almost any time of the year.

COLD FRONTS

For spectacular clouds and exciting storms highly unstable air is needed. This commonly comes with the passage of the cold front of a classic depression. The lower the pressure in the centre of the depression, the more unstable the air and the stronger the winds. Very unstable air leads to the development of cumulonimbus clouds (thunderheads) with heavy showers of rain, hail or snow, thunder and lightning. These are conditions when you ought to be out with your camera. The light might be fleeting, but select your view and be patient for patches of sunlight against a sombre background. The clouds can be awe-inspiring and the air is freshly washed and clear. You will of course need some luck to get your picture, but this is part of the fascination of landscape photography – trying to capture a magical unpredictable moment that no one else will ever be able to repeat!

The white fluffy clouds typical of a lazy summer day are cumulus. These clouds are caused by convection from uneven heating of the earth's surface. They are in fact the top of a rising bubble or column of warm air and mark the point where it has condensed out in the colder upper air. This rising bubble of air is the thermal beloved of glider pilots, who use it to gain height. Flying from cloud to cloud allows gliders to travel amazing distances – hundreds of miles in favourable conditions. You will even sometimes see a 'street' of cumulus clouds downwind of a source of warm air such as a power station. Glider pilots are also very familiar with another type of cloud that forms above and in the lee of high mountains. These are the so-

Little Moreton Hall, Cheshire

This building is owned by the National Trust and is the finest remaining example of an Elizabethan moated manor house. Using an ultra-wide-angle lens, I was able to include the building and moat, and the light foliage of early spring did not obscure them.

Leica M4, 21mm Super Angulon, ¹/₁₂₅sec f5.6, Kodachrome 25.

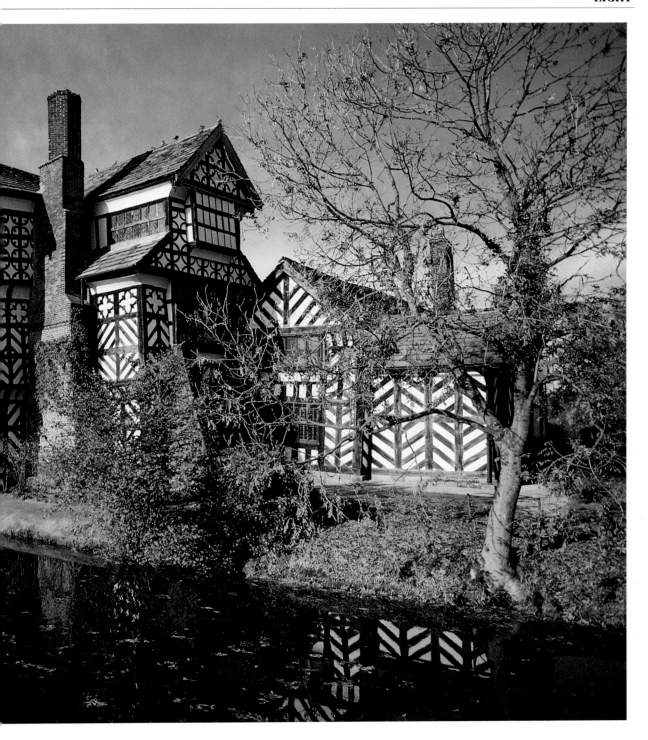

(Overleaf)
Winter, Little Moreton Hall, Cheshire

I had always wanted a 'different' shot of the hall but it was nearly three years before the conditions that I had been looking for coincided with some available time. One clear Sunday morning after a heavy overnight frost and a light dusting of snow, I got my chance!

Leica M4, 21mm Super Angulon, ¹/₁₂₅sec f4/f5.6, Kodachrome 25.

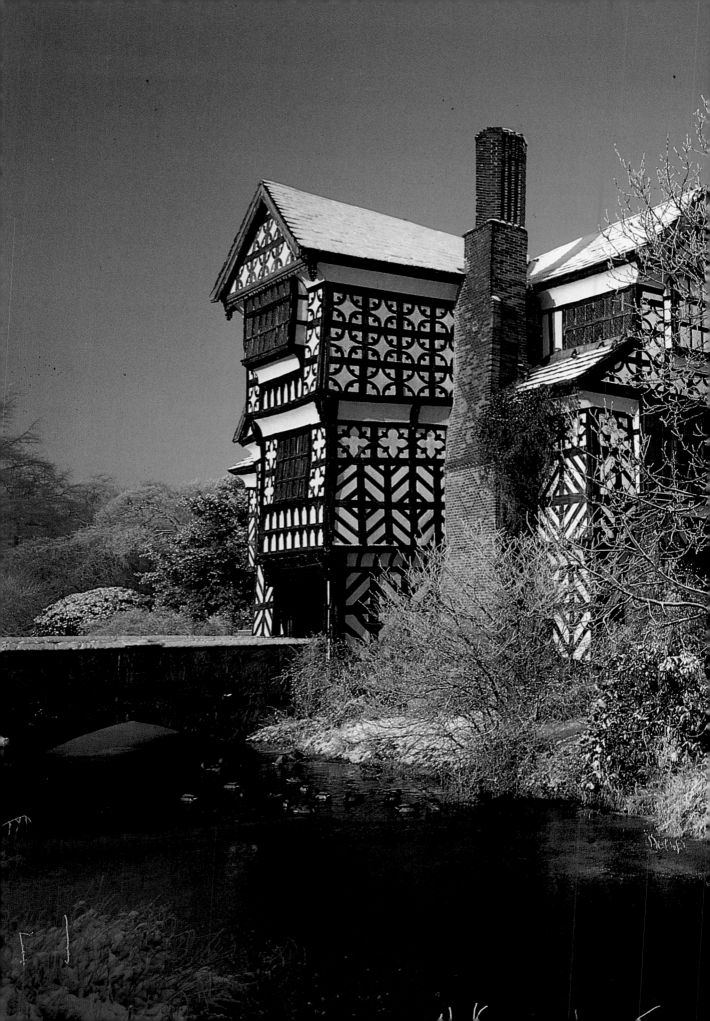

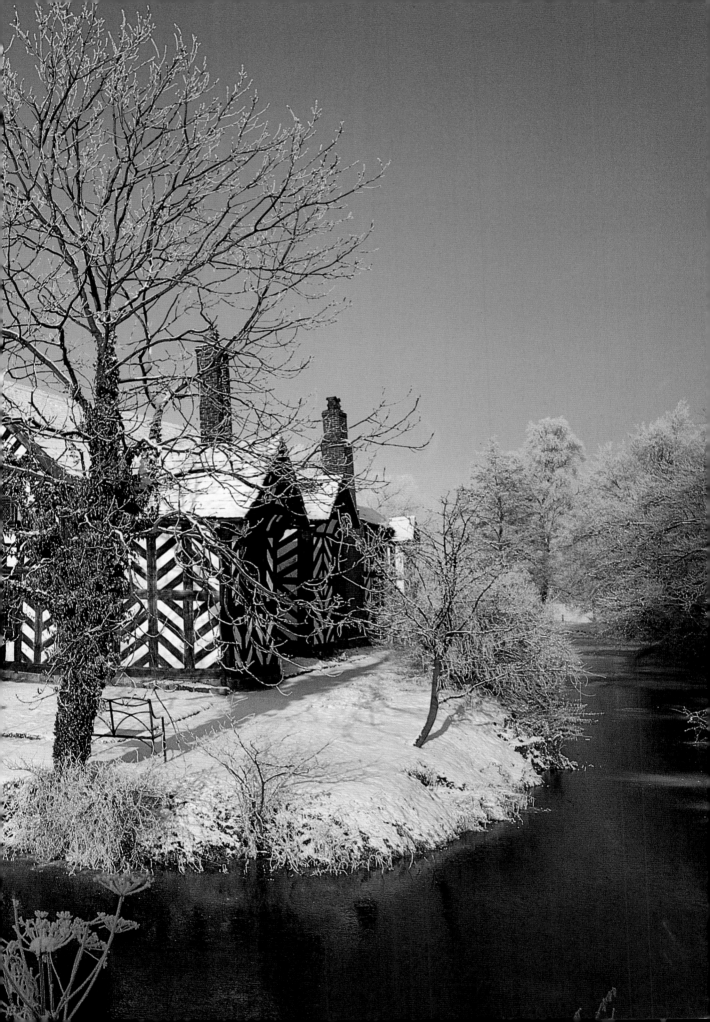

called lenticulars, altocumulus clouds that hardly move in spite of the very high winds that create them. What happens is that the air flowing over the mountains acquires a wave motion. Although the air is moving, the peaks and troughs of the wave are in a constant position. Cloud forms where the air is going up and disperses when it is going down so that it stays in more or less the same place. Glider pilots know where to find their lift, landscape photographers know that if the cloud is in the wrong place they are in for a very long wait!

FROST AND SNOW

When winter comes, frost and snow can completely transform any landscape. The ordinary can look special, the dull can look exciting and an attractive well-known scene takes on a completely fresh appearance with a crisp white mantle.

Clear overnight skies with a sharp drop in temperature are the conditions for a heavy frost. You need to be prepared, ready to work quickly, once the sun is up and before the best effects are lost as the frost melts. Against-the-light shots are often particularly appealing with attractive rim-lighting on grasses, trees and other foreground objects set against strong shadows. The frost that comes with freezing fog can be particularly heavy and if you are in the right place as

Thunderhead

The typical cumulonimbus has a characteristic anvil shape and the top of the cloud can reach an altitude of over 20,000ft. They are moody and magnificent and quite dangerous to aircraft.

Leica M6, 35mm Summicron, ¹⁄₁₂₅sec f4, Kodachrome 25 Professional.

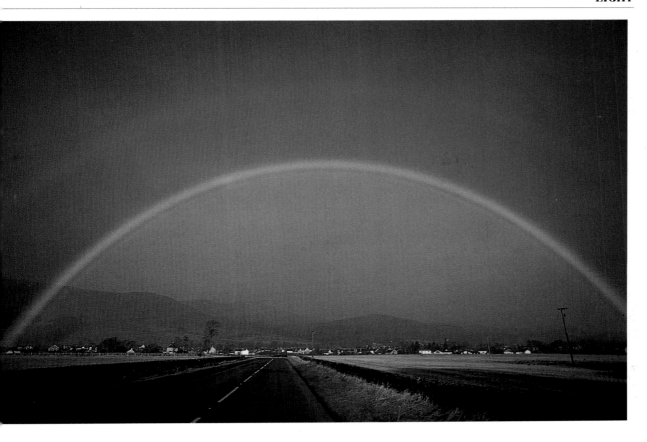

Rainbow, Dollar, Scotland

You have to be quick to catch a picture of a rainbow. The condition created by the sun shining through a rain shower rarely lasts very long and finding a suitable scene to use it with is not easy. You need a very wide angle lens to get it all in. Even with the 21mm used here I did not quite make it. Care needs to be taken not to overexpose and wash out the colours.

Leica R4 SLR, 21mm Super Angulon, ¹/₆₀sec f8, Kodachrome 64 Professional.

(Overleaf)
Autumn, Manhattan

Autumn scenes do not always have to be pastoral. This picture was made in the heart of Manhattan, using the backlit autumn leaves as a foil to the skyscrapers near to the Rockefeller Center.

Leica R4, 21mm Super Angulon, ¹/₆₀sec f8, Kodachrome 25.

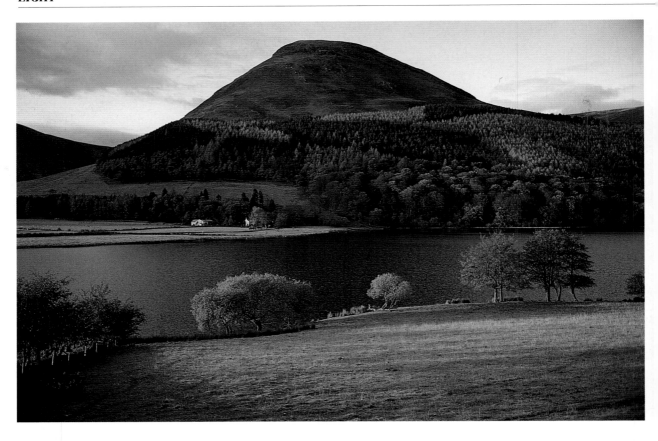

Autumn, Loweswater, Cumbria

The low light of a November morning highlights the autumn colours for which the Lake District is famous. After a light overnight frost the air was very clear.

Leica M6, 50mm Summilux, 1/125sec f2.8, Kodachrome 25 Professional.

the fog disperses there are great picture opportunities.

Snow scenes are best photographed immediately after a fresh fall. In fact, the best days are those when snow showers alternate with periods of sunshine – fluffy white clouds and deep-blue skies. Catch the snow before it melts and refreezes, is trampled down, or is blown or drops off the trees. Backlighting will emphasise the sparkling crystalline texture, thereby ensuring interesting pictures, and moving in close with an ultra-wide-angle lens will ensure that this can be seen sufficiently well whilst still holding the entire scene in sharp focus. Strong graphic designs can also be created even in relatively dull lighting. The contrast between the white snow and the other elements accentuates the composition, which is often best achieved with a medium- to long-telephoto lens.

SEASONAL WEATHER PATTERNS

Large land masses – North America, Continental Europe, Russia etc – tend to have relatively stable weather patterns and a climate with predictable seasonal variations. This is not true of coastal areas and islands where the pattern is tempered by the sea, its various warm and cold currents, and other major local influences. Even with a relatively predictable weather pattern with a land mass, mountains in particular have a highly localised effect.

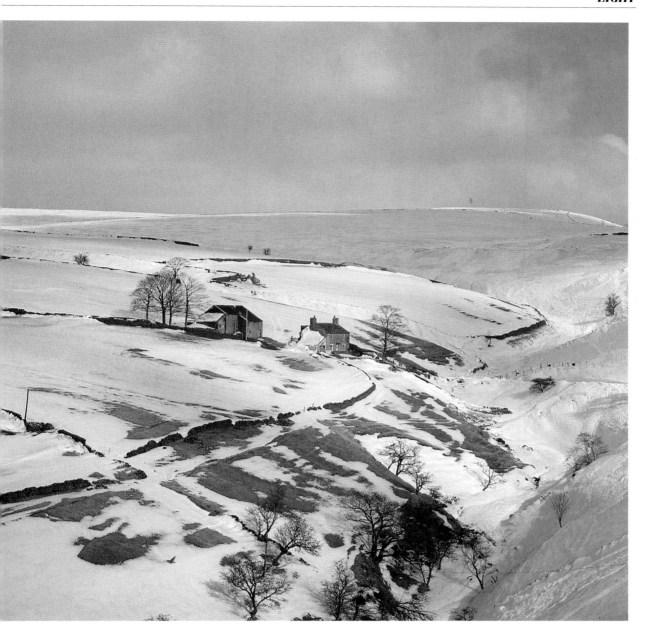

Betterfield Farm, Derbyshire

*A medium telephoto lens concentrates the detail in this shot of a
lonely farm in the High Peak.*

Hasselblad, 150mm Sonnar, ¹/₅₀₀sec f5.6, Ektachrome 100.

There is a joke in island Britain that there is no climate, just weather. When you consider that on the same day within a radius of 250 miles (400km) you can have blustery weather with heavy rain on the west coast of Scotland, a warm pleasant day on the beach in Wales, a low cloud obscuring the Welsh mountains and a hot sticky day in London, you can understand this comment and appreciate the influences of oceans and mountains.

Elevation too has an enormous effect on weather and particularly on temperatures. Arizona has been known to record in the same day both the highest and the lowest temperatures in the USA. This is because within the 400 mile (650km) north–south stretch of the state there is a change in average elevation from near-sea-level (Phoenix) to 9,000ft (2,700m) in the north (Grand Canyon North Rim and Kaibab plateau) and 6,000ft (1,800m) in the south.

SUMMER STORMS

Just as in the case of the highly unstable air of a cold front, in certain circumstances the convection currents that create summer cumulus clouds can get out of hand. Especially in areas with high humidity and powerful sun the cumulus can grow into the cumulonimbus. In fact, in some regions there is a regular cycle throughout the day as the earth warms, the clouds grow, there is a storm and the air clears ready for the process to start all over again. On one trip I made through the Carolinas, Georgia and Florida in the early summer, this happened every day in the afternoon, so that I always seemed to arrive at the hotel in the middle of a storm!

Spring and autumn are the times when the major weather patterns are on the change. Add these global changes to the myriad local factors and you have a recipe for variety and the unusual that every landscape photographer should be ready for. Nature is so capricious that the forecasters will often get it wrong and sometimes hunch plus some local knowledge is worth following. I recently spent a marvellous autumn morning taking pictures by Wastwater in the Lake District. The forecast was for cloud, wind and some rain. The cloud was there all right, but every so often there were breaks with patches of sunlight chasing across the lake and the hills. With the autumn colours who could ask for anything more, even though it did mean lots of patience waiting for the light to be in the right place and then some very quick camera work. All very much in tune with Monet's view that the landscape 'lives by virtue of its surroundings, the air and light, which vary continuously'!

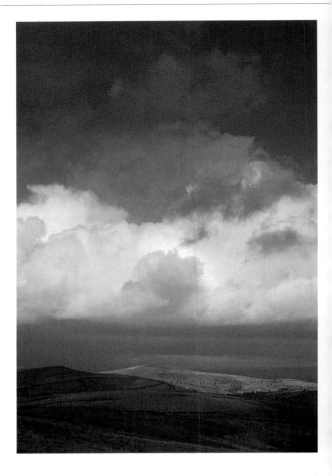

Cloudscape, Derbyshire

Clouds building up over the hills of the Peak District presage a coming storm. This can be great weather for exciting landscape photography, provided that you are wearing the right clothing!

Leica M6, 35mm Summicron, ¹/₂₅₀sec f4, Kodachrome 25 Professional.

Heavy frost

Freezing fog leaves a heavy deposit of frost on trees and other objects. When the fog clears it can make fascinating pictures. You may need to work quickly to catch it before the sun melts the sparkling crystalline structure.

Leica M6, 35mm Summicron, ¹/₆₀sec f5.6, Kodachrome 25 Professional.

6

CAMERAS AND ACCESSORIES

It is possible to take good scenic photographs with almost any camera, but there is no doubt that it is much easier with some than with others and for certain purposes specialised professional equipment is essential.

If you are looking to sell your work commercially for reproduction in calendars, travel brochures, books and magazines, first-class technical quality is a prerequisite. In this respect, at least in theory, the larger the format the better. In practice this is manifestly not so. Many very successful published photographers work only with 35mm. With good equipment, meticulous technique and the right choice of film material, '35' can compete and it is only in certain critical applications that the advantages of a larger format will be overwhelming. Many times, however, the choice of equipment will be dictated as much by the photographer's preferred subject matter and philosophical approach to image making as pure technical considerations. Different formats and camera types tend to go with different styles, and it is sometimes debatable whether photographers choose a camera because it suits their style or whether their style changes to suit the camera!

Whichever format is chosen for serious landscape photography, some degree of lens interchangeability is practically essential as is precise control of lens aperture, shutter speed, exposure and focus. Thus for cameras with auto-exposure and/or autofocus some facility to override manually or lock settings is required.

35mm FORMAT

Current 35mm cameras fall into three categories: the so-called compact, single-lens reflex and precision rangefinder.

COMPACTS

The most popular of all cameras now are the relatively inexpensive compacts, which generally have autofocus, auto-exposure control, auto-flash, and at the higher end of the price scale either a zoom lens or the facility to switch between wide-angle and telephoto. Additional features will include some override on the automatic flash, an extended zoom range and/or closer focusing. A compact is ideal as a light, easily carried, go-anywhere camera. This has the advantage that you will be encouraged to always have it with you when you would not bother carrying more sophisticated equipment. It has to be said, however, that if you are serious about landscape photography and you want to produce big prints (eg over 10×8in) or shoot transparencies, the optical quality, the focusing precision and the exposure accuracy are unlikely to be adequate. Most important of all perhaps, very few have any manual override and the lack of controllability becomes a serious problem.

SINGLE-LENS REFLEX

Outside the studio the 35mm single-lens reflex (SLR) has become a standard working tool of most professional and serious amateur photographers. There is an enormous range available in terms of construction and optical quality as well of the degree of automation. The 35mm SLR is undoubtedly the most versatile and highly developed of all cameras. A bewildering range of lenses is offered, with many from the leading manufacturers of outstanding quality and at the leading edge of optical technology. A choice of accessories and film material to meet any need is available too.

For landscapes a high degree of sophistication is not needed and as with the compacts too much automation can become a hindrance rather than a help. The essential requirements are sound construction, good-quality lenses, an accurate metering system and a good focusing screen to allow easy composition and accurate focus. Auto-exposure and autofocus are fine, provided that you can manually override without difficulty. If you are working to a budget a reliable manual camera (perhaps with aperture priority auto-exposure as well as manual) is a good bet. Useful features to look for with particular relevance to landscape are a stop-down lever to enable you to preview depth of field and the facility to interchange focusing screens which will allow you to substitute a plain ground glass. This screen is much better for composition and depth-of-field viewing, especially if it is the version with horizontal

and vertical lines to form a grid. The grid helps further with composition and with keeping the camera level – no sloping lakes and horizons!

Whichever SLR you choose, make sure that a range of good-quality lenses is readily available. With wide-angle lenses in particular, remember that prime lenses rather than zooms are desirable for best quality. Clear detail and good clean-colour rendition are much more important in landscapes than is often realised.

PRECISION RANGEFINDER

The one other type of 35mm camera that should be mentioned is the modern version of the grandfather of all 35mm cameras, the Leica with a coupled rangefinder and interchangeable lenses. The current model, the Leica M6, is hardly bigger than many compacts but its precision, outstanding optical quality and general robustness are legendary. It is a fully mechanical, manual camera. Only the metering system is battery operated, and the camera is fully functional without this.

The M6 is the professional tool of many leading photojournalists, but for the landscape photographer who hikes or climbs or visits remote places, the compactness and relatively light weight of the camera and lenses as well as the utter reliability and non-dependence on batteries (except for metering), are a

Lake Lugano, Switzerland

This view of one of the many pretty villages along the lake was taken from the ferry boat. Technically this picture is very straightforward and could have been made with almost any camera, whether a simple compact or a highly sophisticated modern SLR. Landscape photography calls for input from the photographer and an understanding of light rather than high-tech equipment.

Leica M4, 35mm Summicron, $\frac{1}{125}$sec f5.6, Kodachrome 25.

(Overleaf)
Bryce Canyon, Utah

A medium-format shot. The great advantage of medium- and large-format cameras is that, other things being equal, the larger film area will always provide higher quality. There are disadvantages, however, in terms of portability and flexibility in the choice of lenses – not to mention cost. All is not equal as the excellent work that many landscape photographers produce from 35mm demonstrates.

Hasselblad, 50mm Distagon, $\frac{1}{500}$sec f8, Ektachrome 100.

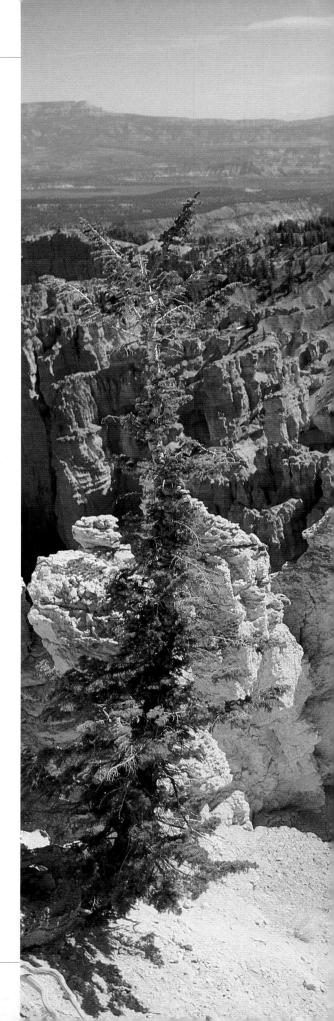

boon. The disadvantages are the limited range of lenses (21–135mm), a direct-vision viewfinder that gives no indication at all of depth of field, and by SLR standards a somewhat limited close-focusing capability. In practice, however, the range of lenses is usually entirely adequate for landscape and travel photography. My own experience has been that, when travelling, over 90 per cent of my photographs in 35mm format are made with only three lenses – the 21, 35 and 90mm – and most of the rest with the 50mm. The Leica 'M' line includes some classics in these focal lengths.

MEDIUM FORMAT

Medium format is generally taken to mean cameras using 120 roll film. This provides a variety of formats: 6×4.5cm (15 or 16 frames per roll), 6×6cm (12 frames per roll), 6×7cm (10 frames per roll), 6×8cm (9 frames per roll), and 6×9cm (8 frames per roll). Naturally the larger the format the bulkier the camera. A 220 size film can also be used in some types, which double the number of frames available per roll. The most popular size is 6×6cm, which gives almost four times the available area of the 35mm format with consequent opportunity for higher image detail and tonal quality.

Camera types are single-lens reflex, rangefinder, and twin-lens reflex. The latter is like two cameras on top of each other, one of which is used for viewing and the other for taking, thereby avoiding the necessity for a mirror that swings out of the way when taking a picture as in a single-lens reflex.

The single-lens reflex is exemplified by the Pentax, Mamiya and Bronica models and the renowned Hasselblad. These cameras have interchangeable lenses (some with built-in shutters) and most models have convenient interchangeable backs that can be changed in mid-roll to allow the use of different films. Most also have a back available that accepts Polaroid film, which is very convenient for test shots in difficult lighting situations. The Pentax 6×7 by contrast is more like a vastly overgrown 35mm SLR. Its operation is therefore more familiar, but it lacks the interchangeable backs and some other conveniences of the more conventional medium-format SLR.

All the above roll-film cameras really need to be worked from a tripod. Hand holding is possible, but accurate focusing and shake-free exposures are not so easy as with 35mm. Operation is therefore much more deliberate and the style becomes careful and thoughtful.

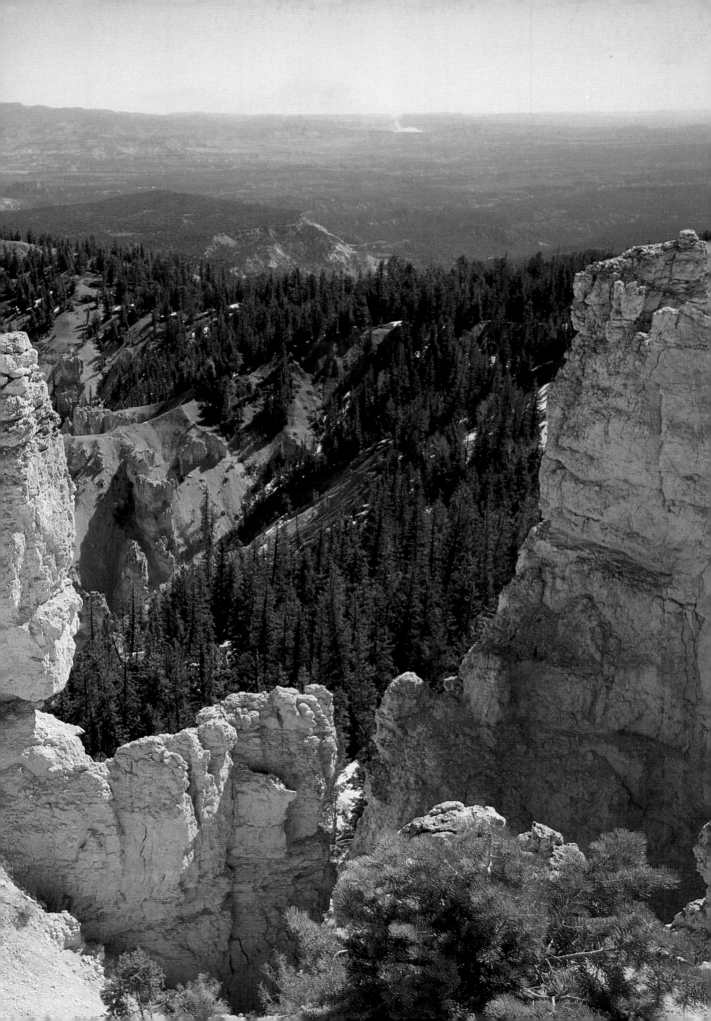

The Linhof range of view cameras is very highly regarded, The one shown here is the Kardon E monorail.

Rolleiflex twin-lens reflex cameras were for many years the top professional 6×6cm model. Although mainly superseded by SLR types they are easy to handle and capable of top-quality results.

The Leica M6 is a robust high-precision compact 35mm camera with interchangeable lenses that couple to the built-in rangefinder for extremely accurate manual focusing. The lenses shown — 35mm f2, 50mm f1.4 and 90mm f2 — are an excellent landscape outfit.

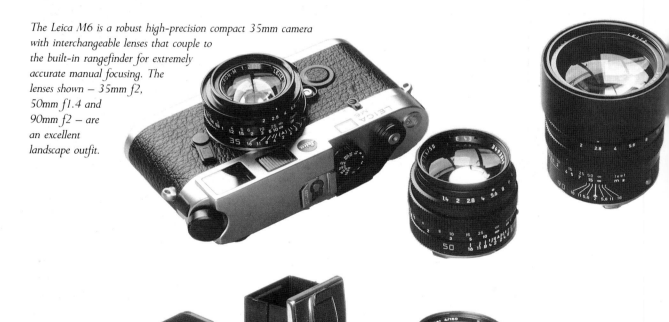

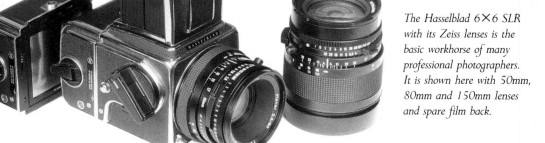

The Hasselblad 6×6 SLR with its Zeiss lenses is the basic workhorse of many professional photographers. It is shown here with 50mm, 80mm and 150mm lenses and spare film back.

Specialist panoramic cameras for medium format are the Fuji 617 and the Linhof Technorama seen here.

The Canon EOS 5 is a fine example of a modern hi-tech 35mm SLR with highly sophisticated autofocus and auto-exposure systems.

Minolta's Riva series of compact 35mm cameras is a popular choice in its class.

In landscape photography this is usually no bad thing, although there have been fast-changing situations during the course of using a Hasselblad when I know that I could have got half-a-dozen frames in with my Leica before I had shot one on the bigger camera!

If you wish to work more quickly in medium format, a rangefinder (CRF) or twin-lens reflex (TLR) is the answer. Although there are exceptions these do not generally have interchangeable lenses. The classic TLR, the Rolleiflex, now has a standard focal-length lens only, but some of the rangefinder models are available with a wide-angle lens as an alternative. My first professional-quality camera was a Rolleiflex and I have a very soft spot for this design. There is much photography for which it is ideal, even with its limitations, but for landscapes a wide-angle lens is often more useful. Fuji have an excellent 6×9cm rangefinder model with a wide-angle lens. They also produced a particularly good 6×4.5cm (645 GSW). Unfortunately this has been discontinued, but you may still find one with a dealer or even a good second-hand one.

LARGE FORMAT

The classic view camera, so called because you first have to view the image on a ground-glass screen before inserting the film in its holder, has been the preferred tool of many famous landscape photographers. The image quality that is available from larger formats is incredible, but a high level of technical ability is required and you have to be fairly dedicated to carry one around for outdoor work.

The most popular formats now are 5×4in and 10×8in. A good range of film types is available in these two sizes, but you are likely to find your choice of material rather restricted in others.

Most view cameras are designed for studio photography. The best known is the monorail type exemplified by the Sinar, the Linhof, the Toya and others. In these types the front standard which carries the lens and shutter and the rear standard which accepts the ground glass for focusing or the film holder are fixed to a metal bar (the rail) and connected by a light-tight bellows. The advantage of a monorail is the incredible versatility it gives the photographer to tilt, swing, or raise either the front or back standard, allowing, for example, perspective correction of verticals and manipulation of the plane of focus.

Other types of view camera have the front and rear standard mounted on a flat 'bed' of wood or metal. The

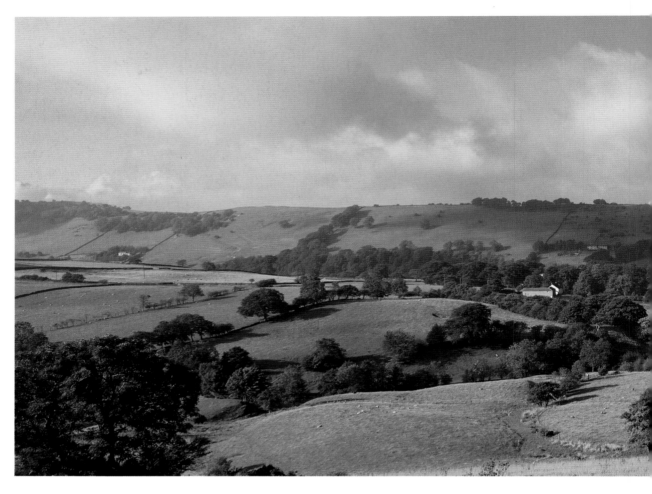

White Nancy, Bollington, Cheshire

To include the whole of this view of White Nancy, a folly on a small hill on the edge of the Peak District, together with the Cheshire Plain beyond required an extremely wide angle lens (110°). It would have been difficult to make a satisfying composition other than in a panoramic format as there would have been an excess of sky and foreground. With such a wide angle, extreme care is needed to keep the horizon level, and the built-in spirit level on this particular camera was a great help. A neutral density graduated filter was used to combat vignetting and the camera was mounted on a tripod.

Fuji 617, ¹/₁₂₅sec f11, Fuji 100 Professional.

range of movements is more restricted (although it is still more than adequate for most purposes), but most important, when the lens is removed, the whole camera can often be folded into quite a compact box-shaped unit which is reasonably portable. Hence this type is often called a field camera.

With a view camera, focusing is carried out on the ground-glass screen the same size as the film format. The image is upside down and reversed left to right and it is necessary to work with a dark cloth to help keep light off the screen and thereby facilitate viewing the image. Once composition and focusing are complete the ground-glass screen is replaced by a sheet of film. These sheets of film are carried in light-tight holders containing either one sheet (single holder) or two in a back-to-back arrangement (double holder). Some sheet films are also available in 'ready load' packs of ten sheets which fit a special holder and obviate the need for darkroom-loading individual sheets into the single or double holders.

It will be obvious from the above that the large-format camera is no easy option for the landscape

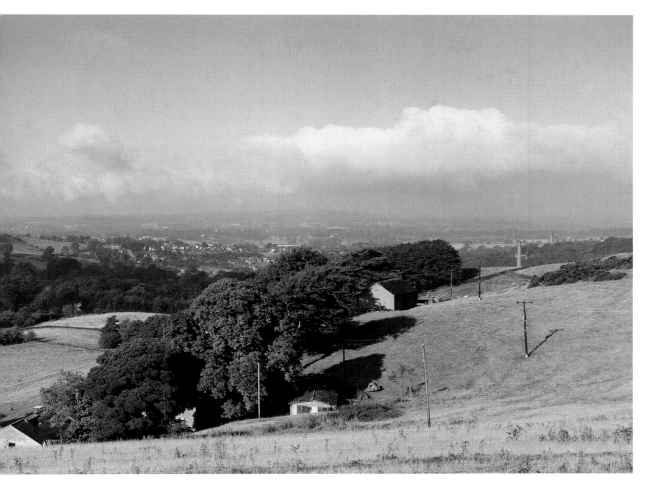

photographer, but there is no doubt that the quality of image that can be achieved with skill and dedication is quite stunning. For those with access to these cameras the result can be some of the most worthwhile landscape photography of all.

PANORAMIC CAMERAS

The panoramic view has long been a challenge in landscape photography. The human eye scans a scene continuously, taking in the whole view, but the brain ignores the areas that are irrelevant to its purpose. Just using an ultra-wide-angle lens and a normal format for the large view will usually result in a massive excess of sky and a hugely uninteresting foreground that is not at all as the eye sees it. The answer can be a special panoramic camera. Already some of the compact-camera manufacturers are offering versions that in effect mask off the top and bottom of a 35mm frame to give a pseudo-panorama. Fuji and Kodak too have introduced 'throw away' cameras providing a similar format. These are fun to use and quite surprisingly effective.

More seriously there are cameras designed specifically to produce true panoramas with an angle of view of $100°$ or more, of professional quality. Using 35mm film the Widelux gives a 24×59mm image, taking in a viewing angle of $140°$ by rotating its 26mm lens through an arc during the exposure.

More conventionally the Linhof Technorama gives a format of $2\frac{1}{4}×5$in – and an angle of just over $90°$ from a conventional 65mm lens. The Fuji 617, which also uses 120 size film, goes even better, as the 65mm lens used gives a viewing angle of $100°$. To compensate for vignetting on such a wide-angle view, a special graduated neutral-density filter is used which is darker at the centre than the edges.

All these cameras have to be used on a tripod and a spirit level is necessary to ensure that they are correctly levelled as this is in fact difficult to judge with the direct-vision viewfinder usually fitted to these specialist cameras.

USEFUL ACCESSORIES

Camera manufacturers and the many independent suppliers offer a seemingly unending variety of accessories. Some are absolutely essential for particular needs, eg extension tubes and bellows units for close-up photography and motor drives for sports photography, whilst others can make photography more convenient – special grips, motor winders, automatic flashguns etc. Landscape, however, is very undemanding; with the exception of large-format view cameras, you can produce first-class pictures without any equipment other than camera and lens. No accessories are absolutely essential and those that are genuinely useful are few in number.

TRIPODS

Perhaps the single most important accessory is a good tripod. With most large-format cameras the tripod is in fact a necessity. These cameras can be used in no other way so that a strong rigid support is really part of the equipment and not an accessory. Obviously for fieldwork the solid, heavy-duty studio types with dollies and massive heavily-geared centre columns are not practical, but there is no point in putting a heavy camera on anything that is not up to the job. If you wish to be successful with large format, give careful thought to your choice of tripod. It is a very important piece of equipment for you; it has to be very strong and rigid yet needs to be reasonably portable. Some makes worth looking at are the professional heavy-duty models in the Bogen, Gitzo, Slik and Manfrotto ranges. Ensure also that you buy an equally robust adjustable head for the tripod, whether pan and tilt or ball and socket.

Most medium-format cameras are at their best on a stand in the studio and even outdoors the majority of experienced photographers still prefer to work with them on a tripod. The same advice applies as with large format. Get the strongest and most rigid support that you can, compatible with portability. A wobbly tripod is worse than none; you might as well save yourself the trouble of carrying it, and adjust your technique and select subject matter that allows you to shoot hand held without risking camera shake. Many of the medium-format pictures in this book were taken hand

The table tripod is a most useful and easily portable support for 35mm and the smaller medium-format cameras when you wish to travel light.

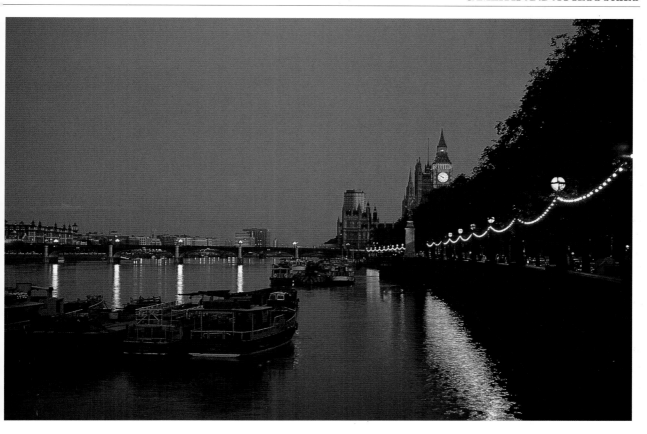

held with a Hasselblad, but you will notice from the caption details that I have used high shutter speeds of ⅟₅₀₀sec or ⅟₂₅₀sec wherever possible, even with standard and wide-angle lens, with correspondingly wide apertures. The tripod I use for medium format (and 35mm when one is required) is the Benbo.

This highly idiosyncratic design takes its name from the 'bent bolt' that locks up the legs and centre column. It is very strong, very rigid and relatively light, and has found favour especially with wildlife and landscape photographers who appreciate its robustness and adaptability to all sorts of rough ground conditions and subject locations. Other makes worth looking at are the previously mentioned Bogen, Gitzo, Slik and Manfrotto types, as well as the heavier-duty Velbon models. I use a large Leitz ball-and-socket head on my Benbo. A ball and socket is often more convenient in use than a pan-and-tilt head, but it has to be a strong, good-quality one if it is to be suitably firm. Benbo and Slik make good professional-quality ones.

My own feelings are that for landscape photography with 35mm the great majority of subjects can be photographed without a tripod and that by carrying and using one you negate the advantages of portability and freedom of movement that the smaller camera gives you. When you do need a tripod with 35mm, eg for night shots, working with long lenses or when

The Thames Embankment, London

For scenic photography in good light a tripod is rarely essential with 35mm or even medium-format cameras. It is usually possible to use a fast-enough shutter speed to avoid camera shake. For night photography some kind of support is essential. A small table tripod is often adequate and very practical when travelling but a strong, well-made and full-size tripod is an accessory that no landscape photographer should be without.

Leica M4, 50mm Summicron, ½sec f4, Kodachrome 64.

extreme depth of field is required, you need a good one – just as good as medium format in fact. The same advice and recommendations therefore apply.

Some photographers find a monopod a useful support for their 35mm cameras when a shutter speed becomes just a little doubtful for hand holding. It is no substitute for a tripod of course, but any help is better than none and a monopod is compact and easily carried. My own choice for an easily portable support is a Leica table tripod with their small ball-and-socket head. This collapses very neatly and will fit comfortably into any gadget bag. It is very rigid and can be set on top of or wedged against a wall or other convenient place and has proved a great asset when travelling light, especially for the occasional night shot. The small ball-and-socket head is no longer available and the large one makes the whole device rather clumsy. If you cannot find a second-hand one I can recommend the Minolta clone – the TR1 which is the Leica table tripod with a small built-in ball-and-socket head. The Leica and the Minolta are the only table tripods I have seen that adequately satisfy the serious photographer's demands for rigidity.

In all cases when using a tripod you need to be careful not to set off vibrations when releasing the shutter. Avoid this by using a cable release and one of adequate length (10in minimum, 18in preferable) to avoid transmitting movement to the camera. If you have no cable release with you a useful trick is to fire the shutter with the delayed action release, thus allowing any photographer-induced vibration to settle down before the exposure is made. Also if you are using an SLR and the camera allows it, lock up or release the mirror before firing the shutter. Most of the vibration in these cameras is induced by the mirror lifting. Medium-format SLR cameras in particular are vulnerable to this problem and it is worth taking trouble to avoid it.

A tripod helps careful composition, accurate focusing and avoiding camera shake, which is the biggest single enemy of sharp pictures. The conventional wisdom for minimum hand-holdable shutter speeds is 1/lens focal length – ie $\frac{1}{50}$sec for a 50mm lens. In practice this gives too slow a speed to be safe and I always reckon to use a shutter setting two or three times as fast – $\frac{1}{125}$sec for a 50mm lens, $\frac{1}{250}$ for a 90mm, and $\frac{1}{500}$ for a 200mm. If at all possible I will use even faster speeds, especially with medium format when I am generally using a faster film (ISO 100 compared with ISO 25 for 35mm) which allows this. Many photographers are ridiculously optimistic about speeds that they can hand hold, especially with longer

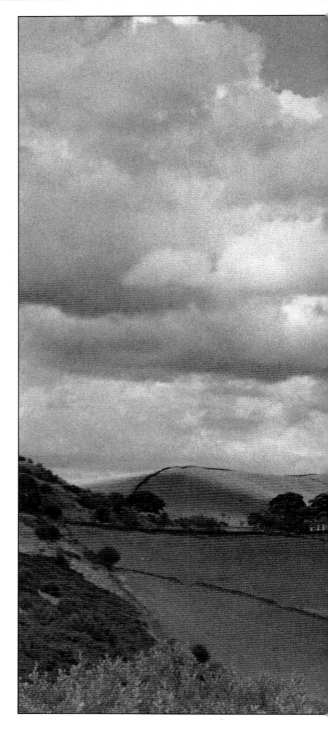

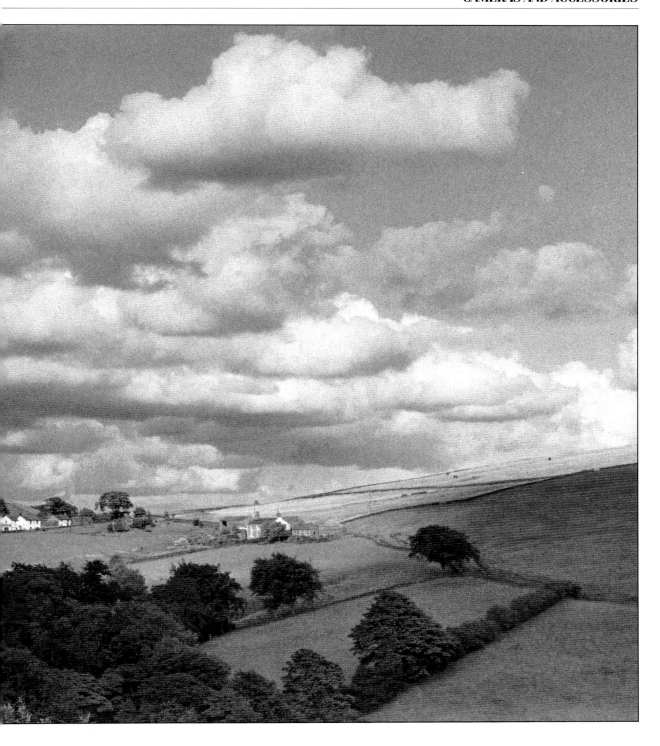

In black and white photography an orange filter strongly emphasises white clouds against a dark sky. Normally a two-stop increase in exposure is required. The picture shows Teggs Nose in Cheshire.

Leica M6, 50mm Summicron, ¹⁄₂₅₀sec f8, Kodak T Max 400.

Mono Lake, California

As well as a skylight or ultraviolet filter which also serves to protect the lens, the polariser is the most useful filter for scenic photography. It darkens blue skies to 'bring out' clouds and helps to penetrate haze and remove blueness in the landscape. Be warned that the majority of modern cameras require the slightly more expensive 'circular polariser'. This has nothing to do with the shape of the filter but is the way that the polarising material is structured so that it does not interfere with the autofocus and built-in metering system.

Hasselblad, 50mm Distagon, $\frac{1}{250}$sec f5.6/f8, Ektachrome 100.

focal-length lenses. A few comparison shots at different shutter speeds with and without a decent tripod will soon convince you of the need for high shutter speeds or a tripod. You will see the difference between apparently sharp results and really sharp ones! Remember that most prime lenses for 35mm cameras deliver optimum sharpness at around f4 or f5.6, so that you need to stop down with consequent slower shutter speeds only if you require extra depth of field.

FILTERS

Only a few filters are seriously essential for scenic photography although there is an incredibly wide selection, ranging from the occasionally useful to the downright gimmicky. The essential ones for colour photography are:

1. Ultraviolet or Skylight (Wratten 1A)
2. Wratten 81A or 81B
3. Polarising
4. Grey graduated.

GENERAL FILTERS

An ultraviolet filter holds back the wavelengths of light that cause distant scenes to appear blue, particularly at higher altitudes. A skylight filter (usually marked 1A or 1B) has a very slight pinkish or straw colouring which in addition to filtering distant haze will also help neutralize excessive blueness in shadow areas. This is most often evident on days with deep blue skies or on very dull days. The Wratten 1A is the true skylight filter, but other filters designated just 1A or 1B are equally effective although the colour transmission may be slightly different with the 1B being just a little stronger. It is common practice to leave one of these filters on the lens all the time (except when using another filter!), as a good-quality one will rarely have any adverse pictorial effect yet will serve to protect expensive lenses from rain, snow, dust and greasy finger-marks.

Wratten 81A and 81B filters (or other equivalents, eg Hasselblad 3R) have a much stronger warming effect. They are especially useful on very dull days or when the subject is entirely in the shade on bright days but with a lot of blue sky. It is a fact that generally the eye is much more tolerant of colours that are a little warm (pinkish) rather than cool (bluish) so that a tendency to err on the warm side is best. There are exceptions, however; an obvious example is snow scenes where the necessary chilliness could be destroyed if the naturally blue shadow areas were given a comfortable warm colour. Beware too of overdoing the elimination of the blueness of distant haze. The blueness is often needed to retain the effect of recession and depth within the different planes of the scene.

POLARISING FILTERS

The polariser is perhaps the most generally useful filter for scenic photography in colour. It is particularly effective in darkening palish blue skies, bringing out the clouds. It will also reduce haze and improve colour saturation in the landscape by eliminating some of the reflections of the invisible water droplets in the atmosphere and on plants and foliage. The polariser's effect of reducing or eliminating reflections may also be necessary if photographing rivers or lakes or other stretches of water when you wish to see something of what is just below the surface, eg weeds, reeds or even fish.

When used to darken the sky the polariser works most effectively at an angle of 90° to the sun. For this reason it is not advisable to use it with ultra-wide-angle lenses (eg wider than 28mm on 35mm cameras) as you are liable to find the sky darker on one side of the picture than the other. Another point to watch is that many cameras now have TTL metering and/or autofocus systems that will be confused if the wrong type of polariser is used. With these systems you cannot use a conventional 'linear' polariser and you must have a 'circular' one. This is nothing to do with the shape of the filter, but concerns the way the polarising material is structured. The effect of a polarising filter of both kinds can be seen as it is rotated and you can therefore choose just how much darkening or reflection suppression you require. This is important because overdoing the effect can give an unnatural feeling to a picture. Remember too to adjust the filter if you change from horizontal to vertical format. Also, in the case of many zoom lenses, the lens rotates when you focus so set the filter *after* focusing.

An exposure increase of up to two stops will be needed. TTL systems will take care of this automatically;

otherwise do not forget to compensate the reading from a separate hand-held meter.

GRADUATED FILTERS

A neutral-grey graduated filter can be especially valuable for those occasions when there is a considerable difference between the brightness of the sky and that of the landscape. Grey days and shooting against the light are examples. It helps to bring the contrast within the range that the film can handle, thus allowing adequate exposure to be given in order to retain detail and colour saturation in the landscape area.

Ideally the effect should be subtle and not overdone to the point that it is obviously unnatural. There is a tendency for some photographers to emulate the exaggerated effects demanded for television commercials, advertising illustrations, brochures etc. Often the most garish magenta and sepia or even worse multicoloured 'grads' are introduced. These and the results from other effects may be attention grabbing, but they rarely make for truly satisfying landscape pictures. Advertising images are one thing, but if a photographer feels that there is a need for 'effects' filters to make a satisfactory scenic image then the subject is probably not worth considering in the first place.

FILTERS FOR BLACK AND WHITE PHOTOGRAPHY

Of the filters discussed above, the polarising filter and the grey graduated are equally useful with black and white and with colour. However, there are others that are needed to correct the excess sensitivity to blue light which is a characteristic of black and white films. The most obvious effect of this tendency is that blue skies appear too pale and clouds do not stand out so well. The filter that will most accurately correct this is a medium yellow. Skies will look natural as will tonal values in the landscape.

A much stronger effect with darker skies and spectacular clouds as well as considerable haze penetration will be obtained with an orange filter and even more exaggerated results will be apparent with a red (No 25). This latter filter is also appropriate for use with infra-red film.

All these filters require extra exposure, and because TTL metering systems have an excess response to yellow and red light, readings should be taken without the filter and exposure actually adjusted to the filter manufacturer's recommendations. A reasonably close guide is +1½ stops for medium yellow, +2 stops for orange, and +3 stops for red.

LENS HOODS

Modern coating techniques have significantly reduced flare and reflections within the lens so that the need for a hood (sunshade to some) is not nearly as great as it used to be. Nevertheless it is always good practice to fit one and there are still situations where one will help quite noticeably. Lenses with a large number of elements, eg zooms and wide-angles, are particularly prone to diaphragm-shaped reflections as are some telephotos. These reflections occur when the sun is in the field of view or just a little outside it. If the sun or even its reflections off some water are in the picture the lens hood cannot help, but it can make a very big difference if they are just outside the field of view and the hood provides effective shading.

The most efficient lens hoods are carefully tailored to the lens angle of view and ideally are rectangular or square to match the film format. Most effective of all are the big adjustable bellows-type shades such as those offered by Hasselblad that can be precisely set to give maximum cut-off of extraneous light without intruding into the picture area.

A separate hand-held meter is necessary where the camera has no built-in metering system — as with view cameras and a number of medium-format types. Some very sophisticated models are available from Minolta and Gossen.

FILM

Maximum detail, smooth well-graduated tonal qualities, and clean accurate colour rendition – these are the characteristics a landscape photographer primarily looks for when choosing film for a camera. Fast films are rarely required so that the compromises that these sometimes represent can most often be avoided and a selection can usually be made based purely on the quality and style of image envisaged.

COLOUR NEGATIVE

With colour the first choice is between colour transparencies or colour negative. If you are not looking to sell your work for publication (eg in books, magazines, calendars and brochures) but mainly require prints for personal use or occasionally to enlarge for house decor or exhibition purposes, then negative film is the answer. It is less demanding in terms of exposure technique and it is easier and cheaper to get satisfactory prints both initially and when enlargements are needed. The great majority of photographs are taken on colour negative and there is an excellent selection of first-class films available from all the leading makers, with constant improvements being announced.

The slowest and, therefore, the sharpest- and finest-grained group of negative films have a speed of around ISO 100. This is plenty fast enough for scenic photography with any reasonable quality camera and a film from this group is a good choice. There are films in this group available from leading manufacturers such as Kodak, Fuji and Agfa which will provide excellent enlargements from 35mm and medium-format (120) negatives. Kodak's Ektar 25 is much slower (ISO 25), but is much the sharpest and finest grained of colour negative films. It is more critical in use and requires accurate exposure and careful camera technique with

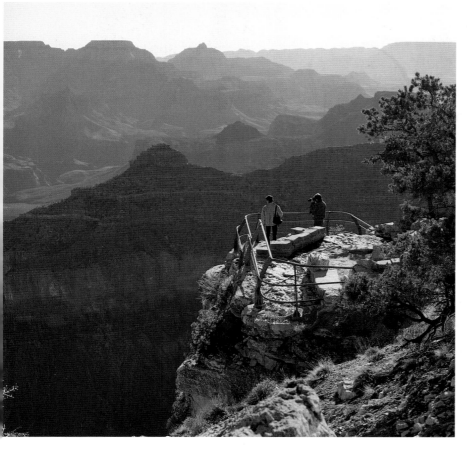

South Rim, Grand Canyon, Arizona

For much commercial work medium format is favoured with 2¼ × 2¼in, the most popular size. An ISO 100 speed film such as the Ektachrome 100 used here is ideal for scenic photography.

Hasselblad, 50mm Distagon, ¹/₅₀₀sec f5.6, Ektachrome 100.

good lenses if its qualities are to be exploited. However, if you work with 35mm this is the one you need for big enlargements. Another film that should be specifically mentioned is Fuji Reala. This is one of the ISO 100 group and is designated a 'professional' film. In common with most of the colour negative films primarily intended for professional use (Kodak Vericolor is another example), it is of lower contrast with less heavily saturated colours than the amateur films. This can be helpful with pictures taken against the light where there are extremes of light and shade and also in cases where subtle colours are important to the picture. In addition Reala is unique in its ability to render fluorescent lighting naturally. Normally this light comes out green with colour film and although it can be corrected with suitable filters there are unavoidable problems with mixed lighting for which Reala offers a much better solution.

The next group of negative films comprises those of ISO 200 speed. Quality is still very good and for the popular compact 35mm cameras these are a good choice for general-purpose photography that will include some landscapes. Sharpness, grain and colour are not so good as the ISO 100 group, but unless you are looking for enlargements beyond, say 10×8in the difference will not be very obvious.

Films faster than ISO 200 are not normally appropriate for scenic photography. In low-light conditions you would be better with a slower film with a tripod whilst in good light (unless you are after some particular special effect, eg very grainy images obtainable with films of ISO 1000 and faster) the quality will almost certainly be disappointing not only in terms of sharpness and grain but also in colour quality.

COLOUR TRANSPARENCY FILMS

Although the choice of a suitable colour negative film is important it has to be recognised that the film is an intermediate step to a print. The final result is as much the result of the printing as the taking. This is not at all the case with colour transparencies. The film that is exposed in the camera is the finished product. Not only the darkness and lightness but also the colour balance is governed at the taking stage by the type of film, any filters that are used, and the exposure that has been given.

The choice of a transparency film is therefore very important. Experienced photographers will often have

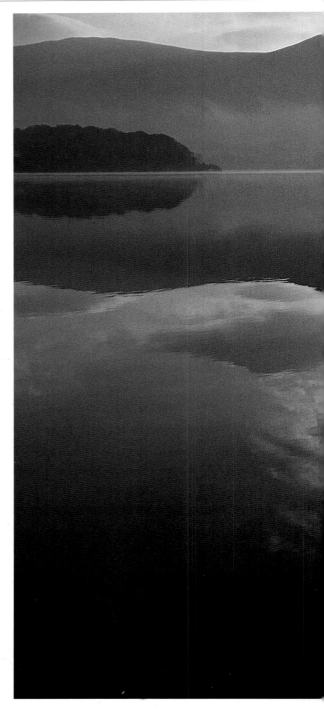

a 'palette' of different films that they know to be suitable for particular subjects and particular lighting conditions and maybe with different formats. They will have got to know these films and their attributes so that they can achieve much more confidently the style of image that they are seeking, whatever the circumstances.

As always the sharpest, finest-grained films with the best colour and smoothest gradation of tones are the slowest. We have seen already that this need not be a

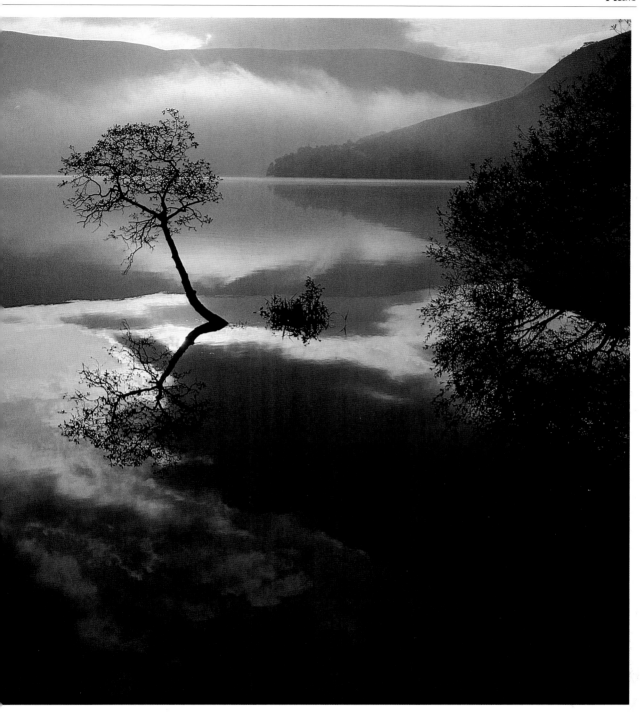

problem with landscape photography, because the subject is often static and a tripod can be used when light levels are too low for reliable hand-held shots or a lens has to be well stopped down to provide the required depth of field.

There are excellent films from all the leading manufacturers, Agfa, Fuji and Kodak. Within any given speed group, quality from these manufacturers is very close and the actual choice can often be based on subjective preferences for colour balance and contrast.

Drowned tree, Ullswater, Cumbria

Taken in the autumn as the sun was rising and beginning to clear the dawn mists. With 35mm, a slow, high-quality film in the range ISO 25 to ISO 64 will ensure the very best results and with medium or large format ISO 100 is a good choice.

Leica R4, 28mm Elmarit, $^1/_{125}$sec f5.6, Kodachrome 64.

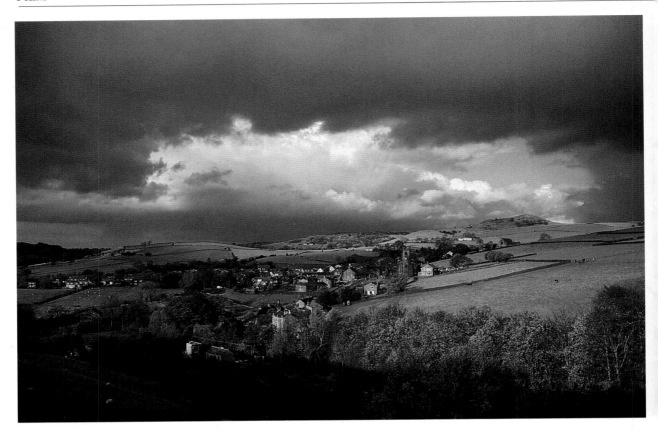

Rainow, Cheshire

These two views of this attractive village on the edge of the Peak District show how different light and different film can give remarkably different results. The first is on slow, high-quality film in reasonably good light. The second on a dullish winter day was taken on quite a fast film. This combination with the change of perspective resulting from the longer focal length creates an almost Bruegel-like effect.

(Above) Leica RE, 35mm Summicron, ¹/₁₂₅sec f4, Kodachrome 25 Professional.

(Above right) Leica R5, 28–70 zoom at 70mm, ¹/₂₅₀sec f5.6, Kodachrome 200 Professional.

In 35mm the slowest film available is Kodachrome 25 (ISO 25). This is the well-established standard by which all others are judged for quality. Not surprisingly, bearing in mind its speed, it is extremely sharp and has extremely fine grain, moderate contrast, clean well-saturated colours and very smooth tonal gradation. In good light the colour balance is fairly neutral, but it does tend to be on the cool side in dull or rainy conditions. Most of the 35mm pictures in this book were taken on Kodachrome 25. Fuji Velvia (ISO 50) is another of the slower films noteworthy for its sharpness. At the time of writing it is undoubtedly the sharpest E6 process film (the Kodachrome process is different). It is also very fine grained and all the colours are highly saturated. Reds are very strong and blue skies never need a polariser! The greens too are very bright and for some are at times a little overpowering in the landscape. Other photographers like these greens and the strong colours make it a useful film in dull lighting. The other Fuji transparency films often used for landscape are Fujichrome 50 and Fujichrome 100. These films are also E6, but are not quite as sharp as Velvia. Their colour is less brash than Velvia, but is noticeably warmer than the Agfachrome and Ektachrome E6 equivalents from Agfa and Kodak.

Fuji 100 (ISO 100) particularly in 35mm and medium format is a popular choice with many

photographers who like the warmer tones. However, the most widely used films in medium and large format are Ektachrome 64 and Ektachrome 100. There are different versions available. Not only are there amateur and professional ones (see below) but there are variations with higher contrast (HC) and warmer rendering (64X and 100X). I find that the standard Ektachrome 100 Professional (EPN), or Ektachrome 100 Professional Plus (EPP) which has slightly more saturated colours, suits me very well for my medium-format requirements. The colour balance is pleasantly neutral with excellent greens and reasonably accurate skies – although like Fuji the blue skies sometimes appear to have been helped with a polariser!

In 35mm, Kodachrome 64 is another very popular film mainly because of the extra speed it offers over Kodachrome 25. This is certainly helpful on occasions, but the colours are not so clean and accurate as 'K25' and the film has more contrast as well as a tendency towards a more magenta colour balance. Sharpness and grain are not quite so good as its slower cousin and very much on a par with Velvia. In practice my choice in 35mm, if I need a faster film than Kodachrome 25, is Kodachrome 200. This film is very sharp in spite of noticeably increased grain, with a pleasant colour balance similar to but somewhat warmer than Kodachrome 25. It performs well in low light situations.

Agfa films now are all E6 process. They are notable for their excellent neutral colour rendering, with particularly clean whites and greys. Colours are somewhat less saturated than Fuji and most Kodak films, but there are many situations when this can be advantageous.

Unless you are looking for a particular effect, increased grain or off-key colour for example, you are unlikely to be pleased with landscape results from the faster films. With the possible exception of Kodachrome 200, I would not recommend a transparency film faster than ISO 100 if you wish to be sure of best detail, natural colours and good tonal rendering. If the light is poor you are better off using a slower film and a tripod whenever this is practical. However, if there is an absolute necessity for extra speed, Ektachrome 400 and Fujichrome 400 are remarkably good at ISO 400. Even faster films are Agfachrome 1000, Fujichrome 1600, Kodak Ektachrome P800/1600 and 3M; the latter has a splendidly individualistic coarse grain that can be exploited for special effects. It should be noted that the ultra-fast Fuji and Kodak films are professional films and are basically ISO 400 emulsions that have been specially designed for 'push' processing to ISO 800 or ISO 1600. You will need to use a professional lab and advise what 'push' you need, ie one or two stops, when you take or send your films for processing.

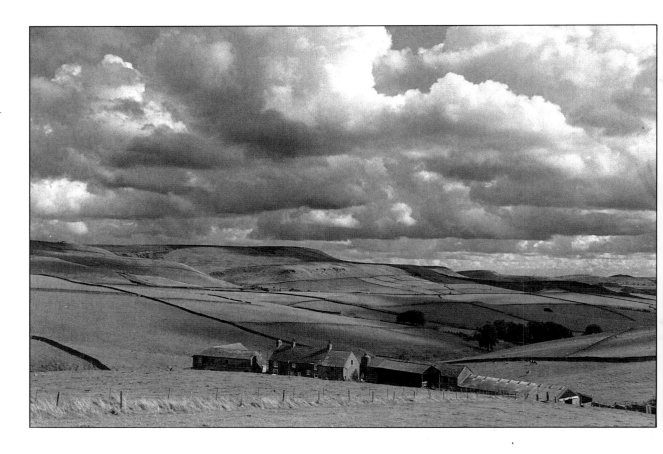

(Left) *Infra-red film completely changes the tonal relationships in a black and white photograph. In this instance, I was looking for something different from the usual pretty colour view of these old cottages in Great Budworth, Cheshire. Notice how the sky has gone very dark and the leaves on the trees are almost white. Using an ultra wide-angle lens and stopping down well ensured that the slightly different focus of infra-red rays was well covered by depth of field.*

Leica M2, 21/4 Super Angulon, ¹/₁₂₅sec f11, Kodak High Speed Infra-Red.

(Below left) *A great sky emphasised by an orange filter is the essence of this view of Wildboarclough in Cheshire.*

Leica M6, 35mm Summicron, ¹/₂₅₀sec f8, Kodak T Max 400.

BLACK AND WHITE FILMS

Although, overall, scenic photography in monochrome is very much a minority interest, a remarkably high proportion of 'fine art' or 'artist' photographers prefer to work with black and white film. Inspiration is still drawn from the achievements of the great pioneering nineteenth- and early-twentieth-century photographers from William Henry Fox Talbot and Roger Fenton to Alvin Langdon Coburn and Alfred Stieglitz who of course had no opportunity to use colour, as well as more recent photographers like Ansel Adams and Minor White who built their considerable reputations with their superlative black and white landscape work.

The great advantage of the monochrome image is that it represents a significant step away from the reality of a scene. This allows photographers more easily to impose their own vision and use their original scene as no more than a starting-point for their creative expression. The process, too, is relatively simple and most photographers develop their own films and carry out the subsequent printing. This ensures that absolute control is exercised over the finished result and final impression. A first-class black and white print has a unique quality of craftsmanship which can be appreciated in its own right – giving added value to a worthwhile image. Subtle toning processes may give a further dimension. This continuing interest has ensured that there is still a wide choice of good-quality black and white films available.

The general rule is that the slower the film, the finer the grain, the better the sharpness and the smoother the tonal gradation. Landscape is not a subject that requires action-stopping shutter speeds, so in poor light a tripod can be used. Ultra-fast films are rarely needed, which means that high quality can be maintained.

GENERAL PURPOSE FILMS

For normal use a medium-speed (ISO 100) film such as Ilford FP4 Plus or Kodak T Max 100 is ideal. Sharpness, grain and tonal quality are so good that the grain from using an even slower film is minimal. A plus point is that the slight extra speed will be a great help whenever filters are required. An orange filter, used to emphasise a dramatic sky for example, has a factor of four times and would reduce the effective speed of T Max 100 to ISO 25, but this is still adequate for hand-held exposures in reasonable light.

In bad weather or for low-light photography an ISO 400 film will still provide good quality and is likely to handle the inevitable extremes in contrast more easily. With an F2 or faster lens hand-held pictures can be made in reasonably lit areas at night, but a tripod will be needed if you need to stop down for depth of field.

ULTRA-FAST FILMS

Many ISO 400 films can be 'push' processed to achieve effective speeds of 800, 1600 or even 3200 ISO. The penalty is increased grain, progressively poorer tonal quality and some loss of sharpness. Some films respond much better than others and it is worth getting the latest literature from the manufacturers to check their recommendations. Fuji and Kodak market 1600 and 3200 ISO films. Correctly exposed and processed these will give quite reasonable quality although they are noticeably inferior to the ISO 400 films exposed normally.

Unless you are after some particular creative effect, eg heavy grain or reduced tonal range, these ultra-fast films or pushed ISO 400 ones are not usually appropriate for landscape photography.

INFRA-RED

Kodak High Speed Infra-Red is a powerful tool for the creative photographer. As well as cutting through mist and haze – a purpose for which it was intended – the distortion of normal tonal values can be exploited to achieve some quite surreal effects. Their lack of infra-red means that skies become black whilst conversely leaves on the trees, which have a high infra-red reflectance, become white. In addition the film is very grainy, which enhances the other-worldly look.

This is not a particularly easy film to handle. Loading and unloading the camera must be carried out in the dark. Even after loading the developing tank, care is

needed as some plastic tanks can pass infra-red wave-lengths so that even the development may have to be done in the dark! The recommended developer is Kodak HC 110 for 6min at 20°C (68°F).

Exposures have to be made through a deep red (Wratten 25, 29, 70, 89B or equivalent) or special infra-red filters in order to exploit the film's special properties. Film speed is difficult to establish precisely because this is obviously dependent on the amount of non-visible infra-red reflected from the scene. A useful starting-point when using the Wratten 25 filter is to set the film speed on the exposure meter to ISO 50. If metering in camera through the lens, remove the filter when taking your reading, or set the film speed to ISO 400. An average scene in good daylight should read $\frac{1}{125}$sec at f11 and if you are not sure of your metering this is a good basic starting-point. Whatever method you use, always bracket exposures +1, +2, −1 and − 2 stops.

Unless you are using an 'apo' (apochromatically corrected) lens you will need to correct the focus on your camera as infra-red rays come to a focus at a different point to visible wavelengths of light. You will have to set the lens to a slightly nearer distance after you have focused normally. Some lenses have an infra-red mark on the scale and you should reset to this. Alternatively, a useful rule of thumb that works with wide-angle and standard lenses is to reset the indicated focus to the f5.6 mark on the depth-of-field scale. Do not forget that this is to the mark that gives a *closer* focus!

PROCESSING

Most photographers working with black and white prefer to process and print their own films. The important thing is to establish a combination of film, film speed rating, and developer suited to a consistent method of working. You will be looking for negatives that are easy to print for maximum quality with your darkroom equipment and methods. This is quite likely to require fine tuning of film speed rating and film development times.

Some reliable well-tried developers are Agfa Rodinal, Ilford ID11, Ilford Ilfosol, Kodak D76 (almost identical with ID11), Kodak T Max and HC 110. Developers supplied in liquid form, with an appropriate quantity used once and then discarded, are the most convenient as well as ensuring consistent results. Rodinal, Ilfosol, T Max and HC110 are in this category. D76 and ID 11 are supplied in powder form and require mixing before use.

PROFESSIONAL FILMS

Some films, colour as well as black and white, are designated as 'professional'. These are usually distributed through a separate stockist network which can provide the controlled storage conditions that are usually required and also the detailed technical information and advice needed for specialised applications. Although in some cases the professional and amateur films may come from the same production, more often the professional film has been specifically designed to meet the particular needs of professionals. An example is Kodak Vericolor III. Because this film is particularly intended for use by professional wedding and portrait photographers, the contrast is much lower and the colours more natural than the general purpose amateur print films which aim for bright saturated colours and relatively high contrast. Similarly the 'aim points' of the professional transparency films are much more specific, with different films of the same nominal speed but slightly different characteristics being available. Kodak's Ektachrome 100 is an example with 100, 100 Plus and 100X each subtly different. Ektachrome Professional 100 is the most accurate in its rendition, 100 Plus has greater colour saturation, and 100X has a warmer rendition with greater contrast.

Kodachrome professional film, however, comes from exactly the same production as the amateur film. The difference comes when batches are tested to ensure that they are within the very tight quality tolerances; those with the absolute minimum deviation from perfect speed and colour standards are selected and then released into the controlled professional distribution chain when at their optimum. All films mature and slight changes occur even prior to the expiry date marked on the box. Amateur films are released on the assumption that this maturing will continue to take place during storage on dealers' shelves. Professional distributors and dealers store, where appropriate, at low temperatures to minimise these changes. All the special films, eg infra-red, duplicating, high resolution and high contrast, are designated professional as are almost all medium-format (roll) films and all sheet-film sizes.

PROCESSING

Professional colour transparency films are sold without processing and need to be handled by a high-standard professional lab if the quality chain is to be maintained. E6 is the now universal process for all except

Kodachrome which because of its very complex procedure has to be returned to a Kodak laboratory. Most professional labs offer a two-hour service on E6. Professional Kodachrome is same day (plus any time for posting or long-distance delivery).

Professional negative films such as Fuji Reala and Kodak Vericolor need special care in printing as does Ektar. Although the film processing is the standard C41, the printing requires different filtration. In the high street the typical mini-lab whose low prices are based on volume and fast throughput will rarely be able to achieve the quality of a professional lab. The cost of the latter will of course be much higher.

For the serious landscape photographer the advantages of professional films and processing by professional labs are reliability and consistency. Eliminating as many technical variables as possible allows the photographer to concentrate on the picture. It pays to get to know the characteristics of just a few films and to use a reliable processor, so that you know the results to expect with different types of subjects under different lighting conditions in order to achieve the effect that you require.

EXPOSURE

Correct exposure of the film is an important link in the chain of quality photography and because you are dealing with natural light – a source that is variable and sometimes unpredictable – landscape can be a demanding subject. An adequate understanding of this topic is, therefore, especially valuable. In the sense that an acceptable print can be obtained, many modern negative films – colour or black and white – are remarkably tolerant of errors in exposure. For the highest-quality results, however, with the finest tonal gradation and highest resolution, an accuracy of plus or minus two-thirds of a stop, equal to plus or minus 60 per cent, is necessary. As already discussed, transparency films require even greater accuracy; plus or minus one-third of a stop is the maximum deviation that can be tolerated by most films without clear loss of quality and very obvious over- or underexposure. Remember too that with transparency films there is no opportunity for correction at a subsequent printing stage – the exposed transparency is the finished result.

THE THEORY OF EXPOSURE

What you are trying to achieve with most subjects is to record good detail through from the brightest highlights to the darkest shadow areas of the subject, and you will wish to set an exposure that ensures that these two extremes fall within the capabilities of the film that you are using. The inherent contrast range of the subject, however, may not permit this, and the options available are to determine whether the highlight areas or the shadow areas are most important and to bias the exposure accordingly so that important highlights are not burned out or important shadow areas are not too dark to record detail. Some compression of the subject contrast almost always takes place, and particularly with negative films the contrast

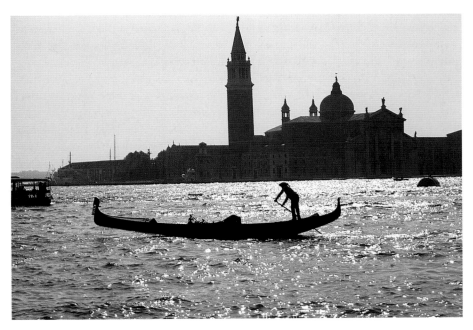

The Lagoon, Venice, Italy

Getting the right exposure for against-the-light scenes is tricky. It is the highlights that give the sparkle and these must not be 'burned out', but a little detail is often required in the shadow areas. Here the gondola is nicely silhouetted, yet there is detail in the buildings beyond. Bracketing the exposure is always worthwhile.

Leica M4, 90mm Elmarit, ¹⁄₂₅₀sec ƒ5.6, Kodachrome 25.

range is reduced during development and can be further modified during printing. This is inevitable anyway because the maximum brightness range of even a glossy print is only around 30:1 and that of a transparency about 125:1, whilst the original scene could easily be two or three times this.

A useful rule of thumb is to give preference to the highlights with transparency films and to the shadow areas with print films. This is because as mentioned above the development process is such that with negative films the highlights are less likely to clog up although the printing process does need good shadow detail. Because transparencies are projected, shadow detail is more easily perceived and it is much more important to retain highlight detail. Also when a transparency is printed in a magazine or a book the reproduction process involves a laser 'scanning' of the transparency which can modify the range by 'pulling up' shadow detail and reducing the overall contrast to that which can be handled on the printed page. What the scanner cannot do is to put detail back when it has been lost in overexposed highlight areas. This is the reason why professionals shooting for reproduction will prefer rich well-saturated transparencies and seriously avoid overexposing their films.

METERING SYSTEMS

Film manufacturers establish the rated speed of their products on the assumption that the average reflectance of all the elements of a subject average 18 per cent. In addition all exposure meters, whether hand held, built-in manual or built-in auto, are calibrated on the same assumption. For many scenes this average of 18 per cent works – in fact, the figure was decided on in the first place because it was representative of the very great majority of subjects.

The trouble is that the most exciting scenic subjects frequently do not conform to the 18 per cent norm. For example, a small patch of sunlight in an otherwise dull landscape does not conform, snow scenes do not conform, and many backlit scenes do not conform either. A good understanding of what your meter or exposure system is measuring and what it is trying to do is important if you are not to miss some great opportunities where the lighting could fool the metering system built into your camera.

Some of these on-board systems are now very sophisticated and the more expensive cameras will perhaps offer the photographer a choice of 'averaging' which includes a broad area of the picture, or 'centre weighted' which takes the greater part of its reading from the centre of the frame, or 'spot' which reads a very narrow angle in the centre. With automatic exposure cameras you can usually 'aim' the meter reading area at the main subject, lock the reading and then recompose the picture before releasing the shutter. With compact and some other autofocus cameras this is usually also combined with the focus lock. This facility allows you to exclude exceptionally bright areas or exceptionally dark areas that would lead the system to give incorrect exposure for the main subject. The 'patch of sunlight' example given above is a typical situation where an averaging or even a centre-weighted meter would take much of its reading from the dull landscape area, giving a result that would overexpose the most important brightly-lit part. The answer is a spot reading of the sunlit patch or some adjustment of the general reading, probably giving one to two stops less exposure than the meter indicates. This can be done easily with a manual camera; with an automatic camera with no alternative manual mode you will probably have an exposure compensation dial or a backlight button that usually provides an extra 1½ stops' exposure.

Even more sophisticated are the 'multi-spot', 'evaluative' or 'matrix' systems on some of the top-line automatic cameras. Multi-spot allows the photographer to take a series of narrow-angle readings from highlights and shadows or different parts of the scene and the camera automatically averages these. This is very effective, but it can be time-consuming and requires experience and skill to make the most of the feature. 'Evaluative' and 'matrix' are essentially the same. The image area is divided into several zones, the metering system reads these zones independently, and on the basis of a series of algorithms which recognise combinations of light distribution likely to cause problems, adjusts the exposure accordingly. The very latest systems combine with the autofocus electronics to give extra preference to the areas of the subject that are in sharp focus, assuming that these are the most important.

The technology is impressive and the results generally are very reliable, but any metering system can be fooled. There is nothing that a metering system can do that an experienced photographer using a separate hand-held meter cannot do at least as well. Perhaps not as quickly, but hurry is not often a problem with scenic photography and most separate meters have a facility denied to the on-board system. They do allow incident-light measurements to be made. These measure the light falling on the subject rather than the light reflected from it. The meter integrates this with a hemispheric cover over the cell which equates the

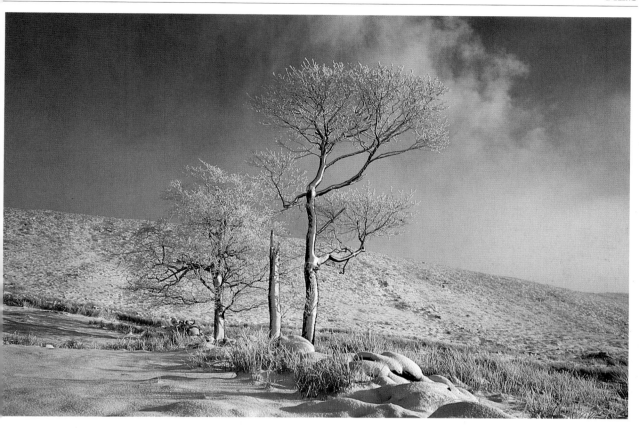

Trees and snow

The difficulty with snow scenes is that the exposure meter is confused with the excess of white. It will try to make the white a mid-grey and to compensate for this you need to increase the exposure by around 1 ½ stops or read a darker area within the picture.

Leica, 35mm Summicron, ¹/₂₅₀sec ƒ5.6, Kodachrome 25.

reading to the 18 per cent reflectance. The meter is pointed towards the camera from the subject position or towards a position which has the same lighting as the subject. This is not always as practical out of doors as in a studio, but the advantage of the incident-light method is that it effectively ensures that the highlights are correctly exposed, which is ideal for transparency films. It can, however, be misled if the subject includes large areas of shadow which could need extra exposure.

SPECIAL SITUATIONS

Backlit scenes can fool any metering system. As they often occur in landscapes the photographer needs to be able to recognise the potential problems and how to deal with them. It is very rare in scenic photography to have to give special consideration to shadow areas. The visual impression is almost always conveyed by the bright areas and exposure can usually be biased in the direction of holding detail in these. The important thing is to avoid readings being affected by excessively bright highlights. The sun itself may be in the picture area or it might be reflected strongly off very light coloured areas, a white wall for instance, or a highly reflective surface such as water. In the latter case, when shooting directly towards the sun, the myriad of tiny reflections is like metering the sun itself. The technique

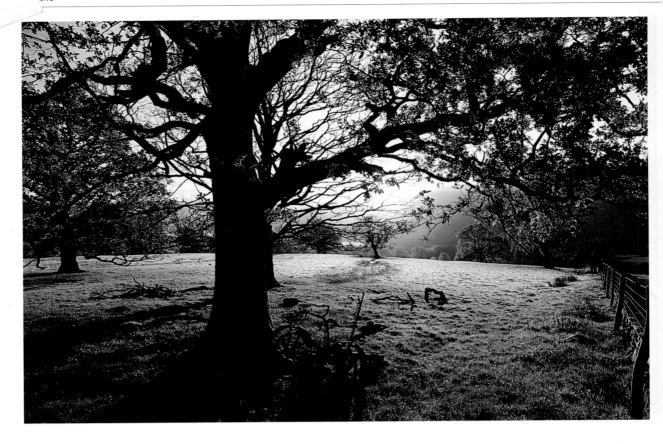

Gowbarrow, Cumbria

Pictures taken with very wide angle lenses may need some adjustment of the indicated exposure. There is always some vignetting (darkening towards the corners) even with the very best lenses and if there is important detail in shadow areas near to the edges of the frame, a little extra exposure will help. Plus half a stop is a good point to start.

Leica M6, 21mm Elmarit, ¹/₆₀sec f4/f5.6, Kodachrome 25 Professional.

is to select an area more representative of an 18 per cent tone from which to meter, or to modify the setting. Between plus one and plus two stops extra will give an exposure that still captures the sparkle of the scene and avoid reducing it to the almost moonlight effect that against-the-light shots over water can easily become. That is of course unless you want the moonlight effect!

Snow scenes can easily cause difficulties too. If you remember that the meter thinks that it is reading an 18 per cent tone, ie a mid-grey, it will be realised that when most of that area is in fact white snow it will be indicating an exposure that will turn the snow into an awful muddy grey. To get nice white sparkling snow you will need to make a close up or spot reading of a darker area, or modify the exposure. Depending on exactly how much snow is in the picture plus one to plus two stops will be required.

There are less obvious situations where judicious modifications of the exposure may be necessary. It is an inescapable law of optics that all lenses vignette, ie less light gets into the corners of the image than the centre. With standard and longer focal-length lenses this is rarely significant – especially if they are stopped down to f5.6 or f8. With wide-angles, however, the problem is more acute and with an ultra-wide-angle lens, even at its optimum stop, illumination at the edges of the

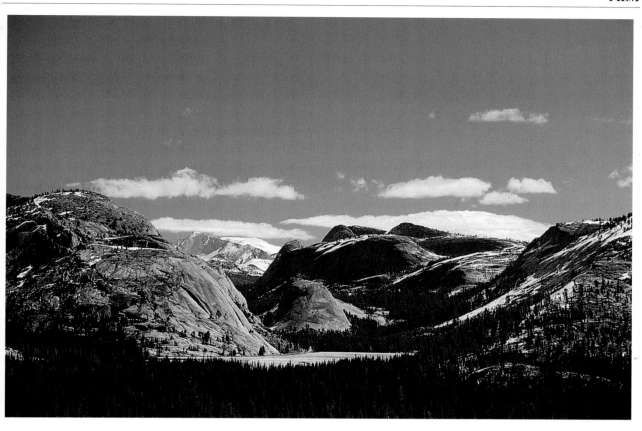

frame will fall off to less than half that at the centre. Thus if there is important detail at the edges of the picture a shade extra exposure – say plus one-third or plus half a stop will be worthwhile.

Conversely with long focal-length lenses a slight reduction of exposure can often be advantageous. This is because in such a situation a built-in camera meter will tend to be reading darker tones than average and slight underexposure will also help to improve contrast and colour saturation reduced by haze in distant scenes.

BRACKETING

In practice exposure is not an exact science. Not only can relatively small tolerances in shutter speed accuracy, meter systems, lens diaphragm settings and precise film speeds lead to cumulative errors but the technically correct exposure may not be the one that gives the most pictorially attractive result. With 35mm and also even with medium format, film is cheap relative to all the other costs and time involved in photography and bracketing is good insurance. Bracketing exposures is normal professional practice. This means taking extra frames with exposure adjustments plus and minus the established reading. Plus a half stop and minus a half stop are usual for transparency film and plus one stop and minus one stop for negative films.

Tenaya Lake, Yosemite, California

Distant views with long telephoto lenses will often benefit from a slight reduction in exposure. This will increase the contrast and saturate the colours that are muted by distant haze.

Leica RE SLR, 180mm Apo Telyt, ¹/₅₀₀sec f4, Kodachrome 25 Professional.

(Overleaf)
Sharrow Bay, Ullswater, Cumbria

Accurate exposure and slow high-quality film used with a precision camera and lens ensure the finest results. With careful technique the popular 35mm format can compete with larger formats.

Leica R4, 16mm fish-eye Elmarit, ¹/₆₀sec f5.6, Kodachrome 25 Professional.

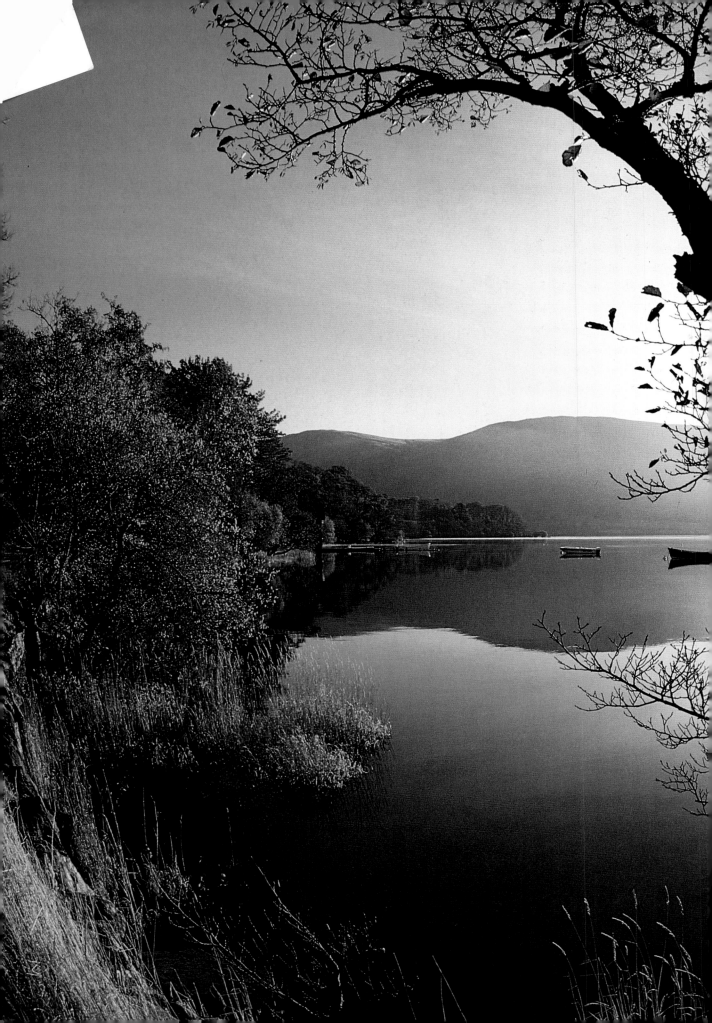

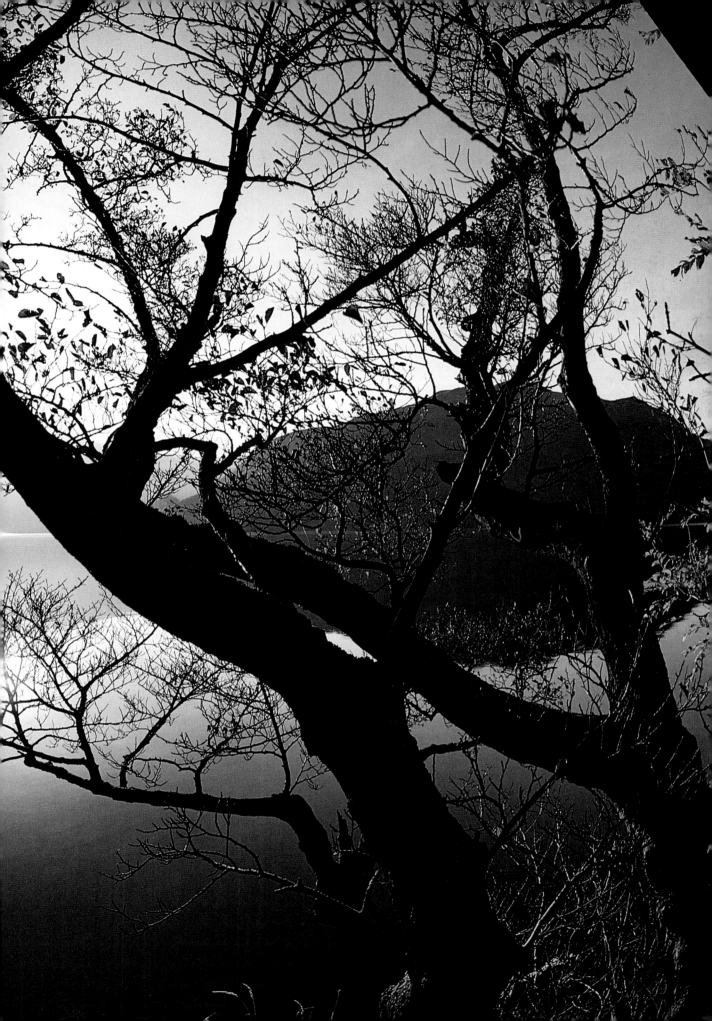

ACKNOWLEDGEMENTS

I am grateful to so many people for their generous support and encouragement in the course of gathering material for and producing this book. Special appreciation to my wife Valerie, whose tolerance of an obsessive photographer, and patience when 'waiting for the light', is remarkable. Not only this but she typed the manuscript and helped me with all the checking and proof reading too! Thanks go to Alison Elks my editor, Brenda Morrison the design manager and all the other dedicated members of the editorial, production and marketing team at David & Charles whose skills and enthusiasm are much appreciated; Bill Archer, Roger Craggs, John Conway, Alison Gayward, Mike Hopwood, Evelyn Mair, Mike Robinson, Jo Shield, Keith Watson and others at British Airways, American Airlines, Cathay Pacific, Page & Moy and the various organisations involved with travel who have commissioned work and smoothed my way across the world; Dr Verena Frey, Ulrich Hintner, Hans-Gunter von Zydowitz and my other friends at Leica Camera; last, but not least, many personal friends, family, fellow photographers and business associates who have not only humoured my camera-carrying obsession but also provided invaluable advice and assistance enabling me to reach the best locations.

INDEX

Page numbers in **bold** indicate illustrations